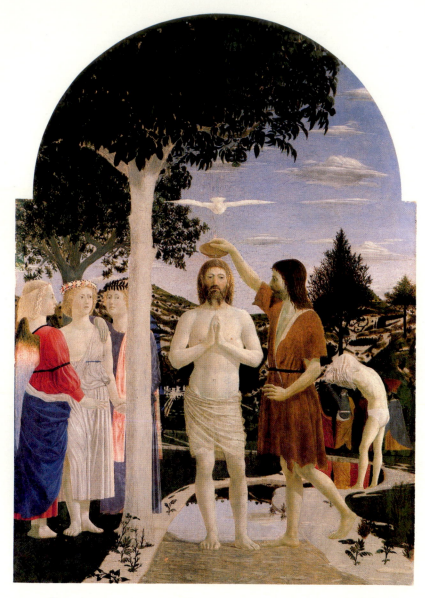

Frontispiece. Piero della Francesca, *Baptism of Christ*, London, The National Gallery (reproduced by courtesy of the Trustees, The National Gallery, London)

PIERO DELLA FRANCESCA'S

Baptism of Christ

MARILYN ARONBERG LAVIN

With an Appendix by
B. A. R. CARTER

New Haven and London
Yale University Press

Designed by James J. Johnson
and set in Waverly Roman type.
Printed in the United States of America by
Vail-Ballou Press, Binghamton, N.Y.

Library of Congress Cataloging in Publication Data

Lavin, Marilyn Aronberg.
 Piero della Francesca's Baptism of Christ.

 (Yale publications in the history of art; 29)
 Bibliography: p.
 Includes index.
 1. Francesca, Piero della, ca. 1420–1492. Baptism.
I. Title. II. Series.
ND623.F78L35 759.5 81–3371
ISBN 0–300–02619–6 AACR2

10 9 8 7 6 5 4 3 2 1

For Amelia and Sylvia

Contents

Illustrations

Preface

Since the late nineteenth century, when it was introduced into the literature of art, Piero della Francesca's *Baptism of Christ* has been recognized as one of the major achievements of the early Renaissance.[1] Its particular contribution was seen to be a remarkable combination of two opposing stylistic elements: one, its naturalism, a milestone on the road to classical revival, the other, its seemingly modern quality of formal abstraction. The landscape vista could be identified as a specific part of Tuscany, and at the same time it was seen as evidently structured with geometry. The statuesque figures were described as stalwart peasants yet were said to function in the design as cylinders and cones. The pure color, rich in chromatic variety, the volumetric forms revealed by light, the clarity of atmosphere, were seen as bringing reality to the event depicted; but they also were said to create a rhythmic surface pattern of solids and voids.[2] The painting's style, in fact, is both naturalistic and abstract, and recognition of this twofold aspect was the first step toward comprehending the strangely evocative power of the image.

The familiar gospel scene, presented frontally and in clear sunlight, is charged with a haunting sense of portent. The mood is tranquil yet disquieting. The space is open yet forbidding. The figures are the usual cast of Baptism characters yet are scattered through the valley as in no previous baptismal scene. Their poses are both suspended and suspenseful. Their gestures seem deliberately awesome.

Perceiving these effects, several recent writers have sought meaning in the figural groups beyond pure narrative. Religious symbolism, ritual, and liturgy have rightly been called upon to elucidate various parts of what is represented.[3] Again, these commentaries are correct; the scene, at one and the same moment, tells a story and is nonnarrative. Recognition of such underlying significance was the second step in grasping the affective nature of the image.

As much as all these analyses have deepened our understanding of the painting, they remain incomplete. For they lack an overarching view that would relate Piero's naturalistic geometry to his iconic narrative. In the study that follows, I hope to provide such a view and to demonstrate that the dichotomous features of Piero's style and content are complementary and mutually reinforcing elements in the expression of one coherent theme. I must warn the reader that the theme as I propose it, in all its ramifications, may strain the credence of the less adventurous. But I maintain that the pursuit of pictorial eloquence and structural subtlety as a total vision will always reveal meaning beyond ordinary expectation in the paintings of Piero della Francesca.

The substance of this study was presented in a series of lectures given for the Christian Gauss Seminars in Criticism, Princeton University, in February 1976. I take this opportunity to thank Professor Joseph N. Frank, director of the seminars, for the invitation to participate in this distinguished series, and the late Professor Walter A. Kaufmann for his kindness in leading the meetings. The lectures were prepared for an audience of scholars in many fields and therefore dealt to some extent with the place of the *Baptism* in Piero's career and Piero's career in the context of fifteenth-century painting. I have restricted this text to the painting itself, its meaning, and its religious context. As a result there is little discussion of stylistic or chronological problems. I have introduced new documentary material, but as it does not solve the problem of the painting's date I consider this task to be still in progress.[4]

I suggest that the painting was commissioned for an altar in a Camaldolite abbey church and that its content to some extent depends on this original location. Analysis of this aspect of the painting, however, is also incomplete. Pursuing the problem to its end, I feel, will only be worthwhile when my hypothesis about the commission has proven correct.[5] While thus in no way definitive, the results as they stand fit into a synthetic view of Piero's oeuvre that I have been developing in a series of publications on individual paintings.[6] These studies show that one of the artist's major preoccupations was spatial reorganization of the compositions of traditional subjects to express concepts new to the visual arts. In the *Votive Fresco of Sigismondo Malatesta* (Rimini), in the *Flagellation* (Urbino), in the *Montefeltro Altarpiece* (Milan), as well as in the *Baptism*, structural innovations provide the framework for neoteric meanings. Yet, in each case, there is no violation of traditional components. On the contrary, Piero invariably retained, even reinforced, the expressive values of the older, more hieratic forms. At the same time, by inventing newly structured settings, he articulated the subjects' specifically contemporary significance.

My analysis of the *Baptism* is organized under the following headings: the setting, the figure groups, the liturgical and exegetical meaning, in that order. There follows a history of the altarpiece as far as it can now be reconstructed. Much of the documentary information referred to was brought to light by Don Ercole Agnoletti, Archivist of the Archivio Vescovile, Sansepolcro; the gist of the documents appeared in a preliminary one-page article in the local religious weekly.[7] Don Ercole plans to make a more permanent publication of these and other of his findings in the near future. He has meanwhile allowed me to make use of the material, and for this collegial generosity I offer my heartfelt thanks. I hope our stimulating conversations have benefited Don Ercole's work as much as they have my own.

Two technical appendixes follow the text. The first is an

analysis of the geometric construction of the *Baptism's* sur-
face organization by Mr. B. A. R. Carter, Professor, London.
Mr. Carter and I had arrived at our similar conclusions inde-
pendently when we were brought together by a mutual friend,
Mrs. Ruth Rubinstein. Inasmuch as Mr. Carter's analysis of
Piero's *Flagellation*, done more than twenty-five years ago in
collaboration with Professor Rudolf Wittkower, first stimu-
lated my interest in Piero's language of visual structure, I am
particularly gratified to have his cooperation in the present
venture.[8] Professor Joseph Dauben, Department of the His-
tory of Science, City College of New York, was good enough
to read and comment on a preliminary version of Mr. Carter's
contribution, and Professor Chandler Davis, Department of
Mathematics, University of Toronto, verified some of the
calculations. The second appendix is an account of the mod-
ern history and physical condition of the painting.

Many friends, colleagues, and students have helped to
make this text better than it might have been. Other than
those mentioned in the notes, I wish to thank most warmly
Professors Samuel Y. Edgerton, Jr., George L. Hersey, H. W.
Janson, and Wallace J. Tomasini. Each in his own way
helped to clarify my language and sequence of ideas. It was
my husband, however, who brought me to a full understand-
ing of my own work. His prodding questions, in fact, led me
to a new insight: like John the Baptist, Irving Lavin is fired
with an intensity that leaves him dissatisfied until he "points
the way."

> Ego dilecto meo, et dilectus meus mihi
> (*Canticum Canticorum*, 6:2)

Princeton, N.J., 1980

NOTES

1. The *Baptism* was originally the centerpiece of a large triptych said to have been on the high altar of the parish church of S. Giovanni in Sansepolcro. The large-scale frame (figs. 2, 52), now in the cathedral of that town, has figures painted by another artist generally thought to be Matteo di Giovanni (see chap. 6). A rondel containing a representation of God the Father and a scrollwork pinnacle surmounted the *Baptism*; both are lost. See appendix 2 for the full documentation.

2. R. Longhi, *Piero della Francesca*, 3d ed., p. 17; K. Clark, *Piero della Francesca*, 2d ed. pp. 11–12; B. Berenson, *Piero della Francesca or the Ineloquent in Art*, 2d ed., (London, 1954), p. 5; C. de Tolnay, "Conceptions religieuses dans la peinture de Piero della Francesca," *Arte antica e moderna* 23 (1963): 213; P. Hendy, *Piero della Francesca and the Early Renaissance*, p. 70; C. Gilbert, *Change in Piero della Francesca*, p. 33. C. Vermeule, *European Art and the Classical Past*, pp. 39–42, discusses possible prototypes in classical sculpture.

3. Clark, *Piero*, p. 13; Tolnay, "Conceptions," p. 214; F. Hartt, *A History of Italian Renaissance Art*, pp. 234–35; E. Battisti, *Piero della Francesca*, vol. 1, pp. 113ff.; M. Tanner, "Concordia in Piero della Francesca's 'Baptism of Christ,' " *Art Quarterly* 35 (1972): 1–21.

4. As no contemporary documents concerning the commission have come to light, dating the painting has depended primarily on stylistic analysis. Assigning a date has been difficult and controversial owing to the extraordinarily consistent character of Piero's style. Most authors consider the rough and almost primitive aspect of Christ's face, the stiffness in some poses, and what seems to be a harshness of the fleshtones (but see below, app. 2) as "immature." Longhi (*Piero*, pp. 17–18) and Tolnay ("Conceptions," p. 213), for example, date it 1442–45, an early—if not Piero's earliest—work. Piero's dates are ca. 1420–92. Tanner ("Concordia," pp. 7ff.) and E. Pogány-Balás ("Problems of Mantegna's Destroyed Fresco in Rome, Representing the Baptism of Christ," *Acta Historiae Artium* 18 [1972]: 107–24), agree with the early date because they relate the painting's subject to the Council of Florence (1439). At one time, the date seemed corroborated by the similarity of one of the angels (the one in the middle) to a figure in the foreground of Piero's *Flagellation* in Urbino, which was traditionally associated with a historical event of 1444. Later scholarship recognized, however, that the historical association was at best doubtful, and both paintings were moved forward five or more years. Clark, for example (*Piero*, pp. 11–12), dates the *Baptism* as a work of "early maturity"; see also Hartt, *Renaissance Art*, p. 234. Still other scholars think the early 1450s is too early for the highly developed perspective of the *Flagellation*, and they once more advance its dates to the later 1450s or early 1460s. Only a few writers have realized that the same

should also be claimed for the *Baptism*; Battisti (*Piero*, vol. 1, pp. 113ff.) dates it between the second half of 1459 (Piero's return from Rome) and 1462, and Gilbert (*Change*, p. 33) dates it 1460–65. I agree that the *Baptism* and the *Flagellation* are related, for reasons not of morphology but of structure. Their compositional principles are similar: they share an unobstructed entrance into the foreground space, separate groups of figures placed at different points in depth, and a single, narrow, off-center vista into the deepest space. I date the *Baptism*, therefore, as I date the *Flagellation*, to the late 1450s or early 1460s (*Piero della Francesca: The Flagellation*, pp. 81–82). See below, chap. 7, for historical support for this date. Perhaps the most important aspect of this dating is that at this time the spatial and atmospheric effects, considered advanced by all viewers no matter to what date they assign the paintings, become historically plausible.

5. See below, chap. 7.

6. M. A. Lavin,. "Piero della Francesca's Montefeltro Altarpiece," *Art Bulletin* 51 (1969): 367–71; idem, *The Flagellation*; idem, "Piero della Francesca's Fresco of Sigismondo Pandolfo Malatesta before St. Sigismund," *Art Bulletin* 56 (1974): 345–74; ibid., 57 (1975): 307 and 607; idem, "The Antique Source for the Tempio Malatestiano's Greek Inscriptions," *Art Bulletin* 59 (1977): 421–22.

7. E. Agnoletti, "Le vicende del 'Battesimo di Cristo' di Piero della Francesca," *La Voce* (*Settimanale religioso-sociale*), Oct. 5, 1975, p. 1. A copy of this publication was most kindly sent to me by Don Ercole.

8. R. W. Wittkower and B. A. R. Carter, "The Perspective of Piero della Francesca's 'Flagellation,'" *Journal of the Warburg and Courtauld Institutes* 16 (1953): 292–302.

PART ONE

The Setting

1
The Composition

It will come as no surprise to those familiar with Piero's innovative perspective views in architectural scenes that the setting of the *Baptism* (frontis., figs. 1, 2) marks an equally important turning point in the history of landscape painting. It is the first altarpiece to show large-scale figures in a consistent landscape with no pictorial barriers separating the painted space from the space of the spectator.[1] A meandering stream meets the picture plane head on; were it not for this invisible membrane, we feel, the clay banks, pebbled riverbottom, and fragmented plants and grasses would continue to move forward. In their perpendicular position, the edges of the banks, though in no sense geometric, recall the illusion made by orthogonals of a pavement floor, leading the eye into the depth. They slant toward each other in a way that suggests convergence toward a single point lying in the center of the composition somewhere close to Christ's knees. Besides guiding us to a fixed viewing position, this sense of convergence emphasizes the centrality of Christ, his figure balanced on either side by John the Baptist and a tall, slender tree. Above Christ, the dove of the Holy Ghost forms a horizontal accent parallel to Christ's shoulders (fig. 3). It also begins a vertical axis that continues in a polyphony of bird, dish, head, and praying hands that is in line with the converging orthogonals. This vertical axis coincides with Christ's center of balance, that is, the line from the tip of the chin to the instep of the weight-bearing leg.[2]

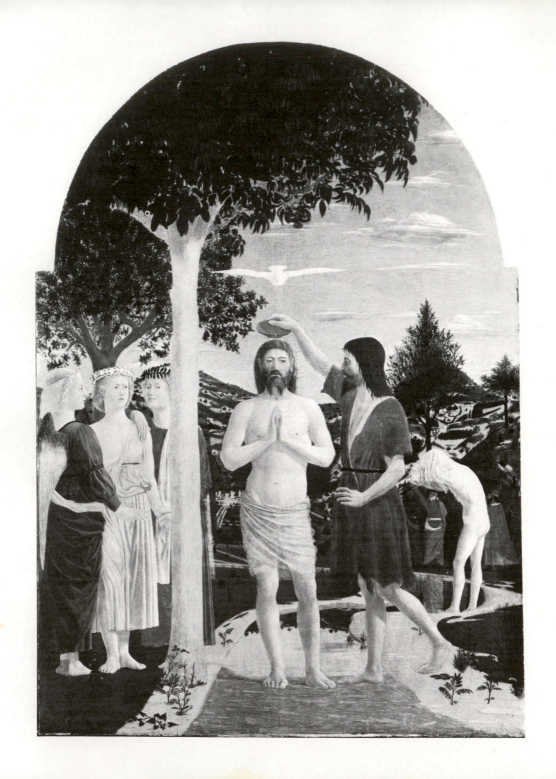

In the interstices between and beyond the baptismal figures, the deep vista unfolds. Three figural groups—angels on the left (fig. 4), a single catechumen on the right, and behind him, further back, four elders (fig. 5, right)—form major station points moving into depth. The eye is carried from group to group by the meandering of the river, and the decreasing size of the figures themselves reinforces the illusion of recession. Their upright positions, in solid contact with the ground, and the logical rate at which their scale decreases suggest, further, the figures' positions having been plotted on a mathematical grid.[3] The deepest recession (fig. 5, left), visible at the left of Christ, is likewise punctuated by a sequence of tree stumps, paths, and roads arranged as loosely parallel to the main orthogonals of the river. The long, verdant meadow is closed in the distance by cultivated mountains, the sun-bleached village nestling in the foothills. The level of the pseudo–vanishing point, and hence the horizon, is below the springing of the hills. This fact, in turn, brings forth the vast amount of sky that arches over the scene. The sky itself is pale behind the mountains, turning bluer as the altitude rises. It is laced with clouds, grayish in a morning light that etches forms and casts short shadows on the ground.[4]

The arrangement we have described differs radically from the majority of fifteenth-century outdoor scenes. More usual in panoramic vistas are foreground figures placed on what has been called a "plateau" of land, parallel to the picture plane. Cut in front by jagged folds of earth and falling away quickly to a valley beyond, the plateau forms a visual barrier separating the depicted realm from that of the spectator.[5] In contrast, the foreground of Piero's design moves directly back; it is uninhabited, with the main figures placed some distance behind the picture plane. It is precisely this empty area that gives the illusion of accessibility, and yet in psychological terms creates a kind of no-man's-land that bars our entry.[6]

In short, without the benefit of ruled lines or regular

1. Piero della Francesca, *Baptism of Christ*, London, The National Gallery (reproduced by courtesy of the Trustees, The National Gallery, London)

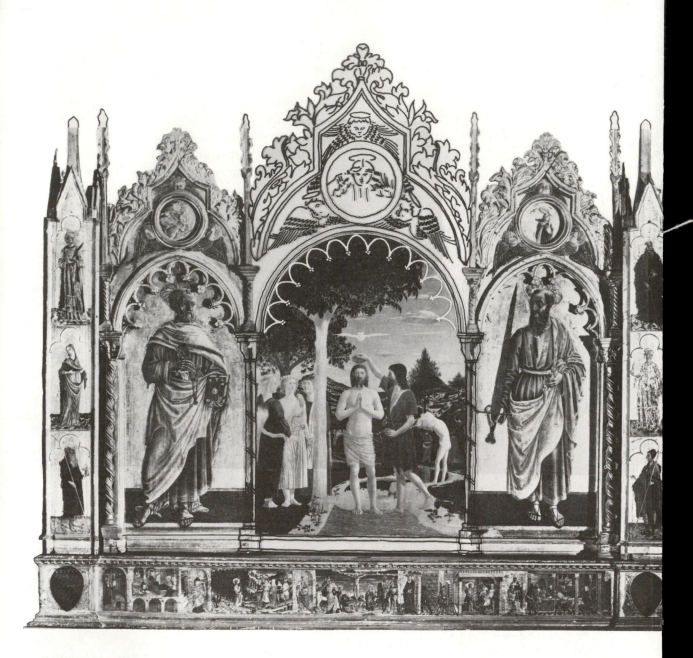

2. Reconstruction of the Baptism Altarpiece, photomontage with ink additions designed by James Brody Neuenschwander, rendered by Johannes G. Albrecht

forms of architecture, Piero produced a coherent, unified outdoor space, based on the principles of linear perspective. The view is what Leon Battista Alberti would have called a "miracle of painting," transforming a flat, impenetrable, two-dimensional surface into a transparent plane or "window" through which one sees a fragment of another world very like our own.[7] But whereas Alberti would have been speaking of architectural views, Piero in the *Baptism* applied the concept to landscape and thereby made a major advance in the history of represented forms.

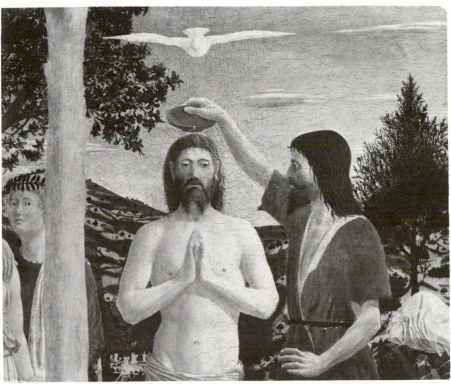

3. Detail of fig. 1, Christ and John the Baptist (reproduced by courtesy of the Trustees, The National Gallery, London)

This structural innovation was for Piero, however, not an end in itself. In spite of its artistic importance for the history of style, unification of the space serves here a thematic purpose. Piero used it to separate the usual components of the

Baptism into discrete groups. These groups function expressively as independent units and yet are bound together in their common setting with imperative reciprocity. We shall see that with his conscious ordering of nature, Piero created a language of visual structure that transforms the traditional scene of Christ's Baptism into what amounts to a new subject.

NOTES

1. Piero's work is frequently cited in discussions of Italian landscape painting: e.g., K. Clark, *Landscape into Art* (London, 1949); D. Neri and H. Kiel, *Paesaggi inattesi nella pittura del Rinascimento* (Milan-Florence, 1952); L. Gori-Montanelli, *Architettura e paessaggio nella pittura toscana. . .* (Florence, 1959); A. R. Turner, *The Vision of Landscape in Renaissance Italy* (Princeton, 1966); G. Pochat, *Figur und Landschaft: Eine historische Interpretation der Landschaftmalerei von der Antike bis zur Renaissance* (Berlin, 1973), 275. Although some of the innovations in its setting are discussed in a recent note by R. Cocke ("Piero della Francesca and the Development of Italian Landscape Painting," *The Burlington Magazine* 122 [1980]: 627–31), the pivotal position of the *Baptism*, so far as I know, has not previously been defined. One major painting prefigures Piero's work in portraying a deep space lacking visual barriers in the foreground: the *Miraculous Draught of Fish* by Konrad Witz, dated 1444 (Geneva, Musée d'Archéologie; reproduced in Neri and Kiel, *Paesaggi*, pl. 70). However, as St. Peter appears twice in this composition, once in the boat and once in the water, it cannot be counted as a composition truly unified in time and space.

A landscape setting is, of course, a basic constituent of the Baptism theme. Until the fifteenth century, the outdoor space tended to end abruptly in flat backdrops not far behind the figural group. Giotto's scene in the Arena Chapel (ca. 1305–10; see C. Gnudi, *Giotto*, pp. 105–07, 154, pl. 94) is the only *trecento* example to include a relatively deep spatial recession before the backdrop appears. In the early fifteenth century, the *Baptism* by the Salimbeni brothers (fig. 12 [Oratorio di S. Giovanni, Urbino, 1416; A. Rossi, *I Salimbeni*, pp. 127–36]), the relief attributed to Donatello in the Baptistry of the Cathedral of Arezzo, ca. 1440 (fig. 33), and the fresco by Masolino in the Baptistry, Castiglione Olona, ca. 1435 (fig. 49), show a progressive deepening of the spatial ambient, a trend to which Piero's painting was, in this and other ways, heir. The *Baptism* by Rogier van der Weyden, at the center of a triptych with three scenes of John's life (Berlin-Dahlem, Staatliche Museen; M. Davies, *Rogier van der Wey-*

4. Detail of fig. 1, Angels (reproduced by courtesy of the Trustees, The National Gallery, London)

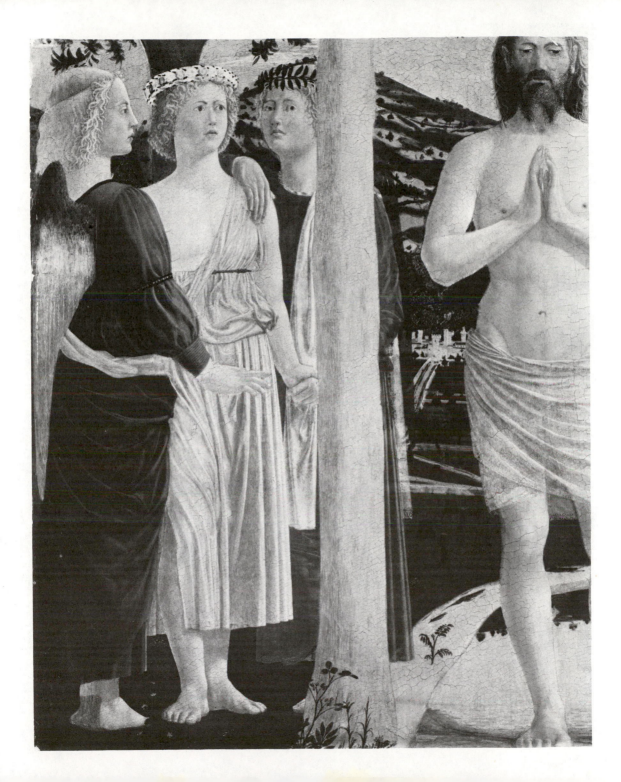

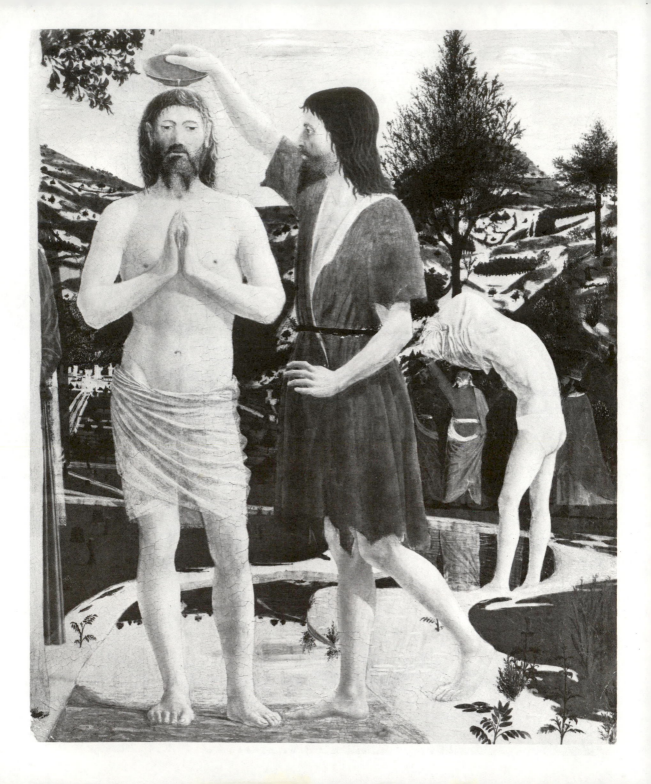

den [London, 1972], pl. 59), thought to date after 1450, has a deep atmospheric landscape that continues into the background without interruption. There is, however, an effective barrier in the foreground where the robe held by the angel falls over what seems to be a bank blocking the river. Furthermore, the scene takes place behind an elaborate stone portal where a groin vault and an arcade projects over the baptismal scene. The locale is thus not a true outdoor scene. Cf. B. Lane, "Rogier's Saint John and Miraflores Altarpieces Reconsidered," *Art Bulletin* 60 (1978): 655–72.

2. See app. 1, figs. 6off, where Mr. Carter finds that Piero followed Alberti's prescription in dividing the figure of Christ into three equal parts. We may observe that the pseudo–vanishing point corresponds roughly with the point demarcating the lower third of the body.

3. Hendy (*Piero*, p. 71) notes the approximate proportional relationship of 4:2:1 between the groups of figures.

4. We have spoken only of the three-dimensional structure of the space and illusion of spatial recession. Please consult app. 1 for B. A. R. Carter's analysis of the two-dimensional surface design and its symbolic significance.

5. The "plateau" formula, which produces a high point of view for the spectator, was a constant feature in both northern and southern painting through the third quarter of the fifteenth century. See discussion of this landscape motif in M. Meiss's 1961 article " 'Highlands' in the Lowlands: Jan van Eyck, the Master of Flémalle and the Franco-Italian Tradition," *The Painter's Choice* (New York, 1976), pp. 36–62, and other references in n. 1, above. Piero had used the "plateau" formula in his small *St. Jerome and Donor* (Venice, Accademia), and would use it again in the allegorical scenes on the backs of the Montefeltro Portraits (Florence, Uffizi) and in the *Adoration* (London, National Gallery [P. De Vecchi, *L'Opera completa di Piero della Francesca*, pls. 12, 62, 63, and fig. 28]).
Characteristically, however, Piero recreates the convention with sovereign disregard for the representational problems it masks, using it objectively to isolate the subject from the spectator and elevate it above the background elements for expressive reasons.

6. We have mentioned these elements as structurally related to the composition of the *Flagellation* (see above, preface, n. 4). As in the latter painting, the organization is also used in the *Baptism* for expressive purposes, as we shall see (cf. Lavin, *The Flagellation*, pp. 31ff.).

7. "Miracula picturae." See Leon Battista Alberti, 'O*n Painting' and 'On Sculpture*,' pp. 55–57.

5. Detail of fig. 1, Christ and John the Baptist, Catechumen, and Background (reproduced by courtesy of the Trustees, The National Gallery, London)

2

Pliny, the Val di Nocea, and Nuova Gerusalemma

The scene depicts the moment at which St. John baptizes Christ (fig. 3). The figure of Christ is astonishing, brutally simple in physical type, and infinitely delicate in its gesture of prayer. John the Baptist, wearing a tattered leather tunic and raising his arm to pour water from a dish, forms a profile counterpart to Christ's bold frontality. Above John's hand the Holy Spirit in the form of a snow-white dove hovers in perfect frontal foreshortening and lowers his head to observe the sacred rite.

This moment marked the climax of John's earthly mission. He spent his life as a hermit in preparation for Christ's arrival, preaching repentance and prophesying the coming of the Messiah. When Jesus appeared, John recognized him miraculously and did his bidding. The two men never met again in this world.[1] Because of the pivotal nature of their meeting, scenes of the Baptism found place in narrative cycles of both their lives. In the life of Christ, the Baptism appears after scenes of Christ among the doctors and before the temptation of Christ by the devil. In cycles of John's life, which proliferated in Italy during the fourteenth and fifteenth centuries, it is preceded by John preaching to or baptizing the multitudes, and followed by scenes of John's arrest, imprisonment, or confrontation with Herod.[2]

In one sense, Piero's *Baptism* follows the prescribed pattern of John cycles. Two of the small panels in the predella, to the left, show scenes of his early life, and two others, on the

12

right, show post-Baptism scenes (figs. 2 and 52). Reading from left to right and including the main panels above as the center, one can follow a continuous narrative sequence. But in another sense, the pattern is interrupted. The center scene of the predella depicts the Crucifixion (fig. 6), which took place long after John was dead. Strictly speaking, therefore, the sequence is not a narrative but a complex of scenes emphasizing John's role as Precursor and the mystic associations between his prophecies and the sacrifice of Christ made for man's salvation.

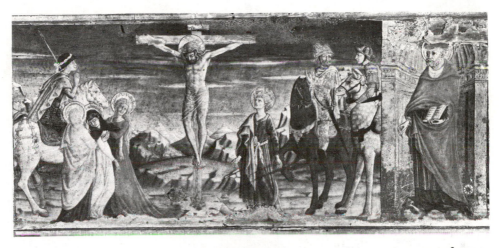

6. Detail of fig. 52, predella, *Crucifixion* (photo: Anderson)

The main factor differentiating the arrangement from a normal cycle, however, is the physical size of the *Baptism* (167 × 116.2 cm) in relation to the other scenes. Isolated as the center of the devotional altarpiece, the *Baptism* was meant to perform as the chief object of veneration. Although not completely without precedent, this use of the *Baptism of Christ* in the mid-fifteenth century was distinctly out of the ordinary.[3]

Notwithstanding its departures in size and function, in terms of what is represented Piero's scene is completely traditional. All the figures find their source in canonical biblical illustration. Christ, John, the bird, and the river, mentioned in

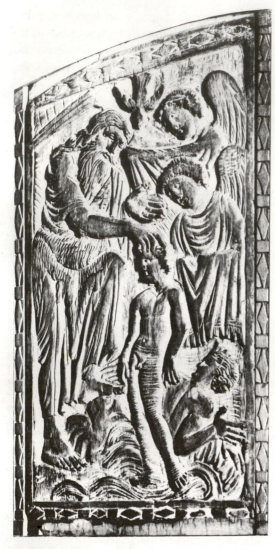

all the Gospel accounts, are the basic visual agents that iden-
tify the theme from early Christian times forward. Though
not described in the Bible, by the first part of the sixth cen-
tury angels became part of the dramatis personae (fig. 7).
They are shown either as witnesses, venerating Christ, or as

7. Baptism of Christ, ivory, Ra-
venna, San Vitale, Throne of
Maximian (photo: Anderson)

participants in the ritual, holding his robes at the side of the river (fig. 8).[4] Figures of disrobing catechumens entered the scene in Byzantine manuscript illumination of the eleventh and twelfth century, taken over from narrative scenes of the baptism of the multitudes (fig. 9). Unknown in Italian nar-

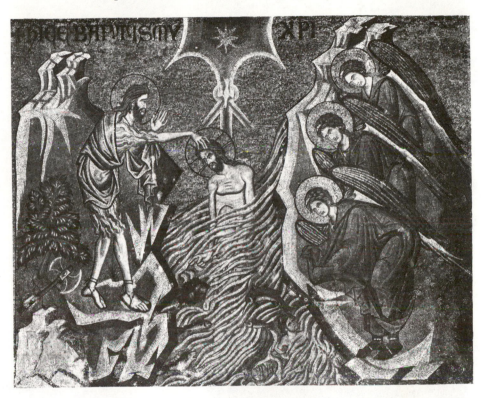

8. *Baptism of Christ*, mosaic, Venice, San Marco, Baptistry (photo: Anderson)

rative painting before the early fifteenth century, they make their appearance in a series of works that had direct bearing on Piero's composition, as we shall see below (figs. 46, 47, 48). Groups of elder publicans also stem from narrative sources, where they are dressed in various ways, often gesticulating and commenting on the action at the river (figs. 10, 11, 12). The outdoor setting, implicit in the story, had for centuries included at least one prominently placed tree (fig. 13), referring

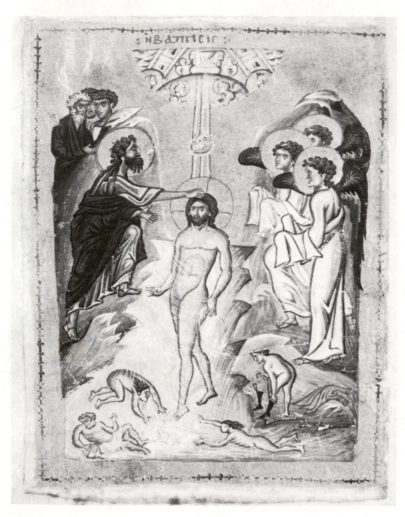

to the words of John's sermon on Repentance (Matt. 3:8–10; Luke 3:7–9).[5]

 Absent in Piero's version but often present in scenes of the Baptism is the figure of God the Father shown in full- or bust-length, or indicated only by a powerful hand with rays of light emanating from the fingertips. Often, too, the words

9. *Baptism of Christ*, manuscript illumination, Byzantine Tetra-evangelium, twelfth century, Vatican Library (Bibl. Vat., Urb. gr. 2, fol. 109v) (photo: Biblioteca Vaticana, Archivio Fotografico)

heard by John the Baptist—This is my beloved son in whom I am well pleased—are inscribed in the space above the dove. When included, these configurations represent the first appearance of the Trinity.

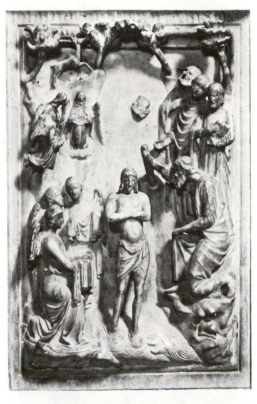

10. *Baptism of Christ*, relief, Baptismal Font, Florence, Baptistry (photo: Alinari)

While the painting was still in the frame, it was surmounted by a rondel with a figure of God the Father (fig. 2). In the space of the *Baptism* per se, Piero made the trinitarian reference in another way. He illuminated the area above Christ's head with a shower of gold (figs. 3 and 16).[6] The golden rain starts at the center top in the form of separate and dispersed dashes. Under the tree, it becomes heavier; it is most profuse below the dove where it fans out in long striations. Although most of the gold is now lost, close inspection still re-

veals its traces, including Christ's perspectivized halo of long
gold lines and John's similar one in profile. When we recon-
struct all these passages in our mind, we realize that a great
quantity of supernatural evanescence was meant to shimmer
on the surface. In early times, the Baptism was known as the
"Feast of Divine Illumination" or the "Feast of Holy Lights." [7]
Piero thus referred to the theological meaning of the moment
with the glistening marks of precious metal, giving tangible
and direct expression to the descent of the light of truth in
pictorial terms. [8]

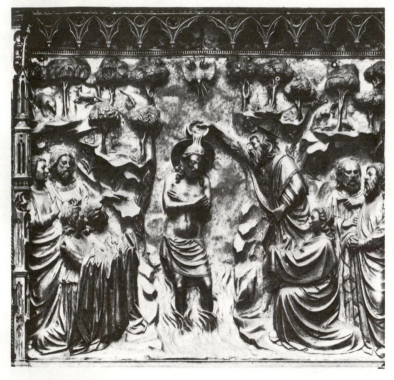

 These ethereal visual effects, in their original state, are
in sharp and deliberate contrast to the mundane naturalism
that surrounds them. All else within the sun-drenched coun-
tryside is thoroughly familiar. So familiar, in fact, that the

11. *Baptism of Christ*, detail,
Dossale d'Argento, Florence,
Museo dell'Opera del Duomo
(photo: Alinari)

early viewers of the altarpiece must have experienced considerable pleasure in their veneration. For as they worshiped, they saw the ritual at the Jordan taking place in the outskirts of their own town: Borgo Sansepolcro in the valley of the Tiber River.[9] Piero's contemporaries, as well as most modern commentators, have recognized the locale of the painting as the Alta Valle Tiberina, in southeast Tuscany. This valley is in fact a huge volcanic crater surrounded on every side by

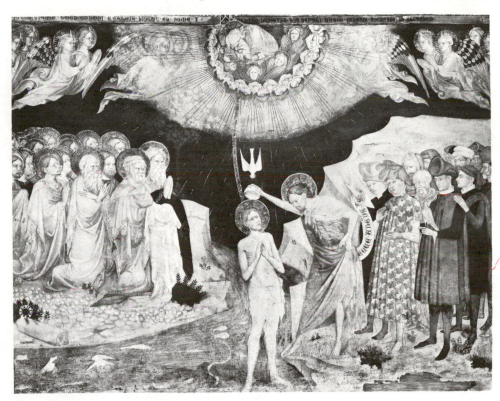

12. Jacopo and Lorenzo Salimbeni, *Baptism of Christ*, fresco, Urbino, Oratorio di San Giovanni (photo: Anderson)

mountain ridges. From the north the headwaters of the river Tiber issue forth and move toward Rome. Farther south, the river becomes a mighty and majestic flow, but at its source it is rather unimposing. It crisscrosses the valley floor as a rather shallow bed, dry for most of the year. A road built in the four-

teenth century cuts across the valley, passing over the Tiber
on a bridge. It follows a line down from the town of Anghiari
in the hills to the west, straight to the gates of Sansepolcro
(fig. 14).

All this Piero describes: the circle of peaks, the dry earth,
the narrow, winding river, the straight road moving to the
portal of the fortified town (fig. 15).[10] Moreover, he describes

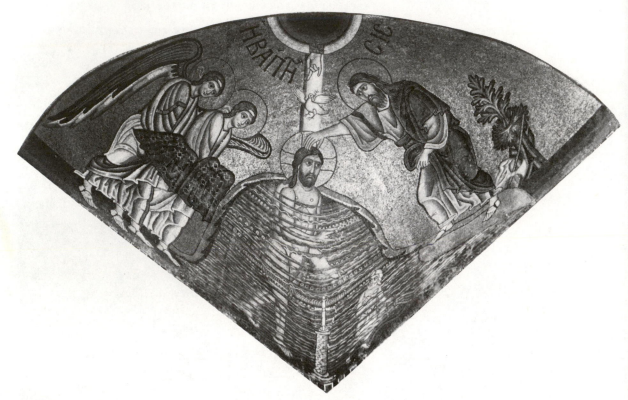

it from a particular vantage point. We are looking upstream
at the Tiber, across the valley to the northeast. Thus we are
oriented and know that east is to our right. The light that
comes in from the right side of the composition is verified as
eastern, and thereby charged with meaning. This early morn-

13. *Baptism of Christ*, mosaic,
Hosios Loukas, Katholikon
(photo: J. Powell, Rome)

ing light is the visual equivalent of the dawning of the new era as Christ receives his baptism of water.[11]

We might construe Piero's motivation in choosing this setting as local pride: the painting, after all, was made for

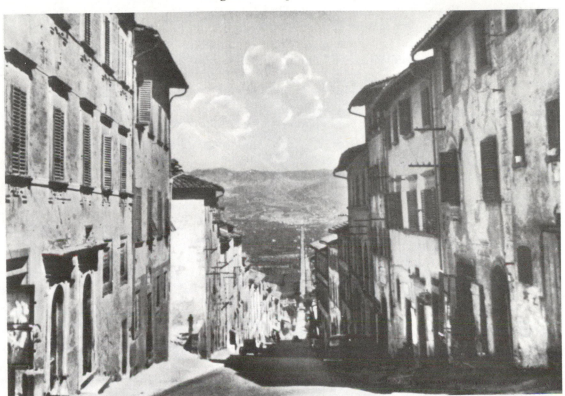

14. View from Anghiari toward Sansepolcro (photo: Ed. A. Boncompagni, Anghiari)

Sansepolcro, his native town, and here it was meant to stay. The identity begins to take on greater resonance, however, when we learn that this very spot has a history in classical literature, indeed was already a topos in Roman times as a delightful and profitable place to live. Pliny the Younger (A.D. 62–113) built a villa there and described it in a famous letter to his city friend, Domitius Apollinaris. Defending the salutary qualities of the position of his villa, Pliny says: "Pic-

ture for yourself a vast amphitheater, such as could only be the work of nature, a great spreading plane . . . ringed around by mountains, very fertile slopes above the flowering meadow." He describes the flora, the climate, the healthy, long-lived populace, the rich but stiff, hard soil that breaks into clumps and is not ready for planting before it has been plowed nine times. After recounting his tranquil rural life, he ends his praise with this astonishing declaration: "It is a great

pleasure to look down on the countryside from the mountains, for the view seems to be a painted scene of unusual beauty rather than a real landscape, and the harmony to be found in this variety refreshes the eye wherever it turns." [12]

15. Detail of fig. 1, Town (reproduced by courtesy of the Trustees, The National Gallery, London)

His picturesque description thus follows the rhetorical

device that parallels nature and art, idealizing the place and naturalizing the literary form. Piero has followed Pliny's description, not in a rhetorical sense, but literally. In order to make it look like the real valley, Piero has painted his valley to look like a painted valley, that is, harmonized by linear perspective. By the same token, in representing the real valley, he has genuinely revived the art of classical landscape painting as described by Pliny.

Yet by including a view of Borgo Sansepolcro, Piero has also made it clear that his painted version is not the rural valley of antiquity. In Roman times, there was no town in the vicinity. Indeed, the fact that Sansepolcro was not built on ancient foundations like most Italian towns was a point of some pride among local chroniclers. They say their "patriam non factam christianam esse," that is, the town was not converted but was Christian from its origin. And further, they say it was established by the intervention of "divinum numen."[13] The founding took place in the tenth century, and there are several recorded accounts telling how and why. Here follows a transcription of a famous local history, recounted by a citizen named Francescho di Christofano de Cescho, on September 21, 1418:

As everyone knows, two holy pilgrims, Arcano and Egidio, the principal founders of this our land, went to the Holy Sepulchre of Jesus Christ [in Jerusalem] and from there obtained certain holy relics; and afterward they went to visit . . . the consecrated churches of holy St. Peter and St. Paul Apostles in Rome; and from there because of their own holiness and devotion, they obtained more relics of saints; and turning around they left Rome to go back to Arcadia, their native land. But this did not please messer Domenedio, who had foreseen that this our land would have its first building miraculously from the hands of these two holy pilgrims. When they arrived in the Valle di Nocea, which the ancients thus called this place where we are because it was full of enormous walnut trees, they rested, took bodily food, and, as God willed, went to sleep with words of God on their lips. And sleeping, the holy Arcano had a vision that convinced him to build a tabernacle or oratory in that place and that took away all

his desire to return home. Naturally, Arcano, wanting to see his homeland, got to his feet and called his companion. After two more similar visions, he tried to leave, thinking of the sweetness of his native Arcadia. And picking up his belongings and counting them off, he found that he did not have the Holy Relics. Since in these [relics] he had placed all his hope and singular devotion, he began strongly to lament for the things for which he searched so futilely. And finally, raising his eyes, hands joined together humbly toward heaven, he saw his knapsack, where the Holy Relics were. In a way so miraculous one could hardly believe it, it had flown up to one of the highest branches of a walnut tree. [It was as if] not wanting to oppose the will and predestination of glorious God, the Holy Relics expressed a desire to remain in this place. And so they stayed here. Certain citizens who understood this miracle left their homes and came running. Clearing space in the forest, they built an oratory for the relics and tiny hovels in which to dwell. In a short time, their numbers multiplied and thus the town, or *borgo*, began.[14]

The little oratory was at first dedicated to St. Leonard, and during the lifetime of Arcano it was placed under the priority of the hermit Romualdo, later saint, and founder of the Camaldolite order, a Benedictine reform. As time went on, the dedication of the church was changed to the Holy Sepulchre and the Four Evangelists. By 1049, a large church, usually called simply San Giovanni Evangelista, was erected on the site. By 1106, a vast complex including church and monastery, known familiarly as the Badia, was conceded to the Camaldolite order.[15] Close around the abbey grew the fortified medieval commune, which kept the original name of Borgo Sansepolcro.[16]

From these facts we gain understanding of the further meaning in Piero's naturalistic setting. One of the major "figures" of the foreground group identifies the postclassical locale in a way that cannot be mistaken. The tree to Christ's right has been shown to be a walnut tree, *noce* in Italian, of the genus *Iuglans Iovis* (figs. 16, 17). Common in the Mediterranean world, the species is characterized by a sturdy trunk, fairly smooth and silvery in color. The high, spreading

branches bear ovate leaves of green-black color, with nut pods that in their ripening state are also blackish green. These are the characteristics of the painted tree.[17] Thus, at its simplest level,[18] the tree represents the "folta, vasta, verdeggiante selva ornata di molti noci, per i quali [the locale] acquistò il titolo

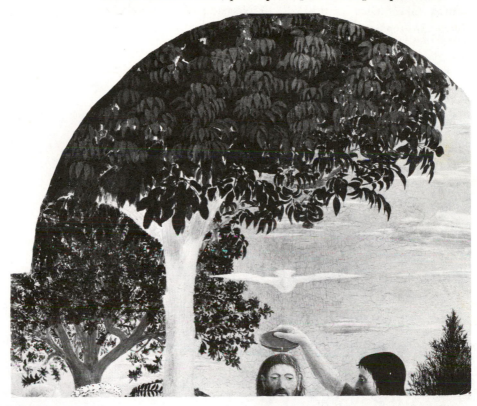

16. Detail of fig. 1, Upper Part of Tree (reproduced by courtesy of the Trustees, The National Gallery, London)

di Val' di Nocea."[19] It reminds one of the great walnut forest that preexisted the tilled fields. Even the reduction to a single tree follows the accounts that say it was by felling walnut trees that space was made for habitations and finally for the town.

In the distant background, juxtaposed to Christ's hip, the town appears (fig. 15). While it is greatly reduced in scale and rather loosely delineated, we can make out its identifying

features. There are crenellated circuit walls, the main entrance tower and the Anghiari road, houses and several unadorned civic towers, and to the right, the bell tower of the Badia with its pyramidal top.[20] Thus as the tree reveals the valley's name, the town identifies the era. The Baptism of Christ takes place in the Val' di Nocea in the environs of Borgo Sansepolcro in "modern" times.

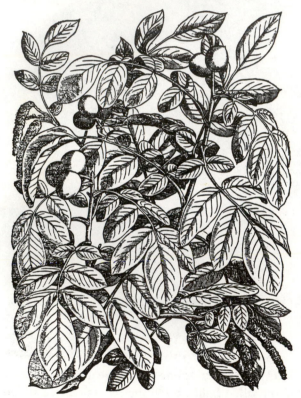

The notion of transferring christological scenes to the spectators' own time and place was not invented by Piero. On the contrary, it was rooted in a pictorial tradition that began as far back as the early fourteenth century in Tuscan painting. Duccio di Boninsegna had introduced Sienese buildings and architectural details in scenes on the back of his *Maestà*

17. *Nvx Ivglans* (Walnut branches), woodcut illustration (after P. A. Matthioli, *Commentarii sex libros Pedacii Dioscoridis Anazarbei de Medica materia . . .* [Venice, 1565], p. 276)

to render the city of Jerusalem. His innovation was almost immediately followed by his contemporaries as well as by painters of succeeding generations in Siena and elsewhere in Italy. At some point, moreover, at least one example of this approach, Simone Martini's *Christ Carrying the Cross* (fig. 18), was literally taken to northern Europe, where, in the last decade of the fourteenth century, it inspired the Franco-Flemish manuscript illuminator of the Brussels Hours to include his own city as the view of Jerusalem in the same christological subject.[21] The idea of transference thus introduced, it was further developed in the manuscripts of the Limbourg brothers, who included representations that have been classified as the first true architectural portraits. We see an example in the *Meeting of the Magi* from the *Très Riches Heures* (fig. 19), now attributed to brother Herman, where a "portrait" of Nôtre Dame de Paris is depicted in the city to which the Magi journey.[22]

By the second decade of the fifteenth century, local cityscapes began to appear with more or less regularity in backgrounds of northern religious scenes. After about 1450, real Jerusalemmic monuments also appear. More precise information concerning specific buildings in Jerusalem became available in the illustrated reports of pilgrims and travelers to the Holy Land. Buildings such as the Dome of the Rock, thought to be the ancient Temple of Solomon, and the Aqsa Mosque, thought to be Solomon's Palace, are represented as though they were side by side with local monuments. Such rendering, in a manner of speaking, made the Jerusalemmic background vistas archaelogically more precise.[23] With or without such exotic additions, as long as the subject was religious in nature, a reference to local topography identified the modern town with biblical Jerusalem, enlivening the holy event in contemporary terms. Piero relied on this tradition in the scene of the *Invention of the Cross* in the Arezzo fresco cycle (fig 20), in which he included a view of the whole town of Arezzo behind a narrative that occurred historically in Jerusalem.[24]

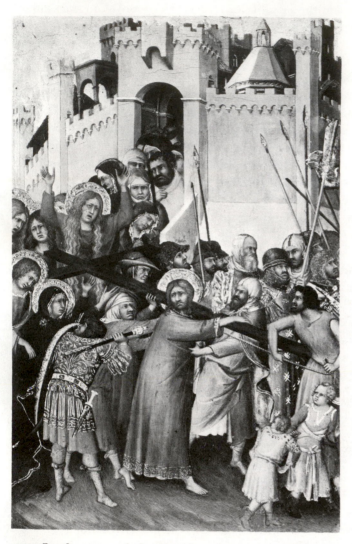

In the case of the *Baptism*, however, the civic portrait carried special emphasis for the following reasons. In its various rebuildings, the church of the Camaldolite monastery, dedicated to the Holy Sepulchre and the Four Evangelists, was gradually enlarged. The three-aisled hall was lengthened and

18. Simone Martini, *Christ Carrying the Cross*, Paris, Musée du Louvre (photo: Musées Nationaux)

19. Herman de Limbourg(?),
Meeting of the Magi, manuscript
illumination, *Très Riches Heures*,
fol. 51v, Chantilly, Musée Condé
(photo: Giraudon)

an ambulatory was added, and the style was changed from Romanesque to Gothic (fig. 21).[25] But the concept that lay behind the structure throughout its life, so the chroniclers tell us, was that the building replaced the Church of the Holy Sepulchre in Jerusalem itself, which had been destroyed by Saracens in 1012. A Latin source of 1454 says:

It can be said to be truly amazing that our own new church was

built in the image of the destroyed church, as though it had arisen
from the materials of that church as its foundation; thus the phoe-
nix arose from the *fenice* [rare thing], and so drew the origin of
its structure and its name.[26]

This notion was not limited to the church but became the basis
for the self-image of the whole town as the New Jerusalem:
"perciò la nostra Terra del Borgo di San Sepolcro fu detta
Nuova Gerusalemme."[27]

It must be pointed out that Sansepolcro was not unique in
identifying itself with the Holy City; many towns in Europe
thought of themselves as Jerusalem or parts thereof. There

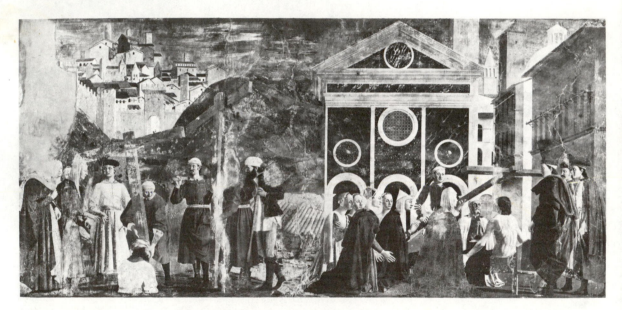

were also many other so-called copies of the Church of the
Holy Sepulchre, built during the Crusader period, likewise
stimulated by the fall or reconquest of Jerusalem. The notion
of their being replicas depended simply upon their having
similar ground plans, the same number of columns, or, as in
the case of Sansepolcro, the same dedication as the church of
Christ's burial.[28]

20. Piero della Francesca, *Find-
ing and Proof of the Cross*, Arezzo,
San Francesco (photo: Ander-
son)

Piero's village, however, must have felt it had qualifications that went beyond the others. Its chief relic had an extra measure of power because it was an actual piece of the tomb that was housed in the church that the village church meant to emulate.[29] Even more important, the village and its church had been founded on the direct mandate of Christ. In the visionary appearance, and with his own words, Christ declared his wish for them to be the new home for his sepulchre.[30] By means of this mystic revelation, Borgo Sansepolcro not only emulated Jerusalem, but, like the ancient city, was itself a Holy Site.

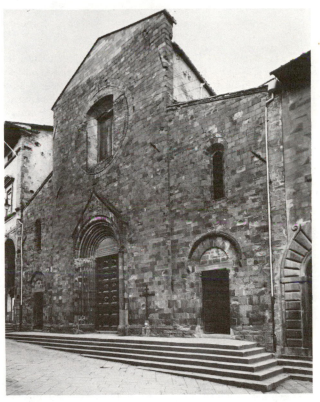

21. Sansepolcro Cathedral, facade (photo: Alinari)

In his painting, therefore, Piero has not so much transferred the Baptism away from its biblical setting as he has identified

the venerability of the Tuscan locale. The carefully constructed landscape shows Pliny's *amphitheatrum* converted to the Christian Val' di Nocea. The river Tiber, sacred river of antiquity, is converted into the consecrated river of papal Rome.[31] The town itself needed no conversion, for it owed its very existence to the will of God. Small wonder the landscape strikes us as strangely portentous. It was designed not to copy nature, but to be a programmatic exposition of the vivified theological state of being in which the citizens of Borgo Sansepolcro felt they lived.

NOTES

1. The Baptism of Christ is recorded in all four Gospel texts: Matt. 3: 16–17; Mark 1:9–11 (in both, Christ is baptized and leaves the water before the heavens open and the paraclete descends in the form of a dove); Luke 3:21–22 (here, at the moment of baptism, Christ is in prayer and the Holy Ghost is upon him; Piero's image follows this text); John 1: 26–36 (which is not a narrative, but the Baptist's account told later to his disciples). Cf. T. Innitzer, *Johannes der Täufer* (Vienna, 1908), and further, *Bibliotheca Sanctorum* (Rome, 1965), vol. 5, pp. 599–624.

2. J. Strzygowski, *Ikonographie der Taufe Christi*; G. Schiller, *Iconography of Christian Art*, 3d ed., vol. 1, pp. 127–43. In the Arena Chapel, for example, the Baptism is preceded by Christ among the doctors and followed by the Marriage at Cana; cf. Gnudi, *Giotto*, pls. 93, 94, 96. In Ghiberti's christological cycle on the north doors of the Florentine Baptistry, Christ among the doctors comes before the Baptism and the Temptation of Christ comes after; see pl. 18 in R. Krautheimer and T. Krautheimer-Hess, *Lorenzo Ghiberti*, 2d ed. Two important early cycles of John's life are both in the Florentine Baptistry; the thirteenth-century mosaics in the dome show the recognition of Christ, the Baptism, and then John before Herod; see A. de Witt, *I mosaici del Battistero di Firenze* (Florence, 1954–55), pls. 6, 7, 8. Andrea Pisani's cycle on the south doors places the baptism of the multitudes next to Christ's Baptism, followed by John berating Herod; see I. Toesca, *Andrea e Nino Pisani* (Florence, 1950), pls. 21, 23, 26. Cf. M. A. Lavin, "Giovannino Battista, A Study in Renaissance Religious Symbolism," *Art Bulletin* 37 (1955): 85–101, for citations of other fourteenth- and fifteenth-century cycles of John's life.

3. See below, chap. 3, n. 4, and fig. 56, for the Baptism altarpieces before Piero's known to me.

4. The spiritual role of angels in baptism was discussed at length by the church fathers: see, e.g., Tertullian, *De Baptismo Adversus Quintillam*, chap. 6 in J.-P. Migne, *Patrologiae Cursus Completus, Series Latina*, vol. 1, cols. 1314–15; *The Writings of . . . Tertullianus*, Ante-Nicene Christian Library, trans. A. Roberts and J. Donaldson (Edinburgh, n.d.), pp. 238–39; and Ephraim the Syrian (d. 373/8), "Hymns for the Feast of the Epiphany," no. 14, "Hymn concerning our Lord and John," in *A Select Library of Nicene and Post-Nicene Fathers of the Christian Church*, ed. P. Schaff and H. Wace, (Grand Rapids, 1956), 2d ser., vol. 13, part 2, pp. 284ff., esp. p. 286. See below, chap. 3.

5. Schiller, *Iconography*, 3d ed., vol. 1, pp. 127–43, figs. 346–88. Cf. below, chap. 5, for discussion of the representation of angels in the *Baptism*; chap. 6, for discussion of the catechumen; chap. 4, for discussion of elder witnesses; below, this chapter, and chap. 6, for discussion of the tree in Piero's painting.

6. For an opinion to the contrary, cf. Tanner, "Concordia," pp. 4ff. Statistically speaking, the figure of God the Father is absent just as frequently as he is present in scenes of the Baptism. Where he is not present, the Gospel of John is the most likely source (see above, chap. 2), for there, the Divinity's words to John are not recorded. John the Evangelist's text is the Sequence Reading in the Mass for January 6.

7. In the Greek Orthodox church, the Baptism of Christ (the Theophania), is still known as the Feast of the Holy Lights (*Photismós*): see J. A. Jungmann, *The Early Liturgy*, pp. 149–51; W. K. Lowther Clarke, with C. Harris, *Liturgy and Worship* (London, 1932), pp. 209–10. Cf. the imagery in the hymns, esp. hymn 14 for the Feast of the Epiphany of Ephraim the Syrian (*Nicene and Post-Nicene Fathers*, pp. 279ff.); and the sermon on the Epiphany and Holy Baptism by St. Gregory Nazianzenus, "Discourse on the Feast of the Holy Lights," read in the Western liturgy on January 13, second nocturn.

8. The reference to Divine Light was strengthened by the luminosity of the many white and near-white passages on the surface, which were meant to be even stronger than we see them today. The middle angel, the foreground tree, Christ and the dove, the catechumen, all would have appeared as radiant brilliances on the highest scale of brightness in their original state. See app. 1 for discussion of the same symbolism represented in mathematical terms.

9. According to biblical narrative, the Baptism took place not far from the wilderness of Judaea, within easy reach of Jerusalem and all Judaea. The exact spot has been much discussed throughout the ages; see references in *Of the Holy Places Visited by Antoninus Martyr*, Palestine Pilgrims' Text Society (London, 1897), ed. P. Geyer, trans. A. Stewart, vol. 2, app. 1, pp. 38–39. See also *A Dictionary of the Bible*, 9th ed., vol. 2, p. 765.

10. Longhi, *Piero*, p. 19, was among the first to identify the locale; Clark, *Piero*, pp. 11–12, identified the road from Anghiari; cf. M. Salmi,

Civiltà artistica della Terra Aretina (Novara, 1971), fig. 102, view from "il borgo 'la Croce,'" high in the town of Anghiari down the full length of the road. P. Farulli, *Annali e Memorie dell'antica e nobile città di S. Sepolcro* . . . , pp. 21–22, reports that the road was ordered to be built in 1318 by Bishop Tarlati of Arezzo. Salmi, ibid., *pl.* 1, shows a view of the Alta Valle del Tevere, looking down from the hills.

11. Battisti, *Piero*, vol. 1, p. 129, recognizes the time as morning. Piero made symbolic use of the direction of light-flow on other occasions, e.g., in the *Flagellation*, coming from the left in the outdoor portions and from the right inside the portico (Lavin, *The Flagellation*, pp. 45ff.). The moment of Baptism is thought to be the birth of Christ as the "Sun of Justice" (cf. F. X. Weiser, *Handbook of Christian Feasts and Customs*, p. 144). See app. 1 for confirmation of this solar symbolism in the geometric structure of the composition.

12. For the whole letter in Latin and English translation, consult *Pliny, Letters and Panegyricus*, trans. B. Radice (Cambridge, 1969), Loeb Classical Library, vol. 1, pp. 337ff., no. VI; see also G. Becatti, *Arte e gusto negli scrittori latini* (Florence, 1951), pp. 244–58, with bibliography. Evelyn [Franceschi-Marini], an English woman married to a descendant of Piero's family, in her book *Piero della Francesca, 'Monarca della Pittura ai suoi dì,'* p. 13, was apparently the first to associate the Pliny letter with the *Baptism*. Since then many art historians have done the same: Longhi, *Piero*, p. 96; P. De Vecchi, *L'Opera completa*, p. 5; Battisti, *Piero*, vol. 1, pp. 118–19 (who quotes the passage in full). The identification between the Alta Valle Tiberina and Pliny's villa is mentioned by many local historians: F. Ughelli, *Italia sacra*, vol. 3, p. 195; L. Coleschi, *La storia di Sansepolcro della origine al 1860*, 2d ed., p. 13. The earliest reference I have found to the Pliny passage in this context is in Antonio-Maria Graziani, bishop of Amelia and native of Sansepolcro (1537–1611), in his *De scriptis invita Minerva*, bk. 1, p. 7. There are several fifteenth-century Italian manuscript transcriptions of the letter to Apollinaris; for example, see the version made between 1450 and 1480, probably in Naples, in the Firestone Library, Princeton University, no. 45; S. de Ricci, *Census of Medieval and Renaissance Manuscripts in the United States and Canada* (1937, reprint ed., New York, 1961), vol. 2, p. 1183 (ms. 2904.1450).

13. "Quod ipsum pro non mediocri fortuna atque adeo pro eximio Dei munere agnoscendum videtur nobis natam scilicet patriam non factam christianam esse; nec unquam maiores nostros hoc coelesti lumine salutiferae rationis, hoc cultu verae ac divinitus traditae religionis caruisse. At hoc solum tam insigne beneficium contigit nobis, verum, quod raro nec nisi miximis urbibus accedit, nostrae statuendae interfuisse divinum numen creditur." A.-M. Graziani, *De scriptis*, bk. 1, p. 5. ("It would seem that the same should be known for not ordinary

fortune and therefore for the special gift of God, namely that our native fatherland was not made Christian, nor ever did our predecessors by this heavenly light of saving Grace lack the worship of the true and divinely handed-down religion. But this alone as an extraordinary benefit touches us, truly, because rarely it happens, save in the large cities, it is believed that the divine power was involved in our establishment." [Translation by John d'Amico.])

14. "Notitia originis urbis Burgi-Santi-Sepulcri Scripta anno 1418," in *Annales Camaldulenses ordinis Santi Benedicti*, ed. J.-B. Mittarelli and A. Costadoni (Venice, 1755), vol. 1, app., cols. 290–92, doc. no. 135. The founding is documented also in the unpublished manuscript "Anonimo Historia Burgi S. Sepulcri (anno 1454)," ex. Cod. 25, plut. LXVI, Bibl. Med. Laurentiana, Florence, fols. 6–7. In a somewhat more elaborate form, it became officially confirmed by Pope Leo X in the bull establishing the bishopric of Sansepolcro, 1517, at which time the abbey church of the Camaldolite Convent was transformed into the cathedral; quoted in full in Ughelli, *Italia sacra*, vol. 3, pp. 195–98. It is retold by Graziani, *De scriptis*, pp. 5–7. The most embellished account is found in A. Goracci, *Breve istoria dell'origine e fondazione della Città del Borgo di San Sepolcro, 1636*, vol. 5, no. 7, pp. 143–317, esp. pp. 147–51.

15. I. Ricci, *L'Abbazia Camaldolese e la Cattedrale di San Sepolcro*. The Camaldolites were the religious leaders of the community for the next four hundred years, although ecclesiastically the town was now under the jurisdiction of the bishop of Città di Castello, now of Arezzo; see [Giovanni Muzi], *Memorie ecclesiastiche di Città di Castello*, vol. 4, pp. 63–110, for the history of this long-standing controversy.

16. From the eleventh century onward, the commune was quite rich and flourishing. The government was in the hands of a number of distinguished but not aristocratic families and was organized into two councils, large and small. In the fourteenth century, it fell under the power of the Malatesta, who fortified the town. In the early fifteenth century, it was annexed to the papal territories. After the Battle of Anghiari, June 22, 1440, in which Piccinino was stopped from overpowering Tuscany and the papal lands, Eugenius IV sold Sansepolcro to Florence, whose representative took possession immediately. The town remained under the jurisdiction of the grand dukes of Tuscany until the Napoleonic period. In modern times, the "Borgo" has been dropped from the name. See I. Ricci, *Borgo Sansepolcro* (Sansepolcro, 1932); entitled in the 2d ed. (1956), *Storia di (Borgo) Sansepolcro*.

17. Battisti (in *Piero*, vol. 1, pp. 129, 480–81, n. 175) reports on his consultation with R. D. Meikle of the Royal Botanical Garden at Kew, London, who made the identification of most of the plants in the painting. See below, chap. 6. Identifying the tree as a walnut laid to rest several old ghosts; Longhi, *Piero*, p. 18, called it a pear; Tolnay and others called it a pomegranate (cf. Tanner, "Concordia," p. 6 and

n. 45). Though ignorant of the topographical significance of the walnut tree, Battisti deserves thanks and praise for making the identification available, and for recognizing the walnut as having meaning.

18. See below, chap. 6.

19. Farulli, *Annali e memorie*, p. 5. The name comes down in several forms: a bull of Benedict VIII, dated 1013, was "pro monasterio Sancti Sepulcri in loco Noceati" (published in *Annal. Cam.*, vol. 1, p. 213); a diploma of Emperor Lothaire III, dated 1137, calls the locality both "Noceati" and "Nucleto" (cf. *Dictionnaire d'histoire et géographie ecclesiastiques* [Paris, 1937], vol. 9, pp. 1246–47f). A.-M. Graziani, *De scriptis*, p. 5, describes ". . . aut multa vite oleoque et frugifera arbore. . ." in the region.

 The curly-leaved tree with darker trunk behind the angels may be a hornbeam (*carpine* in Italian); cf. P. A. Matthioli, *Commentarii sex libros Pedacii Dioscoridis Anazarbei de Medica materia. . .* (Venice, 1565), p. 145. It may therefore allude to another nearby valley (to the southeast of Sansepolcro, near the Lago di Trasimeno) formerly known as the Pian di Carpine.

20. Compare with the photographs of Salmi, *Civiltà*, fig. 101, and fig. on p. 67.

21. E. Panofsky, *Early Netherlandish Painting*, vol. 1, pp. 48–49, vol. 2, figs. 45, 46; C. Sterling and H. Adhémar, *Musée National du Louvre, Peintures, écoles français, XIVe, XVe, et XVIe siècles* (Paris, 1965), p. 3, no. 4, pl. 13. See next two notes.

22. See discussion in M. Meiss, *French Painting in the Time of Jean de Berry, The Limbourgs and Their Contemporaries* (New York, 1974), pp. 203ff. Konrad Witz's *Miraculous Draft of Fishes*, cited above in chap. 1, n. 1, prefigures Piero's landscape not only in the uninterrupted entrance into the space, as we mentioned, but also in its realistic portrayal of nature for symbolic reasons. Cf. M. T. Smith, "Conrad Witz's 'Miraculous Draught of Fishes' and the Council of Basel," *Art Bulletin* 52 (1970): 150–56. See J. G. Links, *Townscape Painting and Drawing* (London, 1972), for a general discussion of architectural portraits as renderings of reality.

23. Cf. C. Krinsky, "Representations of the Temple of Jerusalem before 1500," *Journal of the Warburg and Courtauld Institutes* 33 (1970): 1–19; see further, for the extension of the idea of the settings as representing the "Heavenly Jerusalem," L. B. Philip, *The Ghent Altarpiece and the Art of Jan van Eyck* (Princeton, 1971), pp. 165–91.

24. Cf. Lavin, *The Flagellation*, pp. 38ff., 95–96, for evidence of Piero's also relying on pilgrims' reports and/or illustrations for his representation of the Lithostratos and Houses of Pilate. See also L. Borgo, "New Questions for Piero's 'Flagellation,'" *The Burlington Magazine* 121 (1979): 547–53. It will be recalled that Enguerrand Quarton, as stipulated in the contract for his work, represented in his *Coronation of the Virgin* (Villeneuve-les-Avignon, Hospice) dated 1453, a panorama of Avignon in a continuous landscape with a view of the real

Jerusalem, signifying the terrestrial paradise as a counterpart to the Heavenly Paradise represented above; cf. C. Sterling, *Le Couronnement de la Vièrge par Enguerrand Quarton* (Paris, 1939).

25. Ricci, *L'Abbazia*, passim; also Salmi, *Civiltà*, p. 53.

26. "Cum in oppidum iam burgus crevisset, pontificale templum sub dedicatione sancti Ionnis Apostoli et Evangelistae extruxit. . . . Nam cum eisdem temporibus, currentibus annis Nativitatis Domini millesimo duedecimo Ecclesia S. Sepulcri civitas Ierusalem ab infidelibus destructa fuisset, mirum profecto hoc dici potest ad in star illius destructae novam hanc ecclesiam nostram in burgo sancti sepulcri constructam fore tamquam ex illius materialibus exorta principiis; sicut ex fenice fenix exoritur, ita etiam et rei et nominis originem traxisse." "Anonimo Historia Burgi S. Sepulcri (anno 1454)," ex. Cod. 25, plut. LXVI, Bibl. Med. Laurentiana, Florence, 6; (trans. J. d'Amico; transcribed in part in Ricci, *L'Abbazia*, p. 45).

27. Goracci, *Breve istoria*, p. 158. This author is the first historian (1636) I have found actually to use this term; he makes it clear, however, that he is drawing on older sources with his phrase "fu detta." Moreover, the concept was generally already implicit in the dedication of the church. See next note.

28. For example: Fulda, Paderborn, Cambridge, Bologna, Pisa, Brindisi, Milan. Cf. R. Krautheimer, "Introduction to an 'Iconography' of Medieval Architecture," *Journal of the Warburg and Courtauld Institutes* 5 (1942): 1–33. See also I. Q. van Regteren Altena, "Hidden Records of the Holy Sepulchre," in *Essays in the History of Architecture Presented to Rudolf Wittkower*, ed. D. Fraser et al. (London, 1967), pp. 17–21.

29. Kept in the bell tower of the abbey church under lock and key, guarded by a rotating committee of five, the main relic was described in 1418 as "de la pietra del sancto sepolcro, ove fu immesso il nostro signore yesu christo a cui nome fo edificata questa terra." Other relics likewise brought by Arcano and Egidio include wood from the cross, the winding sheet of Christ, blood from an image of Christ, hair and milk of the Virgin, and a piece of her tomb, relics of St. John Evangelist and the other evangelists, grease from the body of St. Lawrence when he was martyred, relics of SS. Biagio, Martin, Nicolò, and Benedict, the Magdalen, Cecilia, and Scolastica. Cf. *Annal. Cam.*, vol. 1, app., pp. 290–92. See below chap. 6.

30. "O Arcano, gìa che sei venuto in questo luogo, voglio e ti comando, che tù con le Reliquie, che porti in onore del mio Sepolcro, facci quì dimora col tuo Compagno fino all'ultimo spirito, e non abbi ardire di proseguire l'incominciato viaggio; ma bensì dar principio ad un Borgo e Oratorio, che s'intitolo San Sepolcro, in onore, e venerazione della Pietra, che di esso porti." Farulli, *Annali e memorie, pp. 5–6*.

31. See, for example, J. Le Gall, *Recherches sur le culte du Tibre*, Publications de l'Institut d'art et d'archéologie de l'université de Paris, no. 2 (Paris, 1953). For the Christianized river as a fundamental idea, see

Aurelii Prudentii Clementis (d. 348), *Prudentius*, trans. H. J. Thomson, Loeb Classical Library (London, 1953), pp. 28–29, "Peristephanon" (Crowns of Martyrdom), bk. 12, "Passio Apostolorum Petri et Pauli":

"Scit Tiberina palus, quae flumine lambitur propinquo, binis dicatum caespitem tropeis, et crucis et gladii testis, quibus inrigans easdem bis fluxit imber sanguinis per herbas. . ." (l. 7–10). (The marshland of Tiber, washed by the nearby river, knows that its turf was hallowed by two victories for it was witness both of cross and sword by which a rain of blood twice flowed over the same grass and soaked it.)

"Diuidit ossa duum Tybris sacer ex utraque ripa inter sacrata dum fluit sepulcra. Dextra Petrum regio tectis tenet aureis receptum. . ." (l. 29). (Tiber separates the bones of the two [Peter and Paul] and both its banks are consecrated as it flows between the hallowed tombs. The quarter on the right bank took Peter into its charge and keeps him in a golden dwelling.)

Later, the poem says that "the memorial Church of Paul [is] . . . on its left bank." It is tempting to suggest that the figures of SS. Peter and Paul in the wings on either side of the river refer in the *Baptism*, as in the poem, to the great Roman basilicas dedicated to the saints, standing similarly on either side of the Tiber. We even know, from the orientation that Piero gives, that Peter, on our left but Christ's right, is on the west bank of Tiber, while Paul is on the east, as the churches actually are in Rome. Recall, also, that the 1418 account of the pilgrims' visit to Rome says specifically that they visited the basilicas; cf. also below, chap. 6.

3

The Miracle of the Jordan

Emerging from behind the figure of an angel, the river Jordan cuts across the middle ground of the composition and winds forward toward the spectator (fig. 5). As it opens into an extended S-curve, its glassy surface mirrors various images: first the red and orange-yellow robes of elders standing near the banks; next the brownish hills dotted with trees; and finally the brilliant blue sky, a pale gray cloud, and two little shrubs.[1] Behind the feet of Christ and John, the reflections stop, a curling ringlet, colored blue, lapping between Christ's feet. From this point forward, the river bed, composed of cream-beige pebbles, rocks, and sand, becomes visible.

When we examine this foreground area in greater detail, we see threadlike brush strokes of off-white paint crossing all three ankles (frontis., figs. 5 and 22). These little lines indicate the surface of the water, which, one may deduce, continues to the picture plane.[2] It has been noted, in fact, that here Piero displays his formidable knowledge of optics by rendering on the water's surface the shift from reflection to transparency in accord with the spectator's angle of vision.[3] We shall see that it is no accident he situated the reflection / transparency line just *behind* Christ and John, so that the figures are fully visible. And he chose not to show the distorting effects of refraction, or the bending of light rays, on the submerged forms.[4] On the contrary, the feet retain their ideal shapes with undiminished anatomical correctness. As a result, it is clear that Piero used his knowledge of optics to produce a

dual impression: to suggest and, at the same time, to rationalize a miracle. While evidently ankle-deep in water, Christ and the Precursor appear to stand on dry ground.[5]

This anomalous effect is intensified by other details on the riverbanks. Threadlike brush strokes of off-white paint, similar to those on the figures' ankles, are found all along the

22. Detail of fig. 1, River and Bank (reproduced by courtesy of the Trustees, The National Gallery, London)

winding course of the ridges of the banks. Here the strokes unambiguously portray the water surface: what is above the lines is bank, what is below is reflection of the banks in the water. Rounding the final bend of the river, the waterline begins to rise. As if propelled by mystic force, it moves upward gradually, reaching the full height of the bank just at the point of change from reflection to transparency. Moreover,

where the blue color stops to the left of Christ, a curving shape is defined by a darkened edge that swings around to the right. This edge makes the blue water seem to turn under at the bottom and bulge forward just above. A brown area beneath the bulge appears as its shadow on the riverbed; the shadow, in turn, is reflected on the convex surface of the bulge. Once more, by coordinating these details with the reflection / transparency line, Piero rationalizes the precipitous loss of blue color and, by the same token, creates the impression that the waters of Jordan have come to an abrupt halt. All these unnatural effects act as a "visual signal," heightening the drama and evoking the mystery of the sacred rite.

The idea that the Jordan stood still at the moment of Christ's Baptism has a history lying deep in medieval theology, folklore, and art. To understand the sources of Piero's extraordinary image, we must now make a brief excursion into these realms.

The theological aspect of the idea begins with the doctrine that found baptism foretold in various Old Testament events.[6] Many stories involving water, such as the Flood, Jonah and the whale, the crossing of the Red Sea, and Moses striking water from the rock, were seen by patristic fathers as baptismal types. Even more frequently cited are those miracles that took place at the Jordan itself, the most important of which is in the Book of Joshua (3:13–17). The miracle occurs as Joshua leads the Jews from the desert to the Promised Land. Arriving at the Jordan with the full trappings of their religion, they are greatly discouraged to find the river in harvest flood. After Joshua reassures them and describes how they will succeed, "the priests that carried the ark of the covenant, went on before them. And as soon as they came into the Jordan, and their feet were dipped in part of the water. . . . the waters that came down from above stood in one place . . . swelling like a mountain . . . but those that were beneath, ran down into the sea of the wilderness (which now is called the Dead Sea) until they wholly failed. And the

people marched over against Jericho: and the priests that car-
ried the ark of the covenant of the Lord, stood girded upon the
dry ground in the midst of the Jordan." This historical event
(along with the similar miracle of the Red Sea) is recalled in
poetic form in Psalm 114 (113Vulg.):1–2: "When Israel went
out of Egypt, the house of Jacob from a barbarous people:
Judea was made his sanctuary, Israel his dominion. The sea
saw it and fled: Jordan was turned back [*Jordanis conversus
est retrorsum*]." Thus, by reversing Jordan's flow and inter-
rupting the natural course of things, God shows his power and
his presence.[7]

The same point is made with similar miracles in 2 Kings
2:8 and 13. The prophet Elijah "took his mantle and folded it
together, and struck the waters, and they were divided hither
and thither, and [he and Elisha] passed over on dry ground."
After Elijah is taken to heaven in the whirlwind, Elisha cries
and rends his clothes. He then "took up the mantle of Elijah,
that fell from him: and going back, he . . . struck the waters
. . . and they were divided, hither and thither, and Elisha went
over." Again, to show the power of God, first given to Elijah
and then passed to Elisha, the Jordan stops its flow.

Already in the New Testament, these events were re-
lated to John the Baptist, thought by many to be a reincarna-
tion of Elijah (wearing his mantle of skins and leather belt;
2 Kings 1:8; Matt. 16:14; Luke 1:17, 9:8; John 1:21, etc.).
Later, in medieval exegetical writings, these miracles were
given in testimony for the Baptism as Theophany, that is, as
the appearance of God on earth. Commenting on the Joshua
passage, St. Jerome in his 89th Homily says: "The Jordan
river that dried up when Joshua led the Israelites in the Land
of Promise (at the Baptism) longed to gather together all its
waters into one place, if it could, to bathe the body of the
Lord."[8] St. Augustine, commenting on Psalm 114, asserts that
on one level, the lines are historical, referring to Genesis and
Joshua. He then expounds the prophetic level: "The Jordan
therefore signifies those who have received the grace of Bap-

tism; and thus the Jordan is turned back, when they are turned unto God."[9] These examples show the Old Testament types being called upon to verify Christ's messianic truth.

Along with the typological connections made in formal patristic writings and preaching of the church fathers, the miracle of the Jordan was recorded in popular texts and apocryphal literature. One of the earliest cases is in the "Miracles of Jesus" written in the fourth or fifth century perhaps in Arabic in Coptic North Africa. Under the 30th Miracle, we read: "John says to his disciples, 'The Lord told me, when I was in the womb of my mother, that I would baptize men for purification in Jordan. If I would see the water come back, reverse its flow and become hot, I must know that the Lamb of God had come . . . into the world. . . .' One day, while John was baptizing, he sees the river Jordan come back and reverse its flow behind him, and the water also becomes warm as if it were heated with fire. . . . Jesus enters the Jordan. When it sees Him, it goes back and returns forty cubits. Its water becomes like coals of fire. . . . When the Jordan is rolled back, our Lord admonishes it, saying: 'Stay in your place to the moment of my baptism and do not flee' (Ps. 76:17, 114:5). . . . When John sees the flight of the Jordan, its return backward, and its coming back again to its first place, on the order of Our Lord, he trembled a great trembling. . . . When the Lord Jesus left the Jordan after the rites of baptism were accomplished, numerous angels descended from heaven; they carried Him with their wings and took Him out of the Jordan. Then they adored Him together."[10]

The tale is told as if it were an actual event in the travel journal of Antoninus of Piacenza, a sixth-century pilgrim to the Holy Land. Antoninus reports that on the night before January 6 at the place on the Jordan where Christ was baptized, "a vast crowd of people is collected, and after the cock has crowed for the fourth or fifth time, matins begin. . . . As the day dawns, the deacons begin the holy mysteries and celebrate them in the open air. The priest descends into the river

and at the hour when he begins the blessing of the water, at once the Jordan with a mighty noise, rolls back upon itself. . . . The water stands still until the baptism is complete. . . . When all is finished, the water returns to its own bed." [11]

At some point in the Middle Ages, the miracle along with its Old Testament types were joined to the liturgy of the Eastern church in a service known as the Blessing of Waters, held on the Vigil of January 6. At the end of the Divine Liturgy, before the Blessing begins, the following text is read at the baptismal font: "The Jordan returned one day to its source at the touch of the mantle of Elisha; while Elijah was taken to heaven, the waves of the river were divided and a solid roadway opened to the Prophet; and this roadway was through the waters as a figure of Baptism for those of us who cross the river of life. Christ has appeared. He comes to renew all creation. Today the nature of the waters is sanctified; the Jordan is clove asunder and rolls back the current of its flood as it beholds the Lord Baptized." [12]

Until the sixth century, we find no reference to the miracle in the visual arts. The Jordan is often personified as a classical river god, an older male nude reclining on the banks of the river, but with no indication of the direction of its flow. In the dome of the so-called Baptistry of the Arians in Ravenna (fig. 23), the personification appears as a heroic figure seated on a rock, wearing a crab for a crown, holding a reed and an urn from which water is pouring. He raises his hand in a gesture of acclamation acknowledging in Christ the presence of divinity. Soon, however, the miracle was introduced through a change in the pose of the personification. In the Baptism scene on the ivory Throne of Maximian (A.D. 545–56) (fig. 7), for example, he is placed in the river behind Christ's feet. He still raises his hand, awed by Christ's power, amazed, and even frightened by his appearance on earth. But now he is turned around, his back to the spectator, his head turned in profile to look back at Christ. In this position, the personification expresses with his body the idea of physical

reversal of the water, and thus symbolizes the Miracle of the Jordan.[13]

In this form, a reclining figure turned away and looking back, the Jordan Miracle became a standard feature of Byzantine Baptisms in manuscript illumination, large-scale painting, and mosaics. The personification is seen, for example, in the ninth-century Chludoff Psalter, where the Baptism illustrates the 114th Psalm as a typological parallel. Now a tiny figure, he is depicted with his spine fully visible and his head turned back over his shoulder.[14] Or, again, in the eleventh-

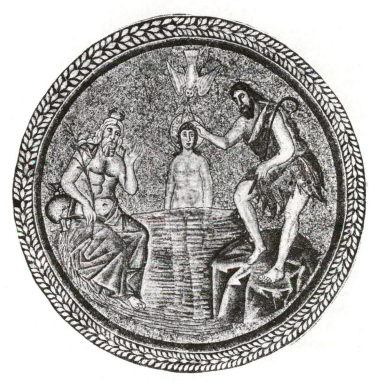

23. *Baptism of Christ*, mosaic, Ravenna, so-called Baptistry of the Arians (photo: Anderson)

century monumental mosaic in Hosias Loukas (fig. 13), the figure is likewise present under the waves.[15] Indeed, in the famous Byzantine *Guide to Painters*, written in the seventeenth century by Dionysius, monk of Fourna, but dependent

on more than a thousand years of tradition, in the formula for representing the Baptism, after speaking of the main protagonists, the author adds the prescription: "Below the Forerunner in the Jordan is a naked old man lying bent up, who looks back at Christ in fear and holds an urn from which pours water."[16]

In contrast to this long, unbroken tradition in the East, in Western medieval art the image of the fleeing Jordan is all but absent. Moreover, the relatively few river personifications that appear before the mid-thirteenth century recline facing forward in the water.[17] It is significant that neither in literature nor in the liturgy is there reference to the Jordan Miracle in the West before the beginning of the fourteenth century. Shortly before then, however, the backward-facing figure is depicted in several Italian visual representations, either made or directly influenced by immigrant Greek artists. Three baptism scenes in the thirteenth-century frescoes of the Baptistry of Parma include the figure (fig. 24).[18] The same is true of a Sienese polyptych dating about 1260 or 1270, on the upper right wing (fig. 25).[19] And again, in the mosaics of the Baptistry of San Marco, Venice, certainly executed by Greek workmen about 1348, the figure turns his back to Christ (fig. 8).[20]

Piero could have known any or all these Italian works. In addition, there was another example much closer to his home: the relief of the *Baptism* on the facade of Santa Maria della Pieve in Arezzo (fig. 26). Signed and dated 1221 by the local sculptor Marchionne, whose style also shows Byzantine elements, the sculpture shows the Jordan turned backward in the rippling wave patterns that cover Christ's body to the waist.[21] Considering the proximity of Arezzo to Sansepolcro and the fact that Piero worked for several years in San Francesco in Arezzo, around the corner from the Pieve, there can be no question that he knew the relief and the traditional symbolism of the figure it includes.

Notwithstanding these prototypes, when he adopted the miracle theme for his painting, Piero rejected the Byzantine

formula. He chose instead to represent the river's reversal by
the action of the water itself. In this way, his image is closer
to the literary tradition, an Italian version of which was cur-
rently available to him. Around the year 1300, there had
appeared in Italy a lengthy life of John the Baptist, known as
La Vita di San Giovanni Battista, written in Tuscan dialect
but incorporating many narrative motives that stem from
ancient Eastern apocryphal sources.[22] Almost immediately
this text became a major source to artists of the region, pro-

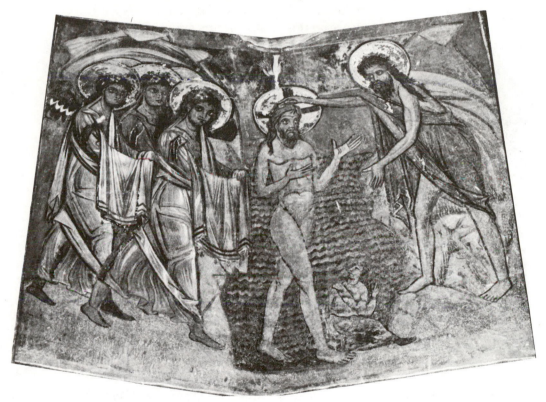

24. *Baptism of Christ*, fresco, Par-
ma, Baptistry (photo: Soprin-
tendenza per i Beni artistici e
storici, Parma)

viding them with episodes and specific details for their narra-
tive cycles. By the mid-fifteenth century, the *Vita* was known
throughout Italy, ultimately generating certain aspects of
non-narrative art as well.[23] In a style both picturesque and
effusive, the text describes John's ecstasy, fear, and humility,

as he recognizes and converses with Christ on the banks of the Jordan. After the baptismal rite, while Christ prepares to leave the water: "John desired the water to stand still, because he and his disciples wished thereafter to throw themselves in; and Messer Gesù understood his desire and it seems to me that he commanded the water to hold fast whilst John entered. And John hearing this [command] concentrated on the water and caught sight of some signal . . . and quickly undressed and threw himself in and dived about in this water."[24]

In spite of the general popularity of the text, as far as I have discovered visual dependence on this passage occurs only once before Piero's painting, on the Arca di San Giovanni, in

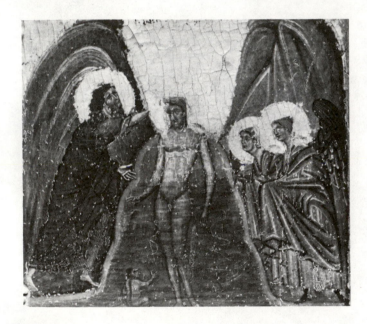

the Cathedral of Genoa. This miniature cathedral-shaped shrine of silver, gilt, and enamel, dedicated to the Baptist and decorated with scenes of his life, is signed by the Genoese goldsmith Teramo Daniele (d. 1438) and documented as finished by 1452 by his Tuscan assistant, Simone Caldara.[25]

25. *Baptism of Christ*, detail, *Paleotto di San Giovanni*, Siena, Pinacoteca Nazionale (photo: Alinari)

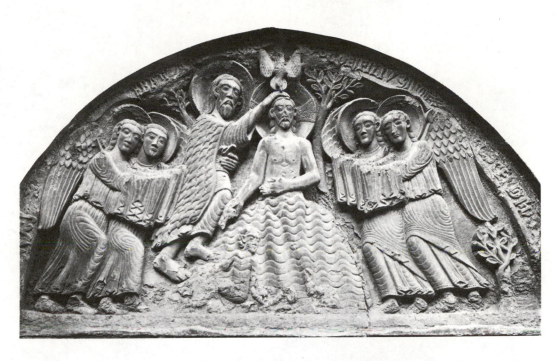

26. Marchionne, *Baptism of Christ*, relief, Arezzo, Santa Maria della Pieve, right portal (photo: Alinari)

Among the several relief scenes that depend on the legend for specific narrative details, the *Baptism* (fig. 27), follows the text by showing the Jordan stopped. Christ stands in the center of a small semicircular pattern that is peaked at the edges and tapers to emptiness in the center. The colors of the enamel make it clear that these are tiny waves meant to be rushing backward, leaving Christ's feet on dry ground.[26] Thus the sculpture expresses the miracle the way it is described in the text, by the action of the water. It is a true precedent for Piero's conception, in that both works extract the essential meaning of the miracle by portraying the Lord's presence with hydraulic reversal.[27]

Yet their interpretations of the scene differ greatly in terms of representational mode. Aside from its miniature status, the reliquary scene makes no pretense at realism in the setting. Hills pile up behind the figures; outsized fruit

hangs on small-scale trees; Gothic tracery stops the progression in the background with finality. In this irrational ambient, the pattern of retreating waves is just one more unreal detail among many. In Piero's painting, on the contrary, the perspectivelike structure of the landscape fabricates a setting of verdant reality. The space continues as far as the eye can see. The careful plotting of the design identifies the valley and orients the river's flow as it is in nature. It is only in this context of naturalism that the stopping of the water interrupts natural law and defines the miracle internally as a prodigious phenomenon. For the first time in the history of art, Piero has revitalized the symbol of Jordan *retrorsum* and made the scene of Theophany a true reenactment.

With the image of the halted water and the dry river bed, Piero summons the whole chain of allegorical types and figures for Baptism from the Old Testament, each proving the presence and the power of the diety. Moreover, by stopping the water behind Christ, he alludes specifically to the Jordan Miracle as described in the Book of Joshua. In his scene, as in the text, "the waters which came down from above stood in one place . . . and those that came down toward . . . the sea of the wilderness . . . wholly failed." As the priests who carried the ark stood "girded upon dry ground in the midst of Jordan," so Christ stands. He replaces both priests and Ark of the Covenant, standing eternally as the fulfillment of the promise. Here is the meaning of the stony face and shining body, strong as an athlete's, framed by the erect and steadfast Baptist. In the dawning light of a new day, we see the very moment the Old Law, prophetic but incomplete, is superseded by the New, and the Son of God is made manifest to the world of the Jews for the first time.[28]

The visual signal that seemed at first so anomalous is thus an allegorical allusion given rational form. Represented as a real occurrence at the Baptism, the sign from God is translated into its own theological equivalent, Theophany, one of the chief elements of which is "firstness." As we now proceed

27. Teramo Daniele, *Baptism of Christ*, detail, *Arca di San Giovanni*, Genoa, Cathedral Treasury (photo: Renato Gasparini)

to study the other figure groups in the painting with heightened expectations, we shall discover that the neoteric message running through the composition as a whole is this very theme of firstness, proclaimed so insistently by the Miracle of the Jordan.

NOTES

1. For the river of Baptism as a mirror, see below, chap. 6, n. 11.
2. Previous authors have described this passage in the following ways: Crowe and Cavalcaselle say merely that Christ "stands in a stream," (J. A. Crowe and G. B. Cavalcaselle, *History of Painting in Italy* (London, 1864), vol. 2, p. 541. Clark calls the Jordan "shallow," (*Piero*, p. 11). Tolnay says "St. John has entered the Jordan with one foot in the water" ("Conceptions," p. 213). Gilbert comments: "The river, required by the story, is not of interest to the artist at this time. . . . It is drier and less emphasized than in any other Baptism of the century" (*Change*, p. 33; but see below, chap. 8). Hartt describes Christ as "up to his ankles in clear water through which one can see the stones at the bottom"; he remarks that the photograph makes the water surface difficult to see (*Renaissance Art*, p. 234). Indeed, old photographs show a diagonal crack running downward from left to right and marring this area; the crack is no longer in evidence (see app. 2). See next note.
3. "Christ and the Baptist stand in the water, not on it or on the shore (a ring of tiny bubbles encircles each ankle). The detail, once observed, not only makes sense of the spatial structure in the foreground, but also reveals startlingly what Piero knew of Optics, and particularly of the refraction-angle in water. At about the right point his water-surface turns from reflection to transparency" (J. Shearman, "The Logic and Realism of Piero della Francesca," in *Festschrift Ulrich Middeldorf*, ed. A. Kosegarten and P. Tigler [Berlin, 1968], p. 184, n. 5; I am grateful to Professor Shearman for calling his footnote to my attention). As noted above, the marks on Christ's and John's ankles are thin lines, not bubbles.
4. Piero seems also to have placed the lines across the ankles at a height that does not relate in a reasonable way to the ostensible height of the ebbing water behind or of the riverbanks in front of the figures. For the meaning of the Jordan stopped behind Christ, see below.

 Note should be taken here of Taddeo di Bartolo's *Baptism of Christ*, a remarkable early example of the representation of the distorting effects of water on the perception of submerged forms. The Jordan blurs and discolors flesh and cloth where it covers Christ's

lower extremities. The fingers of his left hand, hanging by his side and dipping in the water, create small ripples, emphasizing the effect. Taddeo's *Baptism*, signed and dated 1397, was painted for the church of Santa Maria Assunta in the Ligurian town of Triora (Impera). Besides its uncommon pictorial details, there are two angels in the foreground facing into the space, one seen in *profil perdu*, more than twenty years before the San Giovenale Altarpiece. Moreover, it is one of the first large-scale (191 x 100 cm) altarpieces to have the Baptism in the main panel (see below, chap. 7, and fig. 56). The painting was first published by L. Venturi, "Nicolò da Voltri," *L'Arte* 21 (1918): 273; it was displayed in Genoa in 1946 (*Mostra della Pittura Antica in Liguria dal Trecento al Cinquecento* [Milan, 1946], p. 40, no. 13, fig. 4); and republished recently in "Progetti di lavoro di Roberto Longhi, 'Genova Pittrice,'" *Paragone* (1979):349–51, fasc. 6, pl. 7. Jack Freiberg brought the latter publication to my attention.

5. Tanner was the first to note in print "a shelf of dry land . . . visible beneath Christ's feet" ("Concordia," p. 15), from which she concluded Piero's river "seems to flow in both directions."

6. The fundamental work on this subject is A. Jacoby, *Bericht über die Taufe Jesu, nebst Beiträgen zur Geschichte der Didaskalie der Zwölf Apostel und erläuter ungen zu den Darstellungen der Taufe Jesu* (Strassburg, 1902). See also G. Ristow, *Die Taufe Christi*, for the illustrations.

7. Hydraulic reversal was universally understood as a sign of unnatural intervention; see, for example, Ovid, *Heroides*, trans. G. Showerman, Loeb Classical Library, vol. 5, (London, 1914), pp. 29–32: Oenone sees the Xanthus River turn backward, signifying Paris' inconstancy. He had promised eternal fidelity and carved the following inscription on a beech tree: "If Paris' breath shall fail not, once Oenone he doth spurn, the waters of the Xanthus to their fount shall backward turn." I owe my acquaintance with this passage to the mythic knowledge and daily generosity of Professor Rensselaer Lee.

8. *The Homilies of Saint Jerome*, p. 230.

9. St. Augustine, *Expositions on the Book of Psalms*, ed. A. C. Coxe, Nicene and Post Nicene Fathers of the Christian Church, (New York, 1888), pp. 549, 551, esp. n. 7.

10. The text survives in Ethiopian redactions dated ca. fourteenth century. Cf. F. Ohrt, *Die ältesten Segen über Christi Taufe und Christi Tod in religionsgeschichtlichem Lichte* (Cologne, 1938), quoting the passage from "Les Miracles de Jésus," in *Patrologia Orientalis*, ed. R. Graffin and F. Nau (Paris, 1923), vol. 17, part IV, (this fascicle is the third of three recounting the story, including transcription of the Ethiopian text and French translation), pp. 842–49. The reference to Ohrt is found in P. Lundberg, *La Typologie Baptismale dans l'ancienne Eglise*, Acta Seminarii Neotestamentici Upsaliensis Edenda Curavit A. Fridrichsen, 10 (Leipzig-Uppsala, 1942), an excellent study of the subject at hand. As far as I know, this text has not pre-

viously been cited in relation to the visual imagery we are tracing. If the dating of the text is correct, it contains the earliest description of the Baptism in which angels play a role; see below, chap. 5.

11. *Of the Holy Places Visited by Antoninus Martyr*, Palestine Pilgrims' Text Society, vol. 2, ed. P. Geyer, trans. A. Stewart (London, 1897), p. 10; original, Antoninus Placentinus, *Itinerarium*, Migne, *PL*, vol. 72, cols. 897ff. Pilgrims throughout the Middle Ages continued to report on their visits to the site of the Baptism: Theodosius (ca. 530), who saw a marble pillar surmounted by an iron cross in the water (Palestine Pilg. Text Soc., vol. 2, p. 14); Arculf (ca. 670), who saw a wooden cross of great size (ibid., vol. 3, p. 37); the Venerable Bede, who paraphrases earlier writers (ibid., p. 82), and so on. No one after Antoninus, however, mentions the reversal of the river. The *Chronicon Pascale of Alexandria*, a Greek chronicle written in Egypt outlining events of world history from the creation of Adam to ca. 629, recounts the miracle: "[Christ] was baptized in the month of Tubi, on the 11th day at the 10th hour, by John in the flood of the Jordan, and the Jordan turned backwards [*Jordanis conversus est retrorsum*]. Now the Lord said to John: 'Tell the Jordan: stop, the Lord has come toward us.' And immediately the water stopped. Then John adored. . . . When they descended in the water, the waters were seen to boil, even to whirl around and fill up again." Cf. F. Cabrol, *Dictionnaire d'archéologie Chrétienne et de liturgie*, vol. 2, col. 348; Greek original, Migne, *PG*, vol. 92, cols. 545–46. The tradition is further reflected in the legendary event recorded by Marino Sanuto, *Secrets for True Crusaders, to Help them Recover the Holy Land*, written in 1321, trans. A. Stewart (London, 1896), Palestine Pilgrims' Text Society, vol. 12, part 2, pp. 59–60: "In Babylon also there is a wonder worthy of record. In a monastery, built there in honour of St. John the Baptist there is a chest [scrinium] containing his relics. Every year they carry the aforesaid chest some five leagues down the Nile to another church of monks, which is also built in his honour. After Mass they place the chest in the river, to try in which place the saint wishes his relics to rest—that is, whether in this place or the former; and presently, before the eyes of all, the chest moves up against the stream of the river exceeding fast, so that men riding at full speed on horseback cannot outrun it."

12. Author's translation, after P. Guéranger, *L'Année liturgique: Le Temps de Noël*, 3d ed. (Poitiers, 1873), vol. 2, p. 294 (translated into Latin and French from Greek). See also "Epiphany Rite of the Blessing of Waters," *Rituale Armenorum*, F. C. Conybeare and A. J. Maclean (Oxford, 1905), pp. 415–21 (in Greek). Translation of a modern version, entitled "Office at the Great Blessing of Waters at the Holy Epiphany," is found in *Service Book of the Holy Orthodox Catholic Apostolic (Greco-Russian) Church*, ed. I. F. Hapgood (New York, 1906), p. 189. Cf. Earl of Bute [J. P. C. Stuart] and E. A. W. Budge, *The Blessing of the Waters on the Eve of Epiphany* . . . , esp. pp. 47ff.,

for the ritual as performed in Rome in the seventeenth century. The practice was introduced into Italy in the fifteenth century. See below, chap. 7, n. 23.

13. First to sketch this development was Strzygowski, *Ikonographie*; cf. also G. Millet, *Recherches sur l'iconographie de l'Évangile aux XIVe, XVe, et XVIe, siècles d'après les monuments de Mistra de la Macédoine et du Mont-Athos* (Paris, 1916; 2d ed. 1960), pp. 170–215. The lifted hand of Jordan is associated with Ps. 76: "The waters saw thee, O God, the waters saw thee; and they were afraid, and the depths were troubled." It has been suggested that fear of the approach of the Lord and fear of coming into his presence was based on ancient Semitic folk beliefs; indeed, Jordan's flight is explained in these terms in the *Didascalis Apostolorum*, a Syriac translation of a Greek text called "The Catholic Teachings of the 12 Apostles . . ." by a Jewish convert of the early third century. Ephraim the Syrian makes the same allusion in his 14th Hymn (see above, chap. 2, n. 4).

14. N. P. Kondakov, *Miniatures du Ms grec du Psautier du IXe siècle de la collection A. I. Chloudow à Moscou*, translated from Russian, in *Drevnosti* (Antiquities) 7 (1878): 162–83. Now in Moscow, Historical Museum, gr. 129, fol. 117r.

15. E. Diez and O. Demus, *Byzantine Mosaics in Greece, Hosios Lucas and Daphni* (Cambridge, Mass., 1931).

16. Dionysius of Fourna (ca. 1670–ca. 1745), *The "Painter's Manual" of Dionysius of Fourna*, p. 33, no. 89. See p. 101, note to p. 33, where it is postulated that Dionysius no longer understood the meaning of this figure.

17. A prominent example is on the architrave of the East Doors of the Baptistry of Pisa, where the Baptism with reclining river figure facing Christ is one of several narrative scenes of the Baptist's life; see R. Papini, *Pisa* (Rome, 1912), pp. 219ff., ill. p. 226. The relief dates ca. 1200 and is in Byzantinizing style.

18. L. Testi, *Le Baptistère de Parme*; the three versions all called "pure Greek," figs. 166, 204, 209; see also P. Toesca, *Il Battistero di Parma* (Milan, 1960), pl. 25. The figure had already appeared in Sicily in the Norman mosaics of Monreale, the mid-twelfth-century Benedictine monastery, and in the Cappella Palatina; cf. E. Kitzinger, *The Mosaics of Monreale* (Palermo, 1960), p. 32, pl. 47, and O. Demus, *The Mosaics of Norman Sicily*, pp. 25–72.

19. C. Brandi, *La Regia Pinacoteca di Siena* (Rome, 1933), p. 281, called "Senese-Bizantino"; E. Carli, *Guida della Pinacoteca di Siena* (Milan, 1958), p. 15, no. 14.

20. E. Bressau, *La Basilica di S. Marco in Venezia* (Venice, n.d.), pp. 47, 131, pl. 71.

21. Salmi, *Civiltà*, p. 52. This relief includes representations of a withered tree, a tree coming into leaf, and a tree with an axe in its root, all allusions to John's exhortations to repentance. See above, chap. 1, and below, chap. 6.

22. The background of the *Vita* is of some interest. Following a pattern
familiar to historians of mythmaking, the Coptic folktales of Jesus
and John that developed in the early Middle Ages circulated to the
Near East in translations from Arabic to Aramaic and Syriac. Varied
and reworked, they reappeared later in Greek and, by the twelfth
century, began to arrive in Europe in Latin versions. At the end of
the thirteenth century, the tales were given vernacular translations in
various countries. For another example of this pattern, see the study
of the legend of the True Cross by E. C. Quinn, *The Quest of Seth for
the Oil of Life* (Chicago, 1962), passim, and esp. pp. 133ff.

23. The text of the *Vita* was first published in *Volgarizzamento delle vite
de' Santi Padri*, ed. D. M. Manni and A. Cesari (Florence, 1731–35).
The first three volumes contain lives written by Fra Domenico Caval-
ca; the last three contain a number of anonymous lives, all of which
were put under the collective title, "Vite di alcuni santi scritte nel
buon secolo della lingua toscana." St. John's life is in vol. 6, pp. 259–
369. By 1830 there had been six editions of what was called *Le Vite
de' Santi Padri*, some by Cavalca, others anonymous but attributed to
Cavalca. For the effect of the *Vita di San Giovanni* on art, see M. A.
Lavin, "Giovannino Battista" (1955, pp. 85–101; idem, ibid. (1961),
pp. 319–26.

24. "Giovanni disiderava che l'acqua istesse ferma, per volvervisi gittare
dentro poscia egli e' discepoli suoi; e Messer Gesù conobbe il disiderio
suo, e pensomi che comandasse all'acqua che stesse ferma, tantochè
Giovanni entrasse dentro. E Giovanni udendo questo, puose mente
all'acqua e vide alcun segnale . . . ch'egli aveva avvistato, e spogliasi
prestamente e gittasi entro e tuffasi tutto in questa acqua. . . ." *Vite
de' Santi Padri di Frate Domenico Cavalca*, ed. B. Sorio (Trieste,
1858), pp. 403–40, quote on p. 422. See below for a contemporary ref-
erence to the Miracle of the Jordan in Dante's *Divina Commedia*.

25. O. Grosso, "Il Tesoro della Cattedrale di Genova," *Dedalo* 5 (1924–
25): 414–42. Simone Caldara had studied in Siena before moving
north.

26. For color photographs of the Arca (though not of the *Baptism* scene),
see *Chiese di Genova*, text by C. Ceschi, photos by L. von Matt
(Genoa, 1966), figs. 140–45. My thanks are due to Professor Giovanni
Alberto Viano, University of Genoa, for checking the detail of the dry
river for me.

27. In absolute terms, Piero's group is astonishingly close to the little
figures on the reliquary; the central Christ is in a frontal position
with hands in prayer over his chest, and John on the right with up-
raised arm pours water and holds his left hand at waist height. Unless
the Tuscan Caldara were somehow the intermediary in transmitting
these motifs, the similarities are difficult to explain.

28. Mark 1:9–11 (Baptism in the presence of the Jews). See C. Eisler,
"The Athlete of Virtue: The Iconography of Asceticism," in *De
Artibus Opuscula XL, Essays in Honor of Erwin Panofsky*, ed. M.

Meiss (New York, 1961), vol. 1, pp. 82–97, esp. p. 90, for discussion of the meaning of Christ's seminude muscularity. See fig. 9 for a *Baptism* with grisaille representation of the Ark of the Covenant guarded by cherubim taking the place of God the Father in the sky. This manuscript was in the collection of Federico da Montefeltro in Urbino before he became duke in 1474. The initials F. C. (Federico Conte) appear on folio 3.

PART TWO

The Figure Groups

4

The Elders

The group of figures farthest from the picture plane is made up of four men (fig. 5), one partially hidden by the nude figure. All wear long, brightly colored robes and hats, and all are bearded. Two stand in profile facing a third between them; the latter looks up and raises his right arm above his head. A fourth rushes into the scene from the right, that is, the East, striding forward in profile, one leg fully extended behind him.

The inclusion of fully clad, older men in a scene of the Baptism is part of a long visual tradition that is based on Gospel narrative. In describing the multitudes who came to hear John's preaching in the wilderness, Matthew (3:7) names the Pharisees and Sadducees whom John berates; Luke (3:12) names the publicans and soldiers who ask for guidance; John (1:40–41) identifies two men as Andrew and (Simon) Peter, John's disciples who leave him to follow Christ. On this basis, groups of men in varying numbers frequently witness the rite in both Eastern and Western Baptism scenes. In an eleventh- to fourteenth-century Greek Gospel Book from Mount Athos, for example, three men in long robes stand behind St. John on the left side of Jordan, conversing among themselves.[1] On the baptismal font in the Florentine Baptistry dated 1371 (fig. 10), three elders stand on the right; two are bearded, one holds a book, and one looks heavenward with his hand across his chest.[2] Such figures appear on both sides of the river in the *Baptism* on the *Dossale d'Argento*,

1366–67, from the same building, now in the Opera dell'
Duomo. More than ten men in contemporary costumes are to
the right of St. John in the *Baptism* scene in the cycle of fres-
coes by the Salimbeni brothers, dated 1416, in the Oratory of
San Giovanni di Urbino.[3] In the cycle of John's life by Gentile
da Fabriano, formerly in San Giovanni in Laterano in Rome,
recorded in drawings by Pisanello and his shop, the *Baptism*
showed three elders on the right, all bearded, one again look-
ing up (figs. 11, 12, and 48).[4]

While the four figures in Piero's group recall this tradi-
tion, they differ from their prototypes in several ways. First,
they do not appear in the foreground near the Baptism, but
are removed to a distant place from which they cannot ob-
serve the rite directly. In fact they seem unaware of the Bap-
tism, as if concentrating on some objective of their own. Sec-
ond, they do not wear the usual generalized "elder statesman"
garments, but are dressed in clothing of a particular fifteenth-
century fashion. Two have capes over their shoulders, one
blue and one porphyry-colored. Two have cloaks wrapped
about one shoulder and drawn across the thighs, one yellow
with white lining, one crimson with an orange lining. The
three whose heads are visible wear exotic hats: a tall and flar-
ing red cylinder over a white turban (on the man rushing in
from the right); a black, circular-brimmed hat on the pointing
figure; and a sapphire-blue conical bonnet with contrasting
browband, again worn over a white turban, on the man with
his back turned. All these costume elements can be identified
as Constantinopolitan, in fashion during the late 1430s.

As has often been noted, it is likely that Piero became
acquainted with garments like these in 1439 when Byzantine
potentates and prelates came to Florence for the Congress of
Union. He was in Florence at the time, working as a young
apprentice with Domenico Veneziano.[5] Later in his life, he
had another opportunity to study these styles, in reproduc-
tion, on the bronze relief plaques on the Doors of Saint Peter's
in Rome by Filarete (1433–45) (fig. 28), which record the

historical events of the congress with appropriate costumes.[6] Piero's interest in, not to say fascination with, these Eastern styles is obvious since he depicted them repeatedly in many of his works.[7]

Because of the style of these costumes, several modern scholars have claimed that the figures in the background of the *Baptism* represent actual contemporary Byzantines; two authors even read particular historical significance into their presence.[8] But when we consider that Piero put the same clothes on characters from three different historical periods— the first century or period of the New Testament (*Baptism* and *Flagellation*); fourth-century Early Christian period (*Proof of the Cross* [fig. 20]); and the seventh century, the time of Heraclius (*Battle Scene* and *Exaltation of the Cross*), also from the Arezzo cycle—and gave them to pagans and Christians alike, it is difficult to imagine that he meant them to have more than general significance. The scenes where he

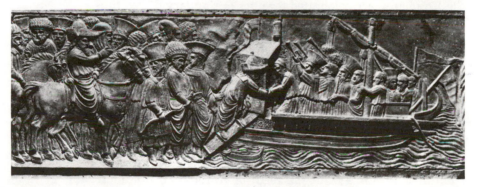

28. Filarete, *Embarkation of Emperor John Paleologus and Entourage*, detail, Bronze Doors, Rome, St. Peter's (photo: Coll. Mus. Vaticani, Archivio Fotografico)

used the costumes do have one thing in common: they all take place in Jerusalem in post-Judaic times. It seems likely, therefore, that Piero was modernizing the fourteenth- and fifteenth-century practice in Western painting of using foreign, mostly Eastern, costume styles and fabrics to refer to the remote Christian past. In the *Baptism*, as throughout his oeuvre, Piero has made his reference more particular than previous artists: he used contemporary Constantinopolitan styles, exot-

ic to Italy, to connote events specifically Christian that oc-
curred far away in time and place.⁹

Most commentators, in fact, have understood the generic
nature of the reference. Roberto Longhi, for example, called
the figures in the *Baptism* "santoni orientali," that is, oriental
Holy Men; Kenneth Clark marked them as "stiff robed Jewish
priests." Charles de Tolnay claimed they were dressed as doc-
tors of the Middle Ages, acting here as prophets or Magi who
"semblent deviner la purification future; en effet l'un d'eux
lève son bras et semble désigner le Saint Esprit."¹⁰ Extending
Tolnay's interpretation of the figures as Magi, Marie Tanner
suggested they are *the* Magi, and that with them Piero was
referring to the Epiphany. This observation was of signal im-
portance for, as Mrs. Tanner points out, there is a funda-
mental unity between Epiphany and Baptism, which is ex-
pressed in the painting.¹¹ In the Western church, the Baptism
of Christ and the Adoration of the Magi, the Theophany and
the Epiphany, are celebrated together on January 6, and thus
are bound together liturgically.

To understand the relationship between these episodes,
one from the childhood and the other from the maturity of
Christ's life, we must look briefly at the history of the Christ-
mas season. The date of Christmas, as historians of liturgy
have often shown, depends on the pagan custom of celebrating
the birth of various gods, particularly sun gods, on the winter
solstice, or December 25, according to the Julian calendar. In
early Roman times, this date marked the birth of Mithras and,
from at least A.D. 274 in the reign of Aurelian, of the more
important solar diety, Sol Invictus. A still older but parallel
festival took place in Egypt, where the calendar was twelve
days behind the Julian system and the solstice was calculated
as January 6. This date was designated as the birthday and
appearance of the chief god Osiris in Pharaonic times; later
the same date was taken as the birth of Aeon, god of the New
Age. These two dates, December 25 and January 6, deter-

mined the first fixed feasts of the Christian liturgical calendar.[12]

As early as A.D. 214, Clement of Alexandria recorded that a Gnostic sect, the Basilidians, celebrated Christ's Baptism as the birth of his divinity on January 6. As we have noted, the feast was known in Greek as the *Photismós*, or Feast of Divine Illumination; the day was soon commemorated throughout the Eastern world as both the Baptism and actual birth of Christ. The custom spread to the West and was practiced during most of the fourth century. Some time before 386, according to John Chrysostomus, the two mysteries were officially separated; the Baptism was left on January 6, while the Nativity was moved to December 25.

In the Eastern church the Baptism remained the only event celebrated on January 6. But in the West, after Christmas was moved, a new departure began to take hold. First in Gaul, and later throughout Europe, the Epiphany or Adoration of the Magi was introduced. As described in the Bible "Wise Men from the East" (*Magi ab oriente*) are miraculously told of the Messiah's imminent birth and led to Bethlehem by a star. They find the child and recognize his divinity, worship him, give him gifts, and depart. As the Western liturgy of the Epiphany season took form, more and more the ritual came to emphasize the joy of the revelation of the Infant Christ to the world of the Gentiles. While the Baptism thus lost its place as the object of the feast, it was retained, albeit in a secondary position. The Baptism is solemnized on January 6 in the first nocturn, at lauds, at second vespers, and, from the eighth century onward, the Octave of Epiphany was designated as the Commemoration of the Baptism with an office of its own (moved to January 13 in 1955).[13]

We may now understand Piero's group of older men, dependent on traditional figures in Baptism scenes, as here overlaid with allusions to Epiphany. Yet, if they refer to the Magi, we may ask why Piero represented four men rather

than the more familiar group of three? Like so many other passages in the New Testament, the brief Adoration text was expanded by apocryphal legends during the Middle Ages. These narratives describe the Magi's journeys, their meeting, and various miracles that occurred after their departure from Bethlehem, including their own baptism. A tradition grew up in the East identifying the Magi as soothsayers and philosophers, varying in number between two and twelve, depending on the source. On the other hand, in the West, at least by the tenth century, they were designated as three in number and identified as regally dressed kings. From the latter evolved the elaborate visual imagery well known in Western art, as well as the many popular customs and practices that persist to this day.[14]

There is, however, one major text suggesting there were four Magi. This is a line in Psalm 72:10–11, interpreted by the church fathers as a type for Epiphany: "The kings of Tharsis and the Isles shall offer gifts .The kings of Arabia and Saba shall bring tribute to the Lord God." Since four lands of origin are mentioned, four "kings" are implied.[15] The importance of this passage lies in the fact that it appears frequently in the Epiphany liturgy: it is the offertory at the Mass at first vespers, and the responses, the verses, and the antiphons in the first and second nocturn. I propose that Piero chose to illustrate specifically this text, by depicting four Magi, in order to emphasize the liturgical significance of their presence. We shall see below that such liturgical considerations were the guiding principles in most of Piero's other pictorial choices.

Wearing exotic oriental costumes, the figures represent Eastern philosophers and thinkers associated with the "enlightenment" aspect of the Epiphany. They are shown as they meet on their journey (cf. fig. 19); the raised arm of the central figure points as if to the star that guides them on their way.[16] The group thus also visualizes the Magnificat Antiphon at first vespers of Epiphany: *Magi videntes stellam,*

"When the Wise Men saw the star, they said one to another: This is the sign of the great King: let us go and search for Him."

Their position in space, far behind the Baptism, might be considered an expression of the separation in time of the two events. Simultaneously, the logic of their placement and, above all, their reflection in the river of Baptism express their liturgical identification with the figures in the foreground.[17] Moreover, the spatial unity binding the two figure groups together expounds the theological reciprocity of the miracles they represent: the Theophany and the Epiphany are both feasts of Firstness. As the Theophany is the first manifestation to the Jews, so the Epiphany, as the revelation to the pagan world of the divinity of Christ, is the first manifestation to the Gentiles.[18]

NOTES

1. Mount Athos, Gospel Book 5, fol. 138r; reproduced in A. Xyngopoulos, *Gospel Books of the Monastery of Iviron* (in Greek) (Athens, ca. 1932), pl. 28.
2. This relief is one of five on the font showing various baptisms (John/Christ; Christ/John; Christ/Apostles; Pope Silvester/Constantine; Priest/Child); cf. A. Venturi, *Storia dell'arte Italiana*, (Milan, 1906), vol. 4, figs. 654–58.
3. The part of the John cycle on the *Dossale* where the Baptism appears is attributed to the silversmiths Leonardo di Giovanni, Betto di Geri, and Christoforo di Paolo; see G. Poggi, *Catalogo del Museo dell' Opera del Duomo* (Florence, 1904), p. 43, no. 97; *Il Museo dell'Opera del Duomo a Firenze*, ed. L. Becherucci and G. Brunetti (Venice, post-1966), vol. 2, fig. 40, pp. 216ff. The Salimbeni frescoes, also a cycle of the Baptist's life, are reproduced in Rossi, *I Salimbeni*, pls. 143–205. See below, chap. 6.
4. The frescoes were destroyed in the seventeenth century. M. F. Todorow, *I Disegni del Pisanello* . . . (Florence, 1966), no. 191, attributed to the school of Pisanello. See below, chap. 6, discussion of the catechumen.
5. This oft-made observation is based on a document dated September 7, 1439, concerning Domenico's work on the frescoes of Sant' Egidio, the hospital church of S. Maria Nuova, Florence: a marginal note saying

"Pietro di Benedetto dal Borgo a San Sepolchro che sta chollui . . .";
De Vecchi, *L'Opera completa*, p. 83.

6. Piero had contact with Filarete's work either when the latter was in
Rimini (Feb.-April 1449) or when he himself was in Rome in 1459
(ibid.). For discussion of the Rimini connection, see M. A. Lavin,
"Piero della Francesca's Fresco," p. 362, n. 82.

7. The flaring cylinder, for instance, appears several times on the left
wall of the Arezzo cycle: in *Proof of the Cross* (fig. 20); with varia-
tions in the *Battle of Heraclius*; and more than once in the *Exaltation
of the Cross*. In the latter case, it is worn by a black-bearded figure on
the right who, like the man in the *Baptism*, strides rapidly into the
scene with one leg extended behind him. The conical bonnet with
contrasting browband is found on the left in the *Proof* scene; in the
Exaltation it is worn by a figure who also wears a lined cloak wrapped
about him; with an arrangement of vertical stripes, it is worn by the
flagellant seen from the back in the panel in Urbino. For reproduc-
tions, see Lavin, *The Flagellation*, passim; De Vecchi, *L'Opera com-
pleta*, pls. 44–45, 50, 51.

8. See C. Marinesco, "Echos byzantins dans l'oeuvre de Piero della Fran-
cesca, *Bulletin de la société nationale des antiquaires de France* (1958):
195–96, who proposes a kind of blanket identification as real contem-
porary Byzantine people for all figures in Piero's works dressed in
Byzantine fashion, regardless of the subject at hand. He gives no
interpretive point to their appearance in the scenes. On the other
hand, Pogány-Balás, "Problems of Mantegna's Fresco," pp. 107–24,
and Tanner, "Concordia," p. 13, use the same costume identifications
to associate the Baptism historically with the Council of Florence. The
former links the subject of the painting with the problems of "re-
baptism" bitterly discussed at the council. The latter contends that
the subject alludes to the Decree of Union signed at the congress and
that it is complimentary to Emperor John Paleologus, whose patron
(that is, whose onomastic saint) was the Baptist. Many of Mrs. Tan-
ner's conclusions are based on an interpretation of the angels' hand-
clasp as a gesture of concord; she sees this gesture as symbolic of
agreement both between the Eastern and Western churches (which
of course failed to materialize once Paleologus left Italy) and between
the three members of the Trinity. As we shall see, this gesture has
theological and liturgical, rather than historical, meaning. See below,
chap. 5.

9. Cf. W. Weisbach, *Triumphi* (Berlin, 1919), p. 34, quoting Flavio
Biondo, *Roma Triumphans* (1459), bk. 10, who says that the Greeks
at the congress must have looked the way ancient Roman priests
looked. Cf. now also, E. Callmann, *Apollonio di Giovanni* (Oxford,
1974), esp. p. 33, for a discussion of contemporary Eastern costumes
used for reference to past events of various sorts. See also, G. Soulier,
L'influence orientale dans la peinture Toscane, Paris, 1924; L. Olschki,

"Asiatic Exoticism in Italian Art of the Early Renaissance," *Art Bulletin* 26 (1944): 94–106.

10. Longhi, *Piero*, p. 17; Clark, *Piero*, p. 13: Tolnay, "Conceptions," p. 215.

11. Tanner, "Concordia," pp. 13–14. While Mrs. Tanner's interpretation of the painting's theological and historical content remains unsubstantiated, her epiphanical observations put the study of the *Baptism* on a new footing.

12. J. A. Jungmann, *The Early Liturgy to the Time of Gregory the Great*, pp. 149ff.; L. Eisenhofer and J. Lechner, *The Liturgy of the Roman Rite* (1961), pp. 224ff.; A. Baumstark, *Comparative Liturgy*, (1958), pp. 157ff.; F. G. Holweck, *Calendarium Liturgicum Festorum Dei et Dei Matris Mariae* (Philadelphia, 1925), pp. 3ff.; E. J. Bickerman, *Chronology of the Ancient World* (Ithaca, N.Y., 1968), pp. 40ff.; A. Hamman, *Baptism: Ancient Liturgies and Patristic Texts* (New York, 1967). The discussion that follows is based on these sources and the references in them.

13. Weiser, *Handbook*, p. 144.

14. See C. Horstmann, *The Three Kings of Cologne, an Early English Translation of the "Historia Trium Regum" by John of Hildesheim* (London, 1886), esp. pp. 141–43; H. Kehrer, *Die heiligen drei Könige in Literatur und Kunst*, (Leipzig, 1908), pp. 23–28, 47–48; R. Hatfield, "The Compagnia de' Magi," *Journal of the Warburg and Courtauld Institutes* 33 (1970): 107–61; G. Messina, *I Magi a Betlemme e una predizione di Zoroastro* (Rome, 1933); U. Monneret de Villard, *Le leggende orientali sui Magi Evangelici*, Studi e Testi, 163, (Vatican City, 1952).

The Eastern medieval tradition seems to have been revived in the mid-fifteenth century. Fra Angelico's *Adoration of the Magi* at San Marco, Florence, in Cell 39, shows three Kings with haloes, but twelve Magi. One holds an astrological instrument and all are dressed in oriental style, with turbans, braided hair, and a tall hat shaped like a flaring cylinder very similar to the one in Piero's painting. Cf. J. Pope-Hennessy, *Fra Angelico*, 2d ed., (Ithaca, N.Y., 1974), fig. 71. Leonardo da Vinci's unfinished *Adoration*, commissioned for the high altar of S. Donato a Scopeto, now in the Uffizi, also shows a company of twelve Wise Men, three of whom kneel. When Filippino Lippi completed this project with his own painting, likewise now in the Uffizi, he again used a combination of adoring Kings and a number of other Wise Men, one of whom Vasari calls "uno astrologo che ha in mano un quadrante. . . ." Cf. K. Neilson, *Filippino Lippi* (Cambridge, Mass., 1938), pp. 113–16, esp. 114.

There are also fifteenth-century representations of the Magi's baptism: e.g., Rogier van der Weyden's *Bladelin Altarpiece* (in Panofsky, *Early Netherlandish Painting*, vol. 2, pl. 199), and Fernando Gallego's *Adoration of the Magi*, ca. 1480–90, Toledo Museum of Art

(in *The Toledo Museum of Art, European Paintings* [Toledo, 1976], p. 62, pl. 49). These representations depend on the apocryphal legends at the same time they refer to the liturgical reciprocity between Epiphany and Baptism.

15. Representations with four Magi were common in early Christian art; see, for example, the scene in the Catacomb of Domitilla, Rome, where two Magi approach the Madonna and Child from each side (cf. J. Wilpert, *Die Katakombengemälde und ihre alten Copien* (Freiburg, 1891), p. 49, pl. 21, and Schiller, *Iconography*, vol. 1, p. 96.

16. Piero used this same gesture on a later occasion, the London National Gallery *Adoration*, where one of the shepherds points heavenward to indicate the same phenomenon; Clark, *Piero*, pl. 119. Cf. Schiller, *Iconography*, vol. 2, p. 128, for discussion of the identification of the star of Baptism with the star of the Nativity.

17. See below, chap. 5, n. 8, and chap. 6, n. 11, for a suggested meaning for these reflections.

18. Matt. 2:1–12; *Meditations on the Life of Christ, An Illustrated Manuscript of the Fourteenth Century*, translated by I. Ragusa, edited by I. Ragusa and R. Green (Princeton, 1961), chap. 9, p. 47.

5

The Angels

Once the liturgical connection between Baptism and Epiphany has been pointed out, we are bound to consider that the Western feast of January 6 includes yet a third miracle, and that is the Wedding at Cana. If, as we have seen, the painting makes the association between Baptism and Epiphany in visual terms, to be logically complete it should allude also to the third part of the day's liturgy. This, I believe, is in fact the case.

The Gospel of John (2:1–11) provides the only description of the historical event. Christ and his mother attend a marriage in Cana of Galilee where it is soon discovered there is no wine. At the request of his mother, Jesus commands that six stone pots used for Jewish ritual washing be filled with water. When the contents are delivered to the chief steward, the water has been transformed to wine. Because it took place in a house (*beth* in Hebrew), the miracle is known as the Bethany. All narrative illustrations of the scene, such as the mid-fourteenth-century fresco attributed to Barna da Siena in San Gimignano (fig. 29), include a banquet table where Mary, the bride and groom, and other guests are seated. The stone jars (they may vary in number) are usually in the foreground and Christ gestures toward them as a sign of the transformation.[1]

According to modern scholarship, celebration of this miracle on the date of January 6 again seems to stem from pagan custom. There was general belief in the ancient world

that on the eve of the birth of a great god, the waters of
streams and rivers were transformed into wine; annual birth
festivals were hence often accompanied by much drinking
and revelry. One such festivity was held, appropriately
enough, on the island of Andros in Asia Minor, the birthplace

of Dionysius. Even more boisterous, apparently, was the cele-
bration on the eve of Aeon's birth at Alexandria. As we have
noted, this theophany occurred on January 6, and on the vigil
of that date a great nocturnal feast took place at the Nile,
which was said to run red with wine. Because it involved a
similar transformation of water into wine, it is now believed
that the Cana miracle was first incorporated into the Christian

29. Attributed to Barna da Siena,
Wedding at Cana, fresco, San
Gimignano, Collegeata (photo:
Alinari)

Theophany ritual there in Alexandria, to counteract this powerful pagan custom. There is evidence that the addition had been made in western Europe by the fifth century.[2]

Medieval liturgists, like Honorius of Autun, Rupert, and Durandus, on the other hand, all assert that the association of the three feasts was historical. The Baptism, they say, took place thirty years to the day after the Adoration of the Magi, and the Miracle of Cana occurred one year to the day after the Baptism.[3] The theological relation of the Bethany to the Epiphany and the Baptism, in any case, is obvious and basic. The Bethany was Christ's first miracle performed in public and his manifestation to the Apostles. Along with the Epiphany and Theophany, it is the third miracle of Firstness.

The tripart nature of the feast of January 6 is announced at several points in the day's liturgy, one of the most succinct of which is the Magnificat Antiphon of second vespers which reads: "We keep this day holy in honor of three miracles: this day a star led the Wise Men to the manger; this day water was turned into wine at the marriage feast; this day Christ chose to be baptized by John in the Jordan, for our salvation, alleluia."[4] It is not surprising, therefore, that in Latin liturgical manuscripts—sacramentaries, missals, breviaries, antiphonals, lectionaries—we find an unbroken tradition of illustrations giving visual form to the doctrine of triple manifestation.

In the Sacramentary of Warmund (tenth or eleventh century, Ivrea, North Italy), for example, the feasts are illustrated in three sections (fig. 30): the Adoration of the Magi on one page and the Miracle of Cana and the Baptism, one above the other, on the next.[5] This order seems incorrect from the point of view of biblical chronology—the Baptism took place before the Marriage. But remembering the order in which the miracles are named in the Magnificat Antiphon, we realize that the scenes are grouped liturgically. The liturgical grouping is even more obvious in the Missal of Odalricus (Fulda, Germany), where all three scenes are portrayed, one

above the other in bands (fig. 31), within one unified frame. They appear again in the banded arrangement bound by a single frame in the thirteenth- or fourteenth-century breviary (fig. 32) (Frankfurt, Germany), with the same liturgical implication.[6] An Italian antiphonary, dated 1314 and probably painted by Neri da Rimini (owned for centuries by the Augustinian monastery of San Giacomo, Bologna), has the three framed scenes on different folios but all illustrating the same liturgical chant.[7]

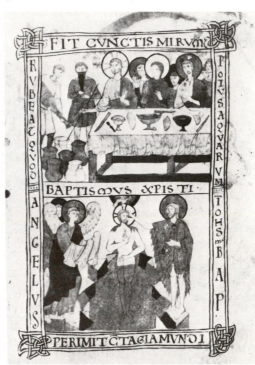

The tradition of liturgical illustration was thus available to Piero, and it seems likely that he drew upon that tradition as a source for his painting. As we shall see in a moment, he alludes to all three miracles of the day and arranges them in a sequence, moving from the background forward, that is, in

30. *Epiphany Illustration*, manuscript illumination, Sacramentary of Warmund, Ivrea, Biblioteca Capitolare, 86, fols. 26v and 27r (photo: Biblioteca Capitolare)

the same sequence as the Magnificat Antiphon. His organization of the figures into differentiated groups even recalls, in a sense, elements of medieval continuous narrative. It should be pointed out immediately, however, that Piero's pictorial

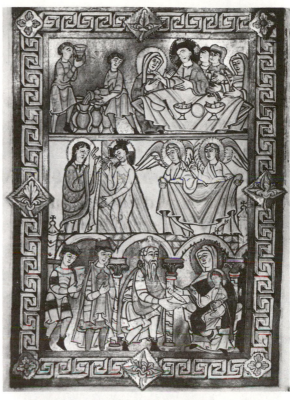

31. *Epiphany Illustration*, manuscript illumination, Missal of Odalricus, Fulda, Landisbibliothek, A.a.35, fol. 60v (photo: Bildarchiv Foto Marburg)

problem was of a different order than that of the manuscript illuminators, who simply took the three scenes from narrative art and brought them together without changing their iconography. Piero, by contrast, starts with a spatially unified setting and through it guarantees the consistency of his primary subject. He alludes to the Epiphany through regular members of the Baptism dramatis personae, differentiating them by location in space and by special visual features of pose and costume. To complete the liturgical reference and still not

interrupt the narrative coherence, we might expect him to allude to the Bethany through other members of the same cast of characters, differentiated in a similar manner.

I propose that Piero evoked the third miracle of the Epiphany season in precisely this way, through the angels of Baptism. He refers to the Wedding at Cana, however, not by

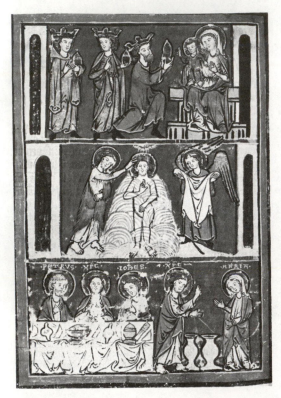

showing the miracle of transformed water; because he had already depicted one watery miracle, to show another perhaps would have seemed redundant.[8] Rather, by giving the angels a number of visual signals, he alludes to the marriage itself. This choice of allusions, moreover, was not arbitrary since a long tradition within the theory of angelology connects angels and the theme of marriage. In fact, as I hope to show, by cast-

32. *Epiphany Illustration*, manuscript illumination, Breviary, Frankfort am Main, Stadt-u.-Universitätsbibliothek, Ms. lat. oct. 3, fol. 108v (photo: Universitätsbibliothek)

ing the angels in a nuptial role, Piero evokes not only the Bethany but the more fundamental theological concept that unifies the liturgy of January 6, namely, the Marriage of Christ and the Church. To understand how he achieved this multilevel expression, we must describe the several visual traditions involved in the angelic group and draw out their meanings step by step.

First we may observe that the angels on the left of the composition, like the Magi to the right, occupy a discrete spatial area (fig. 4). Their position in depth is defined by their scale, which is slightly smaller than Christ's and John's, and, more emphatically, by their placement behind one tree and in front of another. Through these overlappings, the figure group is pinioned, as it were, not very far from but definitely behind and isolated from the Baptism proper. We may note that this compositional device recalls an earlier *Baptism*, a stone relief attributed to Donatello in the Cathedral of Arezzo, which Piero certainly knew (fig. 33).[9]

Second, while all three are winged, haloed, blond, and fair, like traditional angels, in terms of action and dress they depart from convention. Varying in number from one, two, or three to whole crowds of angelic hosts, throughout their history as attendants to the Baptism of Christ angels do one of two things. Flying in the air, standing, or kneeling on the ground at either side of the Jordan, they venerate Christ by approaching with veiled hands, by crossing their arms over their chests, or by holding their hands together in a position of prayer. They also may participate in the ritual of Baptism by holding Christ's robes, acting as deacons and frequently even wearing appropriate liturgical vestments such as the alb or the dalmatic. Piero's angels do none of these things: they do not venerate, nor do they convey sacramental meaning by holding the robes of Christ.[10]

Firmly planted on the ground, the angels are grouped in a closely knit triad. The one on the left, with his back turned to the viewer, rotates his shoulders to a three-quarter pose. As

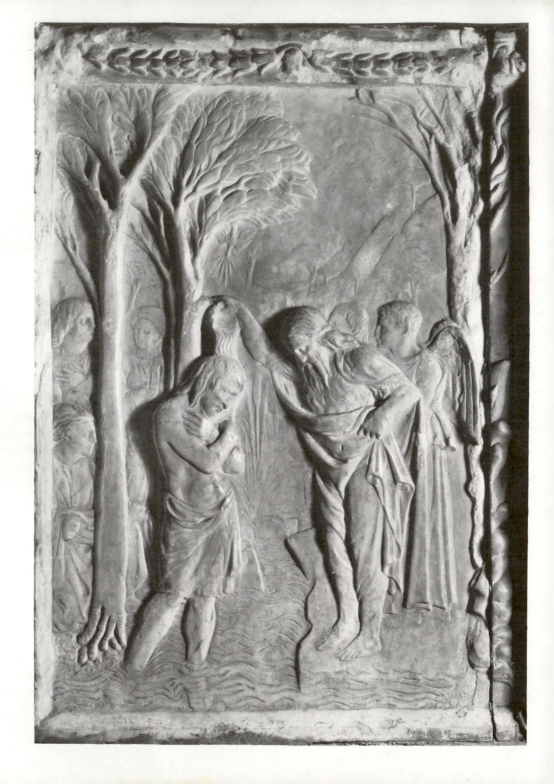

he directs his glance across the river, he raises his right hand to the height of his hip with palm down and fingers spread, as if responding to what he sees. The one in the center faces forward and gazes, somewhat mournfully, at Christ and John. The third, also facing forward, looks steadily at the spectator, the only figure in the painting to make contact with the outside world. The latter two touch each other in exceptional ways: the one behind the tree clasps left hands with his neighbor and places his right hand on the other's shoulder. These gestures require our attention since they are wholly unprecedented in the Baptism context.

Before turning to this problem it must be pointed out that the general grouping of these figures has often been related to certain three-figure motives in ancient art. Charles de Tolnay found the figures reminiscent of sculptured groups of the Three Graces, a Roman version of which was placed in the Cathedral of Siena some time after the middle of the fifteenth century (fig. 34). The Graces also are arranged with two figures facing forward and one facing back with arms linked at the shoulders. In antiquity, the threesome signified Harmony, the poses expressing "giving, receiving and returning of a mutual benefit." Tolnay proposed that the angels in Piero's painting, christianized by their wings and haloes, have the same meaning but in the sense of Christian Virtue.[11]

Another type of classical triad to which the disposition might be related is the group of philosophers or orators seen as three togate figures holding scrolls with one placing his hand on the shoulder of another. An example of this type, surely known to Piero, is carved in the central relief plaque of a late third-century stone urn (fig. 35), today prominently displayed in the right aisle of the Cathedral of Arezzo directly opposite Piero's fresco of *Mary Magdalen*.[12]

While strongly classicizing in their form and grouping, acting as a perfect figural counterpart to the Plinian reference in the landscape, the angels differ in major ways from both these prototypes. They are, of course, not nude females like

33. Donatello(?), *Baptism of Christ*, relief, Baptismal Font, Arezzo, Cathedral Baptistry (photo: courtesy H. W. Janson)

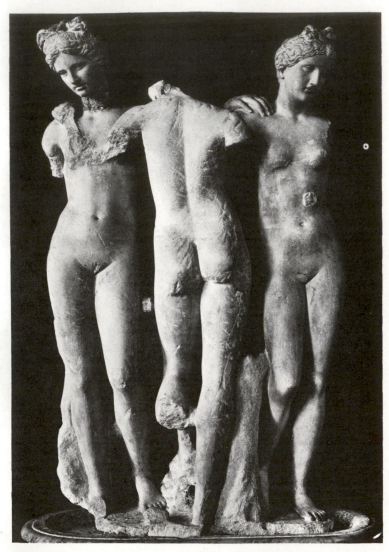

the Graces; nor are they togate like the philosophers. Two are dressed in colorful garments with contemporary sartorial details: the one behind the tree wears a gray-blue gown with flashy pink scarf over the shoulder; the other, to the left, wears a bright raspberry gown with tucked bodice and cuffed

34. *Three Graces*, Roman, marble, Siena, Cathedral, Piccolomini Library (photo: Anderson)

sleeve held at the elbow by a jeweled band. The lower part of the body is wrapped in a sapphire-blue cloak lined in white. In contrast to this polychrome modernity, however, the stony-white dress of the central angel is specifically classical. It is a sleeveless chiton with high-placed belt (blue in color and knotted in a tiny figure eight). The right shoulder portion is slipped off and hanging down above a peplos-like fullness at the waist. The three-quarter-length skirt is slit at the side from the hem to above the knee. What is most out of the ordinary about an angel wearing this kind of dress is that the arrangement leaves one breast emphatically bare. I have found, in fact, only one Christian antecedent for bare-breasted angels:

35. *Urna di San Satiro*, Late Classical, stone urn, Arezzo, Cathedral (photo: Alinari)

a series of stone angels carved by Antelami and his shop at the end of the twelfth or beginning of the thirteenth century in the Baptistry of Parma (fig. 36). Themselves part of an early classical revival, these angels wear unbelted togas slung over one shoulder with no tunics underneath.[13] Though similar in exposing one breast, the costume of Piero's angel differs from those of the Antelami sculptures in ways which relate it, oddly enough, not to male apparel but to classical female dress. The chiton that bares one breast, high-belted and split to the knee, is found constantly in Greek and Roman representations of women—Venus, Victory figures, and, in a shortened form, Amazons.[14] An even more striking use of this mode is in classi-

cal portrayals of men disguised as women, such as the scene of
Achilles discovered among the daughters of King Lykomedes.
On the fourth-century silver dish discovered at Kaiseraugst
(fig. 37), the muscular hero is shown in precisely this garb.[15]
Thus we may say that although the flat breast of Piero's angel
shows he is not female, his costume is that of a woman. It was
perhaps for this reason that Roberto Longhi, although not
making an analytical point (he saw a resemblance between
the angels and certain Italian youthful peasant types), called
the angels "androgynous."[16]

It is in the context of classical characteristics that the
motif of handclasping and touching the shoulder takes its
place. Throughout the history of Greece and Rome, these ges-
tures when made by a man and a woman symbolized marital
union as an act or as a state of being. In early periods, the
possession of the wife by the husband was expressed by the

36. Antelami and School, *Angel*,
stone, Parma, Baptistry, Apse 15
(photo: Fornari and Ziveri,
Parma)

man holding the woman's wrist.[17] We see, for example, on an Etruscan sarcophagus from Chiusi (fig. 38) a married couple at the right, the husband taking the wife's left wrist in his right hand while she expresses consent by placing her right arm on his shoulder. A goddess supports the man from behind by placing her left arm on his other shoulder. A winged Fury,

37. *Achilles Discovered*, detail, Achilles Plate, silver, A.D. fourth century, Augst, Switzerland, Römermuseum (photo: Elisabeth Schulz)

guardian of the deceased woman's soul, supports her from behind. Clearly this grouping, which is one of a type, makes a striking comparison with Piero's figures.[18] Ancient marital union ultimately incorporated the idea of *Homonoia*, or Harmony of the Universe, in Latin *Concordia*, and the marriage gesture then changed to a true handfasting, right hand gripping right. The gesture was known as *dextrarum iunctio*, and was used widely to signify not only marriage but concord and pledges of various kinds as well.[19] When it connoted marriage

specifically, as on a second-century Antonine Stele from Ostia, another widespread type, it was always combined with the hand-on-the-shoulder motif.[20] Handfasting remained part of

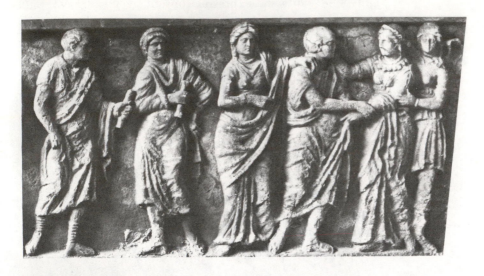

the legal marriage ceremony throughout the Middle Ages and was known as the *fides manualis*.[21]

 Clearly, the handfasting gesture of Piero's angels recalls such precedent images. Yet it must be observed that in the painting the gesture is irregular. Not only is it all but hidden by the walnut tree, it is also reversed: the angels join not right, but left hands. In spite of the associations generally connecting the left side with evil in the Middle Ages, nothing sinister can be implied here. On the contrary, the figures' patently "good" identity relates them, rather, to a theological discussion in which the distinction between right and left carries no moralizing connotations.[22] There are, in fact, various kinds of scenes, including Christ's Descent into Limbo, where left hands are joined with some consistency.[23] One particularly pertinent instance is found in a scene of the Wedding at Cana on the famous eleventh-century Liège

38. *Hasti Afunei Sarcophagus,* Etruscan, detail, Palermo, Museo Archeologica (photo: Brogi)

School ivory plaque from the "Guelf Treasure" now in the Cleveland Museum of Art. The story is shown in three separate narrative compartments. The second on the right represents the banquet table with the bride and groom and two guests served the new-made wine (fig. 39). As the wife places her right hand on the arm of her husband, he moves his left hand to take her left. Here the gestures do not show the act

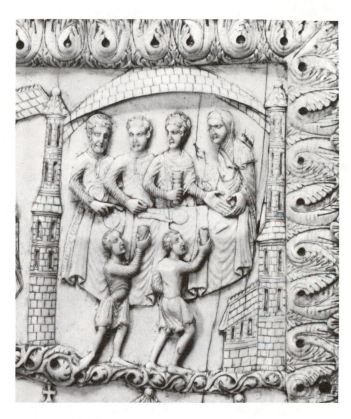

39. *Wedding at Cana*, detail, Bride and Groom at Table, ivory, Cleveland, The Cleveland Museum of Art, Gift of the John Huntington Art and Polytechnic Trust (photo: Museum)

of marriage, which took place before the banquet, but they connote marriage.[24] In like manner, Piero does not intend to show his angels marrying; indeed, since they are sexless spirits, that would be theologically impossible.[25] But by giving them overtones of androgyny, portraying female dress, and

depicting them handfasting and touching the shoulder, he
has created in them, definite connubial connotations.

He continues to develop this idea by giving them crowns
and wreaths (fig. 40). One angel wears a thin diadem with
large pearl jewel at the brow; one wears a garland of inter-
laced red and white roses; one wears a wreath of myrtle. It is

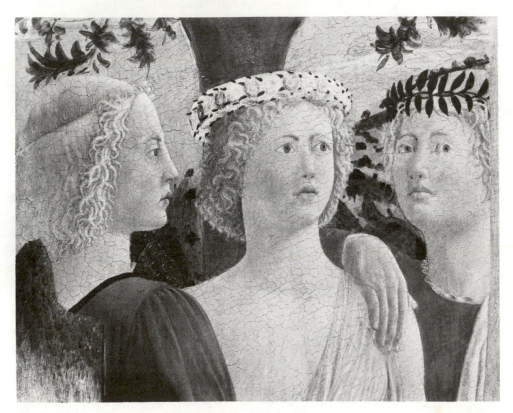

40. Detail of fig. 1, Heads of An-
gels (reproduced by courtesy of
the Trustees, The National Gal-
lery, London)

true that angels crowned with jewels and flowers are com-
monplace in art by the fifteenth century. Indeed, there is
theological justification for such accoutrements: Dionysius the
Areopagite says that angels designated as Dominions wear
crowns.[26] But in conjunction with handfasting, here the an-
gels' crowns refer to marriage. In many early cultures, pagan,

Jewish, and Early Christian, both members of the bridal couple wore crowns during the ceremony. The ancient custom persists to the present day in the ritual of the Eastern church; and although officially discarded in the West, it is remembered still in the conventional bridal wreath or wedding chaplet.[27] Current studies of legal marriage arrangements in fifteenth-century Florence, moreover, show that the nuptial significance of such headgear was so fundamentally understood, poor girls were permitted to bring garlands as symbols of their troth in lieu of real monetary dowries.[28]

The nuptial allusion is further extended by the differentiated materials of the crowns. The large pearl jewel to the left recalls many Biblical descriptions of bridal dress with pearls as jewels and ornaments.[29] And the myrtle wreath on the right recalls the "marriage myrtle" mentioned by Pliny, based on traditional associations of myrtle with goddesses of love (Aphrodite) and marriage (Astarte), to whom it was sacred.[30] Thus in ways parallel to his reference to the Epiphany in the group of elders in the background, by giving his angels gestures and costumes that refer to marriage Piero alludes to the Wedding at Cana.

In emphasizing the marriage aspect of the Cana miracle, moreover, he was following sound medieval tradition. Early in the Middle Ages, human matrimony had been fiercely criticized as perpetuating Original Sin. Its religious status, especially its acceptance as a sacrament, was therefore the subject of controversy. To counter the arguments against marriage, theologians point to the Cana passage in John. Augustine, for example, commenting on the Gospel, says: "Our Lord went to the wedding feast because . . . He wished to emphasize that He himself had established marriage . . . [and had said] What God has joined together, let no man put asunder." These remarks are read in the third lesson of the Mass dedicated to the Cana miracle.[31] Many illustrations of the feast also reflect this positive attitude by stressing the wedding aspect. We find, for example, in the Bible of Avila

(fig. 41, eleventh to thirteenth century), the Baptism on the left and the wedding feast to the right; there the married couple, identified by an inscription, exchange a connubial kiss.[32] It was on the basis of such associative precedents that Piero could elicit from his spectators an understanding of the matrimonial gestures and headgear of his angels as referring to the Bethany.

But the most persuasive reason why Piero singled out the wedding is the mystical significance of the occasion. In their

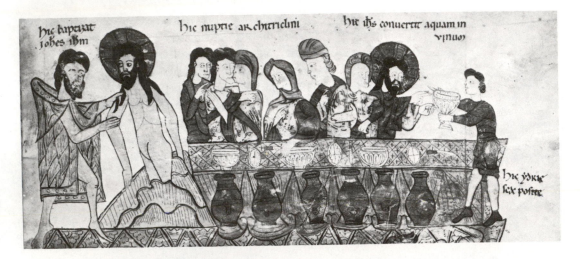

unending chain of inspired connections, the exegetes saw the Cana wedding as an allegory for the New Covenant with God. They interpreted the transformed water not only as a prophecy of the Eucharist, but as a figure of the superiority of the wine of the New Covenant over the water of the Old. The New Covenant is of course Christ's willing sacrifice of his life in order to present all humanity with everlasting life. Every step in the scheme of salvation shows his love for humanity and his desire for union with it. In metaphorical terms, this union was expressed as a marriage between Christ, the Heavenly Bridegroom, and humanity or the Church as a body, his be-

41. *Baptism, Wedding at Cana,* manuscript illumination, Bible of Avila, Madrid, Biblioteca Nacional, E.R.8, fol. 323r

loved Bride. In this light, the marriage of the miracle at Cana
was interpreted also as a figure of the Marriage of Christ and
Ecclesia.[33] This interpretation can be seen in Giotto's *Cana*
scene in the Arena Chapel, Padua (fig. 42). There the bride
is isolated in the center of the composition and raised to the
status of Ecclesia by the golden nuptial wreath she wears.[34]

The most important point of the mystical interpretation
for our painting, however, is that the relationship between the
Wedding at Cana and the Marriage of Christ and Ecclesia
leads back to the Baptism of Christ. It was at that moment

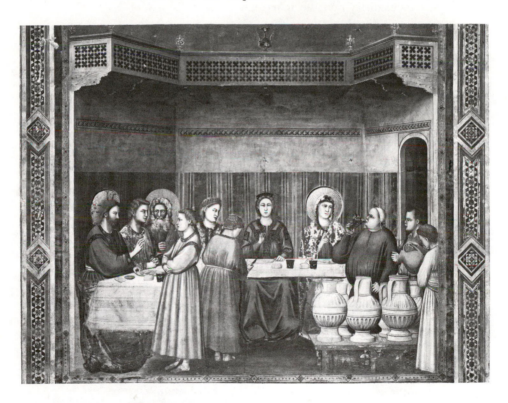

42. Giotto, *Wedding at Cana*,
Padua, Cappella Scrovegni (pho-
to: Alinari)

(along with several other incidents in Christ's life) that the
Marriage of Christ and the Church was said to have been
effected. Humanity was now regenerated by the baptismal

water, filled with spiritual fecundity by the Holy Spirit as it descended, and therefore possessed by Christ. The words of John the Baptist himself define this concept. When John is asked by the multitudes if he is the Saviour, he replies: "He that hath the bride is the bridegroom; but the friend of the bridegroom, which standeth and heareth him, rejoiceth greatly because of the bridegroom's voice" (John 3:29). The Baptist thus identifies himself as the Friend of the Bridegroom who recognizes the Word made flesh, and says he is filled with perfect happiness knowing that salvation is at hand.[35] This is the deepest level on which the marriage of the Bethany and the Baptism are related and why this painting, and in a sense every scene of the Baptism, carries within it a reference to the Royal Wedding.

In the drama of the Marriage of Christ and the Church, the angels play an important role. They too are called the "Friends of the Bridegroom." The casting of angels in this part depends on a long tradition of exegetical writings on the Old Testament Song of Songs first defined by Origen in the late third century. On the basis of St. Paul, and with rabbinical teaching as precedent, Origen takes Solomon's passionate love poem as a grand allegory of Christ's love for humanity. In mode, he sees it as an *Epithalamium* or marriage song in dramatic form, with the following cast of characters: The bridegroom is Christ, representing the Word of God; the Bride is the Church, representing the aggregate of souls; the Daughters of Zion (or Jerusalem) are the Friends of the Bride, representing the souls of believers; and the Friends of the Bridegroom, who before the coming of Christ watched over the Bride, are the Holy Angels.[36] During the course of the Middle Ages, this interpretation was followed and embellished, with the role of the angels as Friends of the Bridegroom becoming a major element in the theory of angelology. Gregory of Nyssa, for example, expands the angels' function to preparers of the holy bridal chamber.[37] St. Bernard of Clairvaux (1091–1153), who wrote more than eighty sermons

on the Canticle, in the 31st tells how one's personal angel ". . . one of the companions of the Bridegroom [is] the faithful messenger . . . between the Bridegroom and the Beloved, offering devotion and giving back gifts. . . ."[38] Among illustrated versions of the Song of Songs itself, one of the most widely distributed in the fifteenth century, a Dutch block book of about 1465, repeatedly represents the members of the same cast (fig. 43).[39]

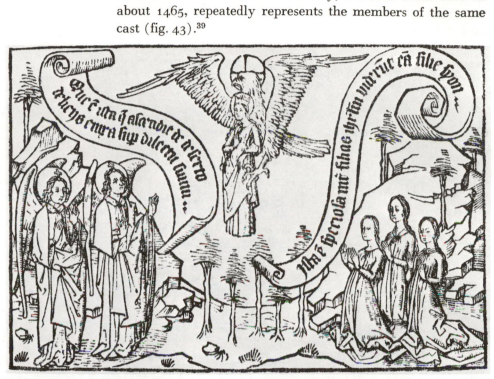

43. *Marriage of Christ and Ecclesia*, woodcut illustration to the *Song of Songs*, ca. 1465 (after Clemen)

But in the early Renaissance, allegories of the *Sponsus-Sponsa* theme had become overt in the context of several different subjects, including the Baptism, the Coronation of the Virgin, and the Annunciation, among others. Three works which refer to the typological interpretation of the Song of Songs by major sculptors predate Piero's painting and, I believe, affected it profoundly. The first is a *Baptism* by Lorenzo Ghiberti (fig. 44), a gilt-bronze relief for the baptismal font

in Siena begun ca. 1426.[40] Here Christ stands in the river, with John at the right in front of a single tree. To the left are nine winged angels in flight, perhaps a reference to the nine choruses in the angelic hierarchy; they venerate and adore in various poses. Below them, standing on the bank of Jordan, are two creatures engaged in conversation. One turns back, in three-quarter view, and the other, gesturing toward the Baptism, faces forward. Their positions thus have much in com-

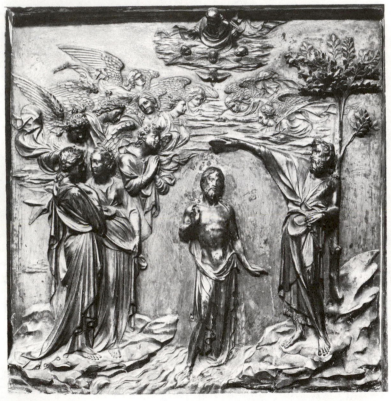

mon with Piero's angels. Ghiberti's figures, however, have no wings and, with elaborate coiffures and rounded breasts, they appear to be females. I suggest that Ghiberti made this unprecedented inclusion of women in his *Baptism* to represent

44. Lorenzo Ghiberti, *Baptism of Christ*, bronze relief, Baptismal Font, Siena, Baptistry (photo: Alinari)

the Daughters of Zion, the Friends of the Bride, assisting at the wedding taking place in the Jordan.[41]

The second work is the marble relief of the *Baptism* (fig. 33) attributed to Donatello in the Cathedral of Arezzo, mentioned above.[42] Here several angels are standing on both sides of the river. The angels on the left peer at the Baptism from behind the trunks of trees, the most forward of which grows on the bank of the river. Again the motif anticipates Piero's arrangement. I suggest that the Arezzo angels represent the Friends of the Bridegroom, who, having completed their work, have withdrawn from the wedding chamber as the marriage is consummated in the waters of Jordan.

The third related work is a curious and little-studied fragmentary miniature stone triptych by Jacopo della Quercia, or his assistants, also dated to 1425–38 (Museo Comunale, Bologna).[43] The central panel shows the Madonna and Child, with Mary seated on a Throne of Wisdom, that is, on Solomon's throne with lions' heads on the arms. This motif representing the Queen holding the King of the World also carries implications of the Royal Wedding.[44] In the pinnacle above are three angels who smile and tilt their heads as if looking at the couple below (fig. 45). While the angel in the center smiles openly, they all seem possessed of great joy and satisfaction. They are closely entwined in a three-part embrace which includes the joining of hands and the placing of a hand on the shoulder.[45] Thus, with their own gestures they refer to the Wedding below, and as Friends of the Bridegroom who have completed their mission they express the fulfillment of their joy. Without such a reference to their role as *amici sponsi* the angels' emotional state and physical bonding would indeed be hard to interpret.

Piero seems to have combined the figural positions and glacial elegance of Ghiberti's female attendants, the "clandestine" isolation of the figures behind a tree (as well as the disposition of the tree itself) in the Arezzo relief, and the connubial gestures of the Quercia triad to express the *Sponsus-*

Sponsa theme with his angelic group. He went beyond his predecessors by including marriage wreaths and crowns, the central one of which contains a further symbol of the theme. Red and white roses, at their simplest level, symbolize Christ and Mary: the red stands for Christ's Passion, and the white stands for Mary's purity, and by extension, Ecclesia's.[46] Here the flowers, by being intertwined, literally laced together, become an image of marital union. The angelic group as a whole goes yet another step beyond its prototypes in its value as a

double allusion. For, in the context of Baptism with reference to the Epiphany, the angels' gestures and headgear evoke both the Mystic Marriage of Christ and the marriage of the Miracle of Cana.

 With this understanding of the multiple role played by the angels, we find that not only do they complete the visuali-

45. Jacopo della Quercia and School, *Three Angels*, detail, miniature stone tabernacle, Bologna, Museo Comunale (photo: Soprintendenza per i Beni Culturali, Bologna)

zation of the triple manifestation celebrated on January 6, but, together with the rest of the composition, they give visible form to the complex theological unity of the day. This unity is proclaimed in the liturgy, in the ancient Benedictus Antiphon sung at lauds on the Feast of Epiphany, *Hodie caelesti Sponso iuncta est Ecclesia*: "This day the Church is joined to her heavenly Spouse, for Christ has cleansed away her crimes in the Jordan; with gifts the Magi hasten to the royal nuptials and the guests are gladdened with wine made from water, alleluia."[47] The worshiper at this altarpiece may have heard these words each Epiphany season of his life. But never before Piero's painting had he experienced the theological unity of their meaning in the brilliant light of dawn on powerful sacred figures through the language of visual structure.

NOTES

1. "And the third day, there was a marriage in Cana of Galilee: and the mother of Jesus was there. And Jesus also was invited, and his disciples, to the marriage. And the wine failing, the mother of Jesus saith to him: They have no wine. And Jesus saith to her: Woman, what is that to me and to thee? My hour is not yet come. His mother saith to the waiters: Whatsoever he shall say to you, do ye. Now there were set there six waterpots of stone, according to the manner of the purifying of the Jews, containing two or three measures apiece. Jesus saith to them: Fill the waterpots with water. And they filled them up to the brim. And Jesus saith to them: Draw out now, and carry to the chief steward of the feast. And they carried it. And when the chief steward had tasted the water made wine, and knew not whence it was, but the waiters knew who had drawn the water; the chief steward calleth the bridegroom, and saith to him: Every man at first setteth forth good wine, and when men have well drunk, then that which is worse. But thou hast kept the good wine until now. This beginning of miracles did Jesus in Cana of Galilee; and manifested his glory, and his disciples believed on him." Cf. E. Mâle, *The Gothic Image; Religious Art in France in the Thirteenth Century* (1958) p. 179; L. Réau, *Iconographie de l'art chrétien*, vol. 2, pt. 2, pp. 362–66; Schiller, *Iconography*, vol. 1, pp. 162–63; W. Kuhn, "Die Ikonographie der Hochzeit zu Kana von den Anfängen bis zum XIV. Jahrhundert;" W. H. Sterling, Jr., "The Wedding at Cana in Western Art of the Fourteenth, Fifteenth, and Sixteenth Centuries."

2. K. Holl, "Der Ursprung des Epiphanien festes," *Sitzungsberichte der Akademie der Wissenschaften zu Berlin* (1917): 402–38; P. Th. Camelot, "La triple Épiphanie de la Gloire du Fils de Dieu," *La Vie Spirituelle* 92 (1955): 5–15; Jungman, *Early Liturgy*, pp. 149–50; F. G. Holweck, *Calendarium Liturgicum Festorum Dei et Dei Matris Mariae* (Philadelphia, 1925), p. 7.

3. Cited in Mâle, *Gothic Image*, p. 181.

4. Tribus miraculis ornatum diem sanctum colimus;
hodie stella Magos duxit ad praesepium:
hodie vinum ex aqua factum est ad nuptias:
hodie in Iordane a Ioanne Christus baptizari voluit,
ut salvaret nos, alleluia.
See the fifth-century hymn "Crudelis Herodes" by the Roman Sedulius, also sung at second vespers and at matins on Epiphany: "The Magi went on their way, following the lead of the star they had seen. By its light they go in search of the Light. . . . The lamb from heaven touched the Jordan's cleansing waters and, washing us, took away sins that were not His. A new kind of miracle: The water-jars redden, for the water, bidden to come out as wine, changed its nature." See below, n. 8.

5. Biblioteca Capitolare, 86, fols. 26v, 27r; R. Deshman, "Otto III and the Warmund Sacramentary," *Zeitschrift für Kunstgeschichte* 34 (1971): 1–20.

6. Missal of Odalricus, Landesbibliothek, Fulda, A.a.35, fol. 6ov, first half of the twelfth century; H. Swarzenski, *Berthold Missal* (New York, 1943), pp. 19, 71, 105, 117. German Breviary, Stadtsbibliothek, Frankfort, IV.3, fol. 108v, late thirteenth–early fourteenth century; G. Swarzenski, *Die illuminierten Handschriften und Einzelminiaturen des Mittelalters und der Renaissance in Frankfurter Besitz* (Frankfurt a.M., 1929), pl. 31(a). Other examples found in an antiphonary, Breslau, Staats-u.-Universität Bibliothek, I F 401, fol. 32r, late thirteenth century; E. Kloss, *Schlesische Buchmalerei des Mittelalters* (Berlin, 1942), fig. 30, p. 31; in a sacramentary, Biblioteca Capitolare, Udine, 76, V, fol. 19v, eleventh century; E. Zimmermann, *Fulda Buchmalerei in Karolingischer und Ottonischer Zeit* (Vienna, 1910), pp. 17, 20, fig. 12. There are other examples in which the Baptism is joined with the Marriage scene, or with the Magi scene in two-part compositions; see, e.g., the Limoges Missal, Paris, Bibliothèque Nationale, lat. 9438, fol. 24r, eleventh–twelfth century, Baptism and Cana combined in a symbolic image; reproduced in Schiller, *Iconography*, vol. 1, fig. 372.

7. M. Jarosławiecka-Gąsiorowska, "Les manuscripts à peintures du Musée des Princes Czartoryski à Cracovie," *Bulletin de la Société Française de reproduction de manuscrits à peinture* 18 (1935): 30–35, Ms. 3464, fols. 1r, 24v, 37r, pl. 7; cited in Sterling, "The Wedding," vol. 2, pp. 277ff. See also a Bohemian manuscript dated 1409, the Hasenburg Missal in Vienna, Nationalbibliothek, where the three

scenes appear on one page illuminating the Epiphany Feast, and are connected by scrollwork; K. M. Swoboda, *Gotik in Böhmen* (Munich, 1969), pl. 18; this example was kindly brought to my attention by Mrs. Edith Kirsch.

8. Professor Phillip Berk suggested to me that the miracle is in fact represented: in the river, where the robes of the Magi reflected in the water change it to the colors of wine. (Cf. below, chap. 6, n. 11.)

9. Dated ca. 1440 by H. W. Janson, *The Sculpture of Donatello*, p. 94, and attributed to a retardataire Donatello assistant. J. Pope-Hennessy, "Some Donatello Problems," in *Studies in the History of Art Dedicated to William E. Suida on His Eightieth Birthday* (London, 1959), pp. 47–65, gives the relief to Donatello himself and dates it 1410–15. The surface seems to me too dry and lifeless to be by Donatello but this condition may be due to its position near the floor, where it was surely splashed with bleach and other cleaning agents over the centuries. In any case, the first decade of the fifteenth century is much too early for the atmospheric panorama, which would have been a progressive invention even in the 1440s. Its design is surely due to Donatello. Pope-Hennessy observed the "clandestine" quality of the angels' position, and M. Davies, *The Earlier Italian Schools*, p. 427, pointed out the relief's "connection" with Piero's *Baptism*.

10. See illustrations in this study and other examples too numerous to document. Tolnay, "Conceptions," p. 214, observed that Piero's angels do not hold robes and are not kneeling. Gilbert's generalization that three was the usual number of angels at this period (*Change*, p. 33 and notes) is not borne out by fact.

11. Tolnay, "Conceptions," p. 214. The fundamental study of the Graces in the Renaissance is in E. Wind, *Pagan Mysteries in the Renaissance* (1st ed., 1958), New York, 1968, pp. 26–52. Concerning the statue in Siena, see G. B. De Rossi and G. Gatti, "Miscellanea di notizie bibliografiche e critiche per la topografia e la storia dei monumenti di Rome," *Bullettino della Commissione Archeologica comunale di Roma* 14, no. 8 (1886): 345–47; the statue was given by a Colonna cardinal to a member of the Piccolomini family in Siena, either ca. 1458–63 or ca. 1503. See below, chap. 7, n. 15.

12. The urn, said to come from the Aretine catacombs, is atop the "Deposito di S. Satiro," dated 1340, which contains the bones of the first bishop of Arezzo and other local martyrs. They are located in the Chapel of Ciuccio Tarlati, the urn having been placed there in 1810, according to an inscription below it; A. del Vita, *Il Duomo d'Arezzo* (Milan, 1914), p. 21, fig. 9. The *Magdalen* is reproduced in De Vecchi, *L'Opera completa*, pl. 53. Philosopher sarcophagi are discussed in N. Himmelmann, *Typologishe Untersuchungen an Römischen Sarkophagreliefs des 3. und 4. Jahrhunderts* . . . (Mainz, 1973), pp. 1–13.

13. G. de Francovich, *Benedetto Antelami* (Milan-Florence, 1952), vol. 1, pp. 167ff.

14. Cf. *Victory* of Paionios (R. Carpenter, *Greek Sculpture*, [Chicago,

1962], pl. 24), and Hellenistic examples (*Catalogue raisonné des figurines et reliefs en terre-cuite, grecs et romains, Myrina* (Musée du Louvre, Paris, 1963), vol. 2, pt. 2, pls. 12–14, 80–89). Vermeule, *European Art*, pp. 39–42, is incorrect when he says the angel is dressed "like some youthful charioteer."

15. Made by Pausylypos in Thessalonike, mid-fourth century, found at Augst, Switzerland (*Age of Spirituality, Exhibition, The Metropolitan Museum of Art, Nov. 1977–Feb. 1978*, ed. K. Weitzmann [Princeton, 1979], pp. 230–37, esp. 231ff, no. 208, ill. p. 233); same subject, fresco, Pompeii (H. H. Swindler, *Ancient Painting* [New Haven, 1927], fig. 456); same subject, Roman sarcophagus, Fitzwilliams Museum, Cambridge (*A Catalogue of Greek and Roman Sculpture in the Fitzwilliams Museum, Cambridge*, ed. L. Budde and R. Micholls [Cambridge, 1964], no. 162, pl. 56).

16. Cf. Longhi, *Piero*, p. 17; see Arezzo fresco cycle, *Death of Adam*, left end: one of the children of Adam, equally androgynous, wears the same garb; reproduced in De Vecchi, *L'Opera completa*, pl. 19.

17. L. Reekmans, "La *dextrarum iunctio* dans l'iconographie romaine et paléochrétienne," *Bulletin de l'Institut d'Histoire Belge* 31 (1958): 23–95; R. Brilliant, *Gesture and Rank in Roman Art*, Memoirs of the Connecticut Academy of Arts and Sciences, 14 (New Haven, 1963), pp. 19ff. Superiority of one being over another is expressed with the wrist-grasping motif throughout the ages; e.g., in ancient Egypt, where the deceased is led through the underworld by a deity in this manner; in classical Greece, where a mortal is led by a god, such as Eurydice brought to Orpheus by Hermes (F. M. Schoeller, "Darstellungen des Orpheus in der Antike," Ph.D. diss., Freiburg, 1969, pl. 13); in the Middle Ages, for example, Adam is freed from Hell by Christ (see below, n. 23), or a saved soul received in heaven with this gesture; e.g., *Cardinal Montefiore Received by St. Martin*, fresco, Simone Martini, Lower Church, San Francesco, Assisi; A. de Rinaldis, *Simone Martini* (Rome, n.d. [post-1934]), pl. 61. See also Ghiberti's relief of the *Meeting of Solomon and Sheba*, East Doors, Baptistry, Florence (Krautheimer and Krautheimer-Hess, *Ghiberti*, pl. 117). See below, n. 34.

18. *Hasti Afunei Sarcophagus*, Palermo, Museo Archeologico; D. Valeriani, *Etrusco Museo Chiusino* (Fiesole, 1838), pt. 1, pp. 16ff., found in the nineteenth century. The type continued into Roman times, e.g., Uffizi Sarcophagus no. 82, where both members of the couple are elderly and are supported by spirit figures (E. Kantorowicz, "Marriage Belts and Rings at Dumbarton Oaks," *Dumbarton Oaks Papers* 14 [1960]: n. 10 and fig. 4).

19. See Piero's *Meeting of Solomon and Sheba* in the Arezzo fresco cycle (De Vecchi, *L'Opera completa*, pl. 26) for a representation with this meaning.

20. Brilliant, *Gesture*, pp. 34–35, 79, 92, and 137, fig. 3.82.

21. G. Bovini, "Le Scene della 'dextrarum iunctio' nell'arte cristiano,"

Bullettino della Commissione Archeologica Comunale di Roma 72
(1946–48): 103–18. I. Schuster, *The Sacramentary (Liber Sacramen-
torum)*, p. 193; also G. E. Howard, *A History of Matrimonial Institu-
tions* (Chicago, 1904), vol. 1, pp. 268–69, and R. Schumacher-Wolf-
garten, " 'Dextrarum Iunctio' bei Giotto," *Pietas: Festschrift für
Bernhard Kötting*, ed. E. Dassmann and K. S. Frank, *Jahrbuch für
Antike und Christentum Ergänzungsband*, 8 (Münster, 1980), pp.
585–93. Cf. P. H. Schabacker, "De Matrimonio ad Morganaticam
Contracto: Jan van Eyck's 'Arnolfini' Portrait Reconsidered," *The Art
Quarterly* 35 (1972): 375–98, fig. 2, for a fifteenth-century repre-
sentation of the *Fides manualis* in a marriage painting by the Aachen-
er Schranktüren Master.

22. A prominent discussion of right and left hands, both representing
good elements, centered around the line in the Song of Songs, "His
left hand is under my head, and his right hand shall embrace me,"
(2:6 and 8:3). St. Irenaeus, late second century, says the two hands
of God are referred to here, representing the Word and the Holy Spirit
(*The Demonstration of the Apostolic Preaching*, trans. from Armen-
ian, ed. J. A. Robinson [London, 1920], pp. 50–51.) Origen, in his
second homily on the Canticle, relates the line to the proverb of
Solomon, 'Length of days is in her [wisdom's] right hand; and in
her left hand riches and glory,' (3:16); Origène, *Homélies sur le
cantique des cantiques*, p. 95; San Bernardino of Siena took up the
theme in one of his Italian sermons: "the right [hand] of God is love
and the left is awe [*timore*]"; *Le Prediche Volgari, Campo di Siena,
1427*, I Classici Cristiani, no. 55, (Siena, 1935), p. 503.

23. Scenes of the Descent into Limbo most frequently show Christ using
his right hand to grasp Adam's left. But there are also many left-to-
left examples: French polyptych, Pierpont Morgan Library, New
York (H. Bouchot, *L'Exposition des primitifs Français, La Peinture
en France sous les Valois* [Commemorative Publication] [Paris,
1904], pl. 17); Raphael, pen study, "Christ in Limbo," Florence,
Uffizi, no. 1475r, and the bronze tondo made after this design (repro-
duced by M. Hirst, in "The Chigi Chapel in S. Maria della Pace,"
Journal of the Warburg and Courtauld Institutes 24 [1961], pls. 31b
and c); Alessandro Allori, *Christ in Limbo*, 1584, Florence, S. Marco
(reproduced by M. B. Hall, *Renovation and Counter-Reformation . . .*
[Oxford, 1979], pl. 96: Christ holds Eve's left hand with his left). The
mosaic of *Peter Raising Tabitha*, Cappella Palatina, Palermo, shows
another left-handed handclasp with good connotations (Demus, *The
Mosaics*, fig. 42b). The same is true of *Bartolomeo Aragazzi Bidding
Farewell to his Family*, Aragazzi Tomb, Michelozzo, 1438, Monte-
pulciano, Duomo; to the right, Bartolomeo clasps left hands with a
seminude youth (J. Pope-Hennessy, *Italian Renaissance Sculpture*
[London, 1958], pl. 40). Luca Signorelli (Piero's student) made a
variation on the theme in his tondo, the *Visit of Elizabeth, Zachariah
and Infant St. John to Mary, Joseph and Infant Jesus*, Staatliche

Museen, Preussischer Kulturbesitz, Berlin (*Catalogue of Paintings, 13th–18th Century*, 2d ed., trans. L. B. Parshall [Berlin-Dahlem, 1978], pp. 410–11, no. 79B.). Held in the arms of their fathers, the Infant St. John and the Christ Child act out their future meeting at the Jordan: John inverts a small bowl over Christ's head; simultaneously the children grasp left hands. On the right Mary and Elizabeth join hands in greeting with a true *dextrarum iunctio* (cf. M. A. Lavin, "Giovannini Battisti" [1955], pp. 97–98).

24. W. Milliken, "The Guelf Treasure," *Bulletin of the Cleveland Art Museum* 17 (1930): 147ff., 176ff. Left-handed motive observed by Kuhn, "Die Ikonographie," pp. 81–82, nos. 529, 530. See the fourteenth-century Italian antiphonary, mentioned above, n. 7, where on fol. 24v, the Cana scene seems to have the same left-handed gesture. Professor James Lynch has brought to my attention a sixteenth-century example of an actual marriage portrait with a left-handed handclasp: *Wedding Portrait of Mary Tudor and Charles Brandon, Duke of Suffolk*, dated 1515, anonymous English painter, owned by the Earl of Yarborough; reproduced in N. Williams, *Henry VIII and His Court* (London, 1971), p. 41.

25. See Matt. 22:29ff., where, when asked whose wife the woman who had married seven brothers would be at the resurrection, Christ replied: "You err, not knowing the Scriptures, nor the power of God. For in the resurrection they shall neither marry nor be married; but shall be as the angels of God in heaven." This subject is discussed by R. H. West, "Milton's Angelological Heresies," *Journal of the History of Ideas* 14 (1953): 116–23, esp. pp. 121ff. However, according to Marsilio Ficino's definition of angels in his magic realm of number forms, they do "combine" with one another; cf. G. Hersey, *Pythagorean Palaces, Magic and Architecture in the Italian Renaissance* (Ithaca, 1976), pp. 90, 91, 194. See the one-act play by F. Ryerson and C. Clements called *Angels Don't Marry* (New York, 1938).

26. Denys l'Aréopagite, *La Hiérarchie Céleste*, trans. M. de Gandillac, Sources Chrétiennes, no. 58, (Paris, 1958), pp. 120ff. G. Davidson, *A Dictionary of Angels* (New York, 1967), pp. 336–37. Elaborate jeweled crowns are seen, for example, on the musical angels in the *Ghent Altarpiece*; garlands of red and white roses are worn by angels in Fra Filippo Lippi's *Coronation of the Virgin*, among other places. See below, n. 30, for other angels with myrtle wreaths. (This plant is distinguished as myrtle, rather than laurel, by its thin, pointed leaves, equally pinnate in arrangement, that is in continuous pairs on each side of the stalk; laurel is alternately pinnate.)

It should be pointed out that crowns in Baptisms have a long history. In medieval scenes, they are delivered to Christ by the hand of God, by apostles, or by angels, referring to the descent of divine power, universal kingship, and Christ's victory over death. Cf. Schiller, *Iconography*, vol. 1, pp. 134–35, 138.

27. Tertullian, in the second century, was already complaining about this

holdover from pagan custom (*Liber de Corona*, Migne, *PL*, vol. 11, cols. 93–122). Nevertheless, it continued in both the East and West as late as the ninth century; see Schuster, *The Sacramentary*, p. 193, quoting a letter to the Bulgarians from Nicolas I (r. 858–67) which refers to the entrance of the couple in the church "coronas in capite gestant. . . ." Cf. K. Baus, *Der Kranz in Antike und Christentum (Theophaneia, II)* (Bonn, 1940), pp. 93ff. B. Kötting, "Dextrarum iunctio," *Reallexikon für Antike und Christentum*, vol. 3, (Stuttgart, 1957), pp. 881–88, discusses the handclasp with the wreath. The Old Testament citation for the wearing of crowns, "Quasi sponsum decoratum corona . . ." (Isa. 61:10) is part of the third lesson of the first nocturn at Epiphany. The Byzantine painter's guide by the Monk of Fourna describes the bridal couple at the Wedding at Cana: ". . . In the midst of them is the bridegroom with grey hair and a rounded beard, and the bride near him; they wear crowns of flowers on their heads . . ." (p. 33, no. 90, p. 217 [175]).

28. Information from Anthony Molho and Jules Kirshner, who are engaged in a study of early fifteenth-century Florentine dowry regulations and practices.

29. E.g., "And I put a jewel on thy forehead, and earrings in thine ears and a beautiful crown on thine head," (marriage of God and Israel, Ezek. 16:12). As is well known, the bridal gown today is still frequently encrusted with pearls. See below, n. 46.

30. See M. Levi D'Ancona, *The Garden of the Renaissance*, p. 237, no. 108, items 1, 3, and ills. Cf. *Funk and Wagnalls Standard Dictionary of Folklore, Mythology, and Legend*, vol. 2, p. 776, for the medieval German belief that wearing myrtle wreaths at the wedding prevented pregnancy. Piero's myrtle-wreathed angel has precedents in a long series of Tuscan angels of the Annunciation who wear wreaths of myrtle, sometimes also presenting the Virgin with boughs of the same plant. The first and most outstanding is Gabriel in the *Annunciation* by Simone Martini and Lippo Memmi, 1333, Uffizi; this innovation was followed and variations were made upon it throughout the fourteenth and fifteenth centuries. See G. Prampolini, *L'Annunciazione nei pittori primitivi italiani* (Milan, 1939), figs. 7, 9, 36, 37, 48, 119, 120, 122, and pls. 55, 113, 114, and 126. As mentioned below, chap. 8, n. 4, the Annunciation was also recognized as the moment of the Mystic Marriage.

31. Sterling, "The Wedding," vol. 1, pp. 17–21, gives a summation of the arguments of Gaudentius, Cyril, Augustine, Bede, and Aquinas.

32. E. B. Garrison, *Studies in the History of Mediaeval Italian Painting* (Florence, 1954), vol. 1, part 3, pp. 110–11. Cf. Schuster, *The Sacramentary*, pp. 193–94, for the wedding ceremony in which the kiss comes after the reading of the Cana passage and the couple bring their lips to the blessed cup. For a fifteenth-century representation of the *Feast of Cana* that emphasizes marriage, see the altarpiece by the Master of the Retable of the Reyes Catolicos, National Gallery of Art,

Washington, D.C. Behind the feast table, there is a view through a doorway into a bedchamber with a large-scale nuptial bed covered in red velvet. This painting, in fact, is thought to be a marriage painting celebrating the union of Ferdinand and Isabella's children to those of the Emperor Maximilian, 1496–97. See J. Walker, *National Gallery of Art* (Washington, D.C., New York, 1967), p. 143, ill. 150.

33. Hildebert du Mans, "Nuptiae significant copulationem Christi et Ecclesiae in quibus aqua mutatur in vinum quia Vetus Lex conversa est in Evangelium."; quoted in Réau, *Iconographie*, pp. 362–66. In the bull of Eugenius IV, "Exultate Deo" of 1439, where the seven sacraments are listed in full for the first time, marriage is the seventh, and it is said that "septimum est sacramentum matrimonii, quod est signum conjunctionis Christi et ecclesiae secundum apostolum . . ."; quoted in A. Harnack, *History of Dogma*, trans. W. M'Gilchrist (London, 1899), vol. 6, p. 274. And to end the circle, the Gospel reading in the Marriage Mass is the passage from John 2:1–11 on the Marriage at Cana.

34. L. M. Bongiorno, "The Theme of the Old and the New Law in the Arena Chapel," *Art Bulletin* 50 (1968): 11–20, esp. 15–16; Sterling, "The Wedding," vol. 1, pp. 31–36. See above, n. 27, for the Byzantine formula for the Cana scene. R. H. Rough, "Enrico Scrovegni, the *Cavalieri Gaudenti*, and the Arena Chapel in Padua," *Art Bulletin* 62 (1980): 24–35, esp. 33–34, disagrees with this point.
 I would like to point out the relevance of these concepts to an extraordinary detail in the great fresco *Crucifixion* by Cimabue in the left transept of the Upper Church of San Francesco in Assisi. To the right of the body of the Crucified, John the Evangelist and the Virgin Mary are posed in the *dextrarum iunctio* (Borsook, *The Mural Painters of Tuscany* [London, 1960], pls. 4 and 5). On the first level, the gesture is consolatory in the manner of classical grave monuments (see above, n. 17). It also may carry symbolic reference to marital union: John the Evangelist, according to medieval tradition, was the actual bridegroom at the Wedding at Cana, wedded to Mary Magdalen, whom he left while still a virgin to follow Christ (Sterling, "The Wedding," vol. 1, pp. 131–65). In the "Major Life of St. Francis," by St. Bonaventure, John is called "another friend of Christ the Bridegroom" (*St. Francis of Assisi, Writings and Early Biographies*, trans. R. Brown et al., ed. M. A. Habig [Chicago, 1973], p. 632; see following text and notes), and after Christ's death, John is commended to the Virgin Mary as her new son (J. de Voragine, *The Golden Legend*, trans. G. Ryan and H. Ripperger [New York, 1969], [August 15], p. 450). The hand fasting gesture may thus refer to the new relationship between John and Mary that began when Christ died.

35. "Sacrosanctum conjugium, quod inter Christum et Ecclesiam fuerat . . . promissum . . . hodie est consummatum, confirmatum, et declaratum." Innocent III (d. 1216), Sermo VIII, "In Epiphania Domini," Migne,

PL, vol. 217, col. 483. Cf. *Meditations on the Life of Christ*, p. 114 (chap. 17, On the Baptism): "To effect our salvation He instituted the sacrament of baptism to wash away our sins. He wedded to Himself the Universal Church and all faithful souls individually. In faith in baptism we are wedded to the Lord Jesus Christ, as the prophet said in His person, "I shall wed you to me in faith": (Hos. 2:20). Cf. also Kantorowicz, "Marriage Belts,".p. 13, n. 65. Ephraim the Syrian was one of the earliest writers to develop this theme: "The Bride was espoused but knew not—who was the Bridegroom on whom she gazed:—the guests were assembled, the desert was filled,—and our Lord was hidden among them. Then the Bridegroom revealed Himself,—and to John at the voice He drew near:—and the Forerunner was moved and said to Him—"This is the Bridegroom Whom I proclaimed. . . . I have prepared the way as I was sent—I have betrothed the Bride as I was commanded.—May Thy Epiphany be spread over the world—now that Thou art come, and let me not baptize Thee! . . . The Bride thou betrothest to Me awaits Me,—that I should go down, be baptized, and sanctify her.—Friend of the Bridegroom withhold Me not—from the washing that awaits Me." (*Nicene and Post-Nicene Fathers*, no. 14, pp. 284ff.).

The concept of the Friend of the Bridegroom stems from an important personage in the Hebrew marriage ceremony who is responsible for presenting the spotless bride to the husband (*Dictionary of Bible*, 11th ed., vol. 1, p. 327). The phrase is often used metaphorically in relation to Jehovah in the Old Testament. Cf. Isa. 54:5, 61:10, Hos. 2:20; Christ uses it (Matt. 7:16, 9:14, and 12:23) as does St. Paul (2 Cor. 11:2) (cf. *Dictionary of Bible*, 9th ed., vol. 2, p. 680).

36. The Holy Angels share this role with St. John, and with the Apostles and Patriarchs; see Origène, *Homélies*, pp. 61ff.; Origen, *The Song of Songs, Commentary and Homilies*, trans. and annot. R. P. Lawson, Ancient Christian Writers, no. 26, (Westminster, Md., 1957), p. 21; J. Daniélou, *The Angels and Their Mission*, trans. D. Heimann (Westminster, Md., 1957), pp. 51ff.

37. J. Daniélou, *From Glory to Glory, Texts from Gregory of Nyssa's Mystical Writings*, trans. and ed. H. Musurillo (New York, 1961), p. 205.

38. Sermon 31, Migne, *PL*, vol. 183, cols. 942–43. These ideas are given graphic form in a late-fourteenth-century manuscript of Bernard's Canticle sermons; Codex 970, Biblioteca Casanatense, Rome (*Mostra Storica Nazionale della Miniatura, Palazzo Venezia a Roma* [Florence, 1953], p. 262, no. 414, pl. 60b).

39. O. Clemen, *Canticum Canticorum*, Holztafeldruck von c. 1465, Zwickauer Facsimiledrucke, no. 4, (Zwickau S, 1910), ill. 10b.

40. Krautheimer and Krautheimer-Hess, *Ghiberti*, pp. 150–55.

41. This innovation was understood and copied three times by Giovanni di Paolo and his shop: (1) Norton Simon Foundation (M. Meiss, "A New Panel by Giovanni di Paolo from His Altarpiece of the Baptist,"

The Burlington Magazine 116 [1974]: 72–77, fig. 1); J. Pope-Hennessy, *Giovanni di Paolo* (London, 1937), p. 88; (2) National Gallery, London, no. 5451 (ibid., fig. 4); (3) Ashmolean Museum, University of Oxford, A 333. See my article, "The Joy of the Bride-groom's Friend, Smiling Faces in Fra Filippo, Raphael and Leonardo," *Art the Ape of Nature: Studies in Honor of H. W. Janson*, ed. M. Barach, L. F. Sandler, and P. Egan (New York, 1981), pp. 193–210.

42. See above, n. 9.

43. C. del Bravo, *Scultura senese del quattrocento* (Florence, 1970), p. 55; C. Seymour, Jr., *Jacopo della Quercia, Sculptor* (New Haven, 1973), p. 74, figs. 111, 113. It is possible that the motif of embracing angels depends on earlier works by Donatello; cf. the infant angels on the cornice of the Cavalcanti Annunciation Tabernacle, Sta. Croce, Florence, and the adult angels on the left of the relief of *The Delivery of the Keys*, Victoria and Albert Museum, London; Janson, *Donatello*, vol. 1, figs. 154–56, vol. 2, pp. 103–08; vol. 1, fig. 130, vol. 2, pp. 92–95.

44. I. H. Forsyth, *The Throne of Wisdom* (Princeton, 1972), pp. 22–30.

45. One may observe further connubial references here: one angel touches the area of the womb, another touches the genitals, both allusions to Christ's Incarnation as well as, generally, procreation and marital consummation.

46. For the vast symbolism of the rose, cf. Levy D'Ancona, *The Garden*, no. 141, pp. 330ff.; G. Ferguson, *Signs and Symbols in Christian Art* (New York, 1954), p. 47. The pearls in the diadem of the angel on the left also have direct christological symbolism. According to many legends they represent Christ himself (cf. Marinesco, "Echos," pp. 200ff., and refs. in M. Meiss, *The Painter's Choice* [New York, 1976], p. 138, n. 5). Also Ferguson, *Signs*, p. 57. Myrtle, too, aside from its marriage symbolism has Christian meaning as the flower of the Virgin according to Adam of St. Victor; see Levy D'Ancona, *The Garden*, p. 237, no. 108, item 5. In a sense, reading from left to right, the angels' crowns represent Christ, Christ and the Virgin, and the Virgin.

47. Hodie caelesti Sponso iuncta est Ecclesia,
 quoniam in Iordane lavit Christus eius crimina:
 currunt cum muneribus Magi ad regales nuptias,
 et ex aqua facto vino laetantur convivae, alleluia.

H. Frank, "'Hodie caelesti Sponso iuncta est Ecclesia.' Ein Beitrag zur Geschichte und Idee des Epiphaniefestes," *Vom christlichen Mysterium* (Düsseldorf, 1951), pp. 192–218. A. Baumstark, "Die Hodie-Antiphonen des römischen Breviers und der Kreis ihrer griechischen Parallelen," *Die Kirchenmusic* 10 (1909–10): 153–60.

PART THREE

Interpretation

6

Exegesis and the Visual Image

The liturgical content of Piero's panel associates it with a type of Byzantine icon known as a "feast painting" which, rather than depicting biblical narrative, illustrates the Lectionary of the Church Calendar. A feast painting presents in isolation scenes of the Gospel readings on specific feasts.[1] Insofar as Piero's painting conforms to this definition, it is a kind of westernized feast painting: the center of a devotional altarpiece, it is isolated from narrative and it alludes to all the lections of the Epiphany season: Matthew 2:1–2 (January 6), John 1:29–34 (Octave of January 6), and John 2:1–11 (second Sunday after January 6). As such, it is an astonishing innovation in Renaissance art. But his restructuring of the Baptism goes beyond the circumscriptions of the Western liturgy, by incorporating the motif of the Jordan Miracle, a combination as far as I know not duplicated in the history of art.[2] The effect of conjoining the graphic expression of the liturgy with the typological parallel is to raise the total image to the realm of visual exegesis.

By the end of the Middle Ages, the Fathers of the Church had devised a highly structured method for teaching the basic tenets of Christianity to the faithful. The aims of this catechistical instruction were clear: to show that the texts of the Bible are divinely inspired, that the Old Testament prepared for the New, that Christ is the true Messiah, that man's condition can only be improved by faith, and that beyond all human experience there exists an ultimate realm of unchang-

ing perfection. While varying in technique and terminology from author to author, the method was constant in its structure. Each biblical event has (1) a literal meaning, that is, the event as a historical occurrence; (2) an allegorical, or metaphorical meaning, prefigured by one or more type, figure, or image in the "other" Testament; (3) a moral level of meaning, that is, the event shows man how to improve his conduct on earth; and (4) a final level called anagogical, indicating the prototype of the event in the eschatological realm beyond time.[3] What is important to remember is that this method of exegetical analysis and teaching was at the time of our painting still part of the fabric of everyday life.

LITERAL AND ALLEGORICAL MEANING

We have already noted two levels of interpretation in the *Baptism*. In the first, the primary object of the image is the Baptism of Christ; this is the literal level. The dry river bed, evoking references to the Old Testament Jordan miracles which prove God's presence, shows Christ as the New Covenant replacing the Old; this is the allegorical level. Other details in the painting, moreover, expand this second level. To either side of Christ, on the floor of the valley, are many tree stumps of various sizes. The severed trunk has a long history in scenes of John the Baptist's life as a reference to his words admonishing the multitudes: "And now also the axe is laid unto the root of the trees; every tree therefore which bringeth not forth good fruit is hewn down" (Luke 3:9). Although the axe usually shown at the root of the stump is lacking, such a reference is also implicit here.[4] But at the same time these symbols express an equally relevant allusion to a psalmodic type for Baptism. Psalm 28 (29:5), read in its entirety at the first nocturn of Epiphany, contains the line: "The voice of the Lord shall break the cedars: yea, the Lord shall break the

cedars of Lebanon." The relationship to Baptism is explained by St. Jerome in a homily for Epiphany, where he says the breaking of the cedars is an allegory for the fall of sinners as Christ is baptized.[5]

MORAL MEANING

The beginning of the road to salvation, namely, that aspect of Christ's Baptism to which the worshiper directs himself personally, forms the third, or moral, level of meaning of the painting. This level is visualized by the figure of a single catechumen, a lean, muscular youth disrobing on the bank of the river some distance behind St. John. The presence of the figure in this work depends directly on a series of early fifteenth-century Italian works depicting the Baptism, which in turn reflect an importation from Byzantine art. Nude and seminude youths were introduced into Byzantine manuscript illuminations in the post-Iconoclastic period in narrative scenes of both the baptism of the multitudes and Christ's Baptism. They were shown in the process of undressing, pulling clothing over their heads preparatory to being baptized, or already being submerged in the baptismal waters, sometimes even swimming about (fig. 9).[6] The first appearance of such a figure in Italy seems to be in a fresco combining two subjects, the *Ecce Agnus Dei* and the *Baptism* dating about 1350 in the Baptistry in Parma (fig. 46).[7] Here a small boy in the foreground is one of two people donning white garments. He leans over at the hips while his head and upper back are covered with a loose outer garment.

When the figure was then taken into early Renaissance narrative cycles of John's life, it was used as a vehicle for the new naturalism. Several disrobing neophytes in the *Baptism of the Multitudes*, in the 1416 cycle by the Salimbeni brothers (fig. 47) in the Oratorio of San Giovanni in Urbino, display the artists' pioneering experimentation with human anatomy

and action poses. A range of types prepares for baptism: from the fully clothed, bewreathed child to the right, to the figures tugging and pulling at various garments, to the venerating nude figures in the river, they present a sequence of anecdotal events.[8] This impressive fresco no doubt inspired the next appearance of the neophyte, that in the lost Lateran cycle by

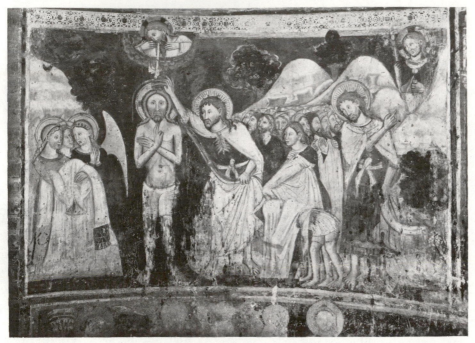

46. *Baptism of Christ, Ecce Agnus Dei,* fresco, Parma, Baptistry (photo: Soprintendenza per i Beni artistici e storici, Parma)

Gentile da Fabriano of ca. 1426. In the Pisanellesque copy (fig. 48), we see that the sequence was reduced to one figure and transported to the scene of Christ's Baptism. But even this single figure tells a story: bending his knees and tugging with both hands, he expresses the difficulty he has in getting off the shirt that has stuck on his chin. The same stage of disrobing is shown in Masolino's fresco (fig. 49) in the Baptistry of Castiglione Olona, now by a figure with his back to the spectator.[9] In this case, again a *Baptism of Christ*, the number of catechumens is increased to four, and the genre value is aug-

mented as well. Dressed in different colors, the figures exhibit different kinds of physical exertion. The man seated in the foreground is having a real tussle with his pale red leggings, and the figure behind him to the left in a yellow robe is actually shivering in the chilly morning air.

47. Jacopo and Lorenzo Salimbeni, *Baptism of the Multitude*, fresco, Urbino, Oratorio di San Giovanni (photo: Anderson)

These then were the prototypes upon which Piero drew for the source of his figure. But in taking over the image, as was the case with all the other previously conceived types he used, he changed it in fundamental ways. Rather than being placed in the foreground or immediately adjacent to Christ, as in earlier compositions by other artists, his catechumen is a considerable distance behind the Baptism proper, isolated in a space of his own. He has entered the shoals of a tiny

pebble beach at the turn of the Jordan. He stands easily with his weight on one leg, bending forward with his head and arms enshrouded in a shirt of pure white. Far from struggling,

48. School of Pisanello, after Gentile da Fabriano, *Baptism of Christ*, drawing, Paris, Musée du Louvre (photo: Musées Nationaux)

he calmly arches over the water in a state of permanent semi-nudity. His static posture is ambiguous, as Clark has already observed, for we cannot say if he is taking off or putting on the white garment.[10] We must add, however, that the ambiguity is purposeful, as both gestures have meaning. Undressing for Baptism represents, according to the church fathers, the stripping off of vice to become clean in the reception into Faith; putting on the white baptismal robe is interpreted as the donning of the Bridal garment of the new man, married to Christ at Baptism.[11] The main point is that by eliminating

all vestiges of genre and anecdote, Piero creates a single representative of mankind, who is moved by Faith and is perpetually prepared to be born into divine life through his own Baptism.[12] Moreover, the figure has liturgical value and once

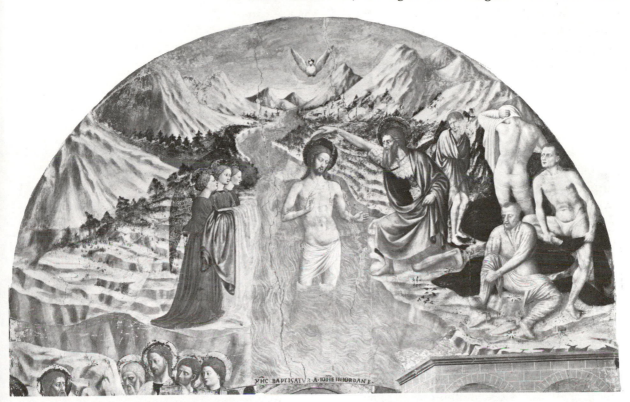

49. Masolino, *Baptism of Christ*, fresco, Castiglione Olona, Baptistry (photo: Anderson)

again it is Firstness. Baptism is the first of the sacraments, without which no man can start on the road to salvation.[13]

ANAGOGICAL MEANING

In order to understand the last exegetical level of interpretation, the anagogical, we must return to our discussion of the paradisiac landscape where trees and plants are depicted

miraculously in bloom on the sixth of January. In its position on the riverbank, the leafy tree to the left of Christ (fig. 16) recalls, first of all, the lines from Psalm 1 that say: "Blessed is the man who hath not walked in the counsel of the ungodly. . . . he shall be like a tree which is planted near the running waters which shall bring forth its fruit in due season and its leaf shall not fall off." The green tree is the symbol of life everlasting offered to the worshiper who delights in the New Law.[14] But as we have seen, this is no anonymous green tree; it is the walnut of the Val di Nocea where Sansepolcro was founded. And its full meaning in the painting lies in this identity.

Throughout history, the walnut was associated with godly nature. *Iuglans Iovis*, the Glands of Jove, it was called in antiquity, and at Greek and Roman weddings, stewed walnuts were served to ensure fertility.[15] Whether or not Piero knew of this ancient custom, he may have intended a play on the word *noce*, Italian for walnut, with the word *nozze*, Italian for wedding, and thereby linked the tree to the matrimonial theme of his subject.[16] In any case, he surely drew on the long and varied association of the walnut with aspects of Christ's nature. St. Ambrose identified the walnut bough with the "priestly gift offered by Christ." "For this is Aaron's bough that blossomed when it was set down. . . ."[17] Other interpretations make the nut a metaphor for Christ's divinity; the sweet kernel a sign of the divine essence of the body; and the woody, hard shell, the wood of the cross.[18] The tree is thus also a reference to the Crucifixion, and Piero has diminished its size to conform to the height of the figure of Christ. The relationship of Crucifixion to Baptism is fundamental: Christ himself equates his Baptism to his bloody sacrifice (Matt. 20:22, Luke 12:50). Through this equation the church fathers saw the Baptism as the beginning of the Passion, and Christ's descent into the waters of Jordan as his descent into the "waters of death," the sorrowful caves of the underworld. The waters are equated with the tomb where sinners are buried,

where Christ enters to lead them to rebirth and eternal exaltation.[19] The walnut tree is not only a compositional counterpoise to the figure of John in the foreground group, its significance completes the action that John's gesture of Baptism initiates.

The arboreal premonition of divine healing is carried forward to the worshiper, literally to the picture plane, by the small inelegant plants depicted on the riverbanks (figs. 50, 51). All these plants had medicinal uses during the Renais-

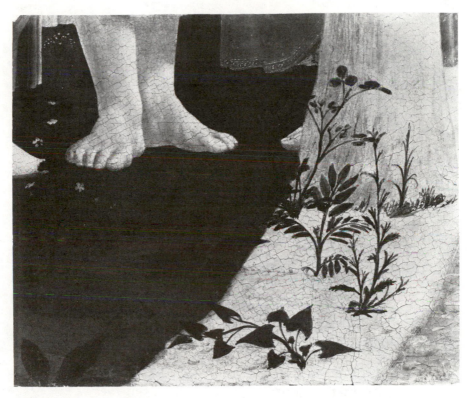

50. Detail of fig. 1, Plants (reproduced by courtesy of the Trustees, The National Gallery, London)

sance. *Ranunculus* (buttercup), found on both sides of the river, once with tiny yellow blossoms near the angels' feet, served for soothing toothaches, curing lunacy, and cleansing the kidneys. *Glycyrrhiza* (licorice, *regolitia* in Italian) seen

on the edge of the left bank, was an emetic and laxative. *Convolvulus* (bindweed), with spade-shaped leaves, was a diuretic. Clover, silhouetted against the tree, was taken for snake and scorpion bites and as a proof against spells and witchcraft. And plantin, growing flat on the ground near John's foot, below the central angel and cut off by the bottom frame line, produces juice for the gums, seeds for constipation, roots for

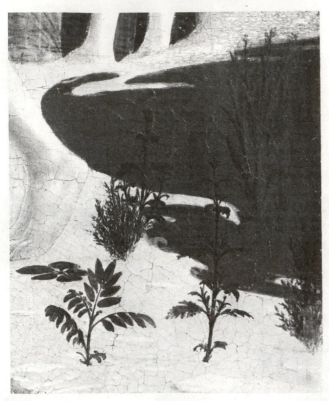

hard swellings, and was used as a coagulant.[20] The last two plants also have direct christological meaning. By its very shape *Trifolium* (clover) is a symbol of the Trinity (one variety bears this name). And plantin is associated with the Passion and Christ's blood because of its ability to staunch bleeding. It is, moreover, known as *Wegerich*, or way bread,

51. Detail of fig. 1, Plants (reproduced by courtesy of the Trustees, The National Gallery, London)

symbolizing "the well-trodden path followed by the multitudes who seek Christ." All these medicinal plants, familiar in the poorest meadows, show the worshiper that in the image on the altar are the means prepared for his own salvation.[21]

At the first nocturn for the Feast of the Epiphany, the following antiphon is sung: "Fluminis impetus laetificat, alleluia, civitatem Dei, alleluia" (There is a stream whose current, alleluia, gladdens the city of God, alleluia). Following the antiphon, Psalm 45 is read. The line "There is a stream whose runlets gladden the city of God, the holy dwelling of the Most High," appears in this psalm. After the psalm, the antiphon is sung again. It seems inevitable that the view of Sansepolcro with the river before it was meant to be seen in relation to these lines, with an allegorical reference to the real Jerusalem and, further, with anagogical reference to the Heavenly Jerusalem, the eternal dwelling of the Most High, the hope of those who are saved.[22]

THE FRAME

The monumental frame (fig. 52) from which Piero's painting was removed in 1859 is today mounted on the right wall of the Capella del Volto Santo, to the left of the High Altar in the Cathedral of Sansepolcro. The paintings on the wings, predella, rondels, and pilasters long ago were recognized as having been painted by another artist, generally thought to be Matteo di Giovanni. An example of Matteo's style may be seen in his *Assumption of the Virgin*, a detail of which is shown in fig. 53.[23] The frame and the *Baptism* have been reassembled in a photomontage (fig. 2), with the pieces that were lost during dismantling suggested in ink. The contrast between the centerpiece and the wings is astonishing. The former has a semicircular top, typical of Renaissance style, while the latter have pointed Gothic arches. Next to Piero's volumetric forms and deep space, the figures of St. Peter and St. Paul look like

wrinkled surfaces of tin, pressed against the picture plane. Placed before flat gold backgrounds, they stand on tilted-up ground lines, their feet overhanging the painted step. Weightless and unreal, these grim figures look almost twice the size of Christ in the *Baptism*. Small wonder most scholars have doubted the two parts of the altarpiece were conceived together.[24]

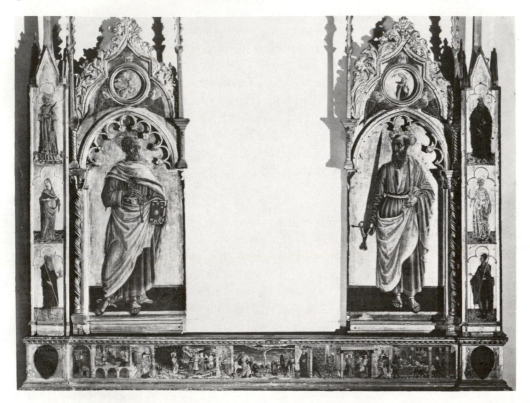

Notwithstanding this mismatched look, the *Baptism* and the frame, in a physical sense, are a unit. The width of the *Baptism* is the nexus joining the measurements of the two pieces and, as will be shown by Mr. Carter in appendix 1, this dimension is a finite number in fifteenth-century terms. The width equals two Florentine *braccia*, a measurement so simple

52. Attributed to Matteo di Giovanni, Frame of the Baptism Altarpiece, Sansepolcro, Cathedral, Cappella di Volto Santo (photo: Alinari)

it could easily be conveyed to the frame-maker to ensure ac-commodation of the centerpiece.[25]

Beyond this reciprocity of dimension, there are several points of correspondence between the frame and the *Baptism* that show the decision to put such stylistically divergent pieces together to be less naïve than one might at first think. There are ample precedents in earlier altarpieces for combining central narrative panels having figures on a smaller scale in

53. Matteo di Giovanni, *God the Father*, detail, *Assumption of the Virgin*, Santa Maria dei Servi (photo: Istituto Centrale del Restauro, Rome)

spatial settings with larger-scale figures shown against gold-grounds in the wings. For example, a polyptych in the Pina-coteca Nazionale in Siena from the first half of the fourteenth century by Andrea Vanni has a central *Crucifixion* flanked by two sets of wings, the first showing Mary, John, and the

Magdalen larger in scale than Christ, and the second set containing prophets who are still larger. The figures in Paolo di Giovanni Fei's *Birth of the Virgin* (fig. 54), 1381 or 1391, are flanked by saints in the wings who are more than twice the size of the narrative figures. In the first quarter of the fifteenth century, Masolino and Masaccio continued this practice; they designed the *Miracle of the Snow*, the centerpiece of one side of the Santa Maria Maggiore Altarpiece, with perspective recession, but in the wings they retained gold-ground

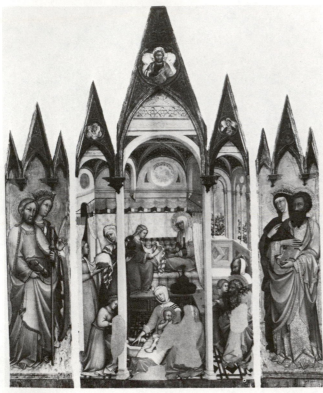

saints on a scale much larger than the figures in the narrative.[26] In each of these cases, the contrast in scale establishes the locale of the central image as in the eschatological realm, elevating the scene beyond simple narrative.

54. Paolo Giovanni Fei, *Birth of the Virgin Altarpiece*, Siena, Pinacoteca Nazionale (photo: Pinacoteca Nazionale, Siena)

The *Baptism Altarpiece* is heir to this scheme. Moreover, upon analysis, we find that the seemingly irrational scale-leap between Piero's figures and the figures in the wings, though emphatic, is only apparent. If in our mind's eye we bring Christ forward, up to the picture plane where he is on the same level as Peter and Paul, we find he is nearly the same size as they. This operation is easily accomplished on the basis of the perspective construction and the three-part composition of Christ's body. Piero's contrast in scale actually depends on Christ's placement behind the picture plane, not on his real size.[27] Piero takes advantage of the effects of the traditional discordant juxtaposition, but, typically, he rationalizes the relationship so that, in fact, the scale of the parts corresponds.

Perhaps even more important are the points of correspondence between the frame and the *Baptism* in terms of thematic content. The allusion to Crucifixion in the main scene is made explicit in the predella, where it is the subject of the center panel (fig. 6). The predella scene is a centralized composition, and the figure of the Crucified is on the same vertical axis as the figure of Christ in the *Baptism* above. The other four predella scenes, showing a consecutive narrative of John's life, are blatantly interrupted in the middle by the Crucifixion, which, in the Gospel narrative, takes place long after John's death. The predella thus establishes the mission of St. John, but also shows that the object of that mission was the salvation of mankind through Christ's sacrifice.

The remaining parts of the frame (fig. 52) carry out the theme of Firstness and institution of the New Law. The large figures of St. Peter and St. Paul, flanking the Baptism, depict the chief apostles to whom Christ's divinity was first made manifest at the Wedding at Cana. They relate directly to the other two miracles of January 6 as well, for Peter was the apostle to the Gentiles, and Paul was the apostle to the Jews. Moreover, Peter was the first pope; Paul was the first preacher. St. Paul holds three scrolls, one of which is clearly marked

"Ad romanos," indicating Paul's first epistle in which he explains the relation between Baptism and Christ's death.[28] Above these figures, in the finial rondels, are Gabriel and Mary at the Annunciation, the beginning of the Incarnation cycle. The lost central rondel, which showed God the Father, would have completed the image of the Trinity, the first appearance of which was at the moment of Baptism. On the side pilasters are six saints arranged in order of hierarchy; left top, St. Steven, first deacon and first male martyr; right top, St. Anthony, founder of the anchorites and first Abbot; left, second tier, St. Mary Magdalen, nonmartyr, nonvirgin, first female saint after Mary; right, second tier, St. Catherine of Alexandria, first queen-virgin-martyr.[29] On the bottom tier, left and right, are SS. Arcano and Egidio, founders of Sansepolcro; Arcano holds the sacred relics of the town. The ensemble is completed by figures, between the predella scenes, of SS. Augustine, Gregory, Jerome, and Ambrose, the main authorities of Christian doctrine.

From these thematic relationships it seems evident that the *Baptism* and the frame were conceived in concert, one carrying forward and reinforcing motives established in the other. They were simply painted by different artists, for reasons we do not know. It is clear, however, that the stylistically awkward union has two striking visual effects important for the meaning of the center piece. Placing the naturalistic *Baptism* between stiff, hieratic figures renders unmistakable the symbolic nature of the narrative scene. And the contrast between the perspective construction in the center and the flat gold backgrounds in the frame serves to emphasize the spatial unity of the landscape vista.

What we see in this vista are not the fragments we have sectioned out in order to follow Piero's thoughts. The regularity of progression into space, the change in the figures' size according to their place in depth, the change in clarity of forms as they adjust to distance, portray a harmonious totality. With his visual structure, Piero has composed a geometric

proposition without numbers, a natural architecture without walls, an unbroken prospect, unified in time and place. This increased order in fifteenth-century pictorial forms is frequently interpreted as a loss of religious seriousness and sign of burgeoning secularism. But for Piero, the mantle of naturalism serves to relate the realm of liturgical archetypes immediately to the contemporary world of man.

In the panel celebrating the first believer in Christ, "he who points the way," Piero has illustrated the liturgy of the day that solemnizes the first recognition of Christ's divinity by the Gentiles, the Epiphany; the first miracle by which Christ manifests his divinity to the apostles, the Bethany; and the first declaration by God to the Jews that the Messiah has come and wed his universal church, the Theophany, in a setting that can only be described as the first Christian landscape to prophesy the sacrifice through which the salvation of mankind will be achieved. The prescribed ritual of public worship, especially the intonation of the Benedictus and Magnificat antiphons, groups these miracles in theological unity. But through the harmony of Piero's landscape, in the painting they coexist and are simultaneous. As a visual homily on the Feast of First Appearances, the painting represents the conversion of the world at the dawning moment of transformation; and the identity of style and content, of structure and expression, preserves this moment for all eternity.

NOTES

1. Feast paintings, or as they are sometimes called, festival paintings, seem to have appeared in Byzantine art in the tenth century when the structure of the iconostatis (screen decorated with icons separating the sanctuary from the rest of the church) reached its most elaborate form. On the bema, above isolated vertical images of Christ, Mary, and various saints, were placed smaller rectangular panels with representations of biblical events celebrated during the liturgical year. Cf. K. Weitzmann, "The Narrative and Liturgical Gospel Illustrations," *Studies in Classical and Byzantine Manuscript Illumination*, ed.

H. L. Kessler, intro. H. Buchthal (Chicago, 1971), pp. 247–70, and "Byzantine Miniature and Icon Painting in the Eleventh Century," ibid., pp. 271–313. According to current Russian Orthodox practice, on the day of the specific feast, the appropriate panel is removed from the iconostasis and placed on a lectern to be kissed by the worshipers as they pass before it. Cf. N. P. Kondakov, *The Russian Icon*, trans. E. H. Minns (Oxford, 1927), pp. 29–30. G. Galavaris, *The Illustrations of the Liturgical Homilies of Gregory Nazianzenus* (Princeton, 1969), pp. 87ff., fig. 115, points out that in feast paintings of the Baptism, John wears the himation and chlamys (formal attire), rather than the wilderness *tunica exomis* (a short, draped tunic slung over one shoulder, leaving the other bare) that he wears in narrative scenes.

2. But see a late-fourteenth-century antiphonary, School of Bologna, in the collection of P. G. Conti, Florence, fol. 65v. Illustrating the first lesson of the first nocturn of Epiphany (Hodiem Iordane baptizato domino aperti sunt celi), is a *Baptism* with a Jordan personification in the river. At the bottom of the page are three joined circles showing the journey of the Magi and their adoration of the Child. There is, however, no representation of the Marriage of Cana on this page; see P. G. Conti, *Un antifonario miniato della scuola Bolognese* (Florence, 1940), p. 18, fig. 8.

3. Existing already in the Old and New Testaments, these concepts were further developed by the patristic fathers, both Greek and Latin. The major contributors were Tertullian, Origen, Jerome, and Augustine; codification came in the work of John Cassian in the fifth century. From then to the twelfth century a threefold system (used, for example, by Isidor of Seville) survived side by side with the fourfold system used, for example, by Bede and Hrabanus Maurus. Later, Dante wrote that he expected his *Divine Comedy* to be interpreted this way, and in his introductory letter (to the Can Grande), he explains his own very complicated series of the levels of interpretation. Interestingly, Dante uses lines from the 114th Psalm to explicate many facets of his system. An excellent, concise introduction to this subject is found in J. Chydenius, "The Typological Problem in Dante," *Societas Scientiarum Fennica*, vol. 25, part 1 (Copenhagen, 1958), pp. 11ff., 30ff., 40ff.; discussion of Dante's interpretation of Ps. 114 is on pp. 44ff. Dante demonstrates his preoccupation with this psalm again in the *Divine Comedy*, Purgatory, canto 2, verse 46, where a community of newly arriving Christian souls sing it in its entirety. See *Dante Alighieri, The Divine Comedy*, trans. and comm. C. S. Singleton (Princeton, 1975), *Purgatorio*, canto 2, *Commentary*, pp. 31–32; see also R. Hollander, "Purgatorio II. Cato's Rebuke and Dante's *Scoglio*," *Italica* 52, no. 3 (1975): 348–63; my gratitude goes to Professor Hollander for supplying me with these references and an offprint of his article. On the larger implications of Jordan imagery in the *Divine Comedy*, see J. Freccero, "The River of Death: Inferno II, 108," in *The World of Dante*, ed. S. B. Chandler and J. A. Molinaro

(Toronto, 1966), pp. 625–42 (but see comments by R. Hollander, *Allegory in Dante's "Commedia"* [Princeton, 1969], pp. 261–63).

4. See figs. 8, 12; Lavin, "Giovannino Battista" (1955), p. 94 and n. 49; A. Masseron, *Saint Jean Baptiste dans l'art* (Vichy, 1957), p. 29; see also Battisti, *Piero*, vol. 1, n. 171.

5. St. Jerome, *Homilies*, p. 230.

6. See also, e.g., Galavaris, *The Illustrations*, figs. 246, 247, and 423.

7. Testi, *La Baptistère*, pp. 259–60, fig. 213, ca. 1350, points out the similarity of this pose to the undressing boy in the foreground of the *Christ's Entry into Jerusalem*, in the mosaics of Monreale; E. Kitzinger, *The Mosaics of Monreale* (Palermo, 1960), fig. 45 (one of the four boys).

8. See above, chap. 1, n. 1. The dependence of these frescoes on the fourteenth-century *Vita di San Giovanni* is evident in this scene; see P. A. Dunford, "The Iconography of the Frescoes in the Oratorio di S. Giovanni at Urbino," *Journal of the Warburg and Courtauld Institutes* 36 (1973): 367–73, an article valuable for its textual analysis but sadly neglectful in scholarly etiquette. Dunford cites (n. 3) my "Giovannino Battista" (1961) article as a source for information on the eighteenth-century Manni edition (see above, chap. 3, n. 21) as though it were a service work of philology, without mentioning my primary article (1955) in which the relationship between the Salimbeni frescoes and the fourteenth-century *Vita* is proposed for the first time (pp. 89ff.). Unhappily this is not the only public occasion on which Dunford ignored the precedence of my work; compare Lavin, "Giovanni Battista" (1955), p. 88, n. 24, and Dunford, "A Suggestion for the Dating of the Baptistery Mosaics at Florence," *The Burlington Magazine* 116 (1974): 96–98.

9. Between the Lateran fresco and that of Masolino, there are the figures in Masaccio's *Baptism of the Neophytes* in the Brancacci Chapel, S. Maria del Carmine, Florence; see H. Lindberg, *To the Problem of Masolino and Masaccio* (Stockholm, 1931), pls. 78, 79. For discussion of Masolino's knowledge of the Lateran fresco cycle, cf. L. Vayer, *Masolino és Róma* [Masolino and Rome] (Budapest, 1962), p. 84. The relationship between Piero's figure and the frescoes of Gentile and Masolino has been pointed out repeatedly, e.g., Tolnay, "Conceptions," p. 215; Longhi, *Piero*, pp. 17–18. Pogány-Balás, "Problems of Mantegna's Fresco," reviews this sequence of relationships and points out classical prototypes for some of the poses.

10. Clark, *Piero*, p. 13.

11. H. M. Riley, *Christian Initiation, A Comparative Study of the Interpretation of the Baptism Liturgy in . . . Cyril . . . Chrysostom, . . . Theodore . . . and Ambrose* (Washington, D.C., 1974), Cyril of Jerusalem and John Chrysostom, undressings, pp. 163, 165; John Chrysostom, dressing, ibid., p. 424. Further to this point, plus the idea of the Jordan as a mirror, see the Hymn for the Feast of the Epiphany, by Ephraim the Syrian: "Water is by nature as a mirror,—for

one who in it examines himself.—Stir up thy soul, thou that discernest,—and be like unto it!—For it in its midst reflects thy image;—from it, on it, find an example;—gaze in it on Baptism,—and put on the beauty that is hidden therein!" (hymn 9, v. 7; *Nicene and Post-Nicene Fathers*, vol. 13, p. 279).

12. Until the seventh century in the West, and still today in the Eastern church, the day for baptism of catechumens is January 6.

13. See K. Holl, "Der Ursprung des Epiphanienfestes," *Sitzungsberichte der Akademie der Wissenschaften zu Berlin* (1917), pp. 402–38. In the West, the ritual was moved to Easter Saturday and the Eve of Pentecost. See also references in E. H. Kantorowicz, "The Baptism of the Apostles," *Dumbarton Oaks Papers* 9–10 (1956): 203–54, esp. nn. 5 and 7.

14. G. B. Ladner, "Vegetation Symbolism and the Concept of Renaissance," *De artibus opusculum, XL, Essays in Honor of Erwin Panofsky* (New York, 1961), pp. 303–22. Single trees near the river are often prominent in Baptism compositions; see, e.g., figs. 8, 10, 11, 12, 26, 27, 33, 44, 56 in present work. Cesare Ripa, *Iconologia* (Padua, 1618), p. 61, interprets the image as *Bontà*, or "conformation to God's will."

15. *Funk and Wagnalls*, vol. 2, p. 1164; or strewn on the floor of the husband's house as a symbol of marriage itself; see Levi D'Ancona, *The Garden*, pp. 245ff., no. 111, item 7, citing Virgil, *Eclogae*, 8:29–30, and Catullus, 61, 124–31.

16. Carol Anne Menzi reminded me of this point. The similarity in sound of the words is what in the Renaissance constituted a pun; see C. Mitchell, "The Imagery of the Tempio Malatestiano," *Studi Romagnoli* 2 (1951): 77–90, esp. 88–89.

17. St. Ambrose, *De Iacob et Vita Beata: Jacob and the Happy Life (Seven Exegetical Works)*, trans. M. P. McHugh, The Fathers of the Church, 65 (Washington, D.C., 1972), p. 156.

18. Mâle, *Gothic Image*, p. 30; I. Bergstrom, "Disguised Symbolism in Madonna Pictures and Still Life," *The Burlington Magazine* 97 (1955): 304; also Levi D'Ancona, *The Garden*, p. 245, no. 111, items 1, 2, 6. Battisti, *Piero*, vol. 1, p. 116, recognizes the tree as a symbol of Christ.

19. Cf., e.g., E. Schlink, *The Doctrine of Baptism*, trans. H. J. A. Bouman (St. Louis, 1972), pp. 21ff., "The Baptism, Death and Resurrection of Jesus," plus bibliography. See below. The walnut as a symbol of the saving grace of Christ is noted in the sixteenth-century *Herbario Novo, de Castore Durante*, (Venice, 1667), p. 295, s.v. *Noci, Glansiovis*.

20. Petri Andrae Matthioli Senensis Medici, *Commentari sex libros Pedacii Dioscuridis Anazarbei de Medica materia* (Venice, 1565), *Ranunculus*, p. 614, *Glycyrrhiza*, p. 651, *Trifolium*, pp. 834ff. *Funk and Wagnalls*, vol. 1, p. 176, *Ranunculus*; A. Pucci, *Enciclopedia orticola il-*

lustrata, Dizionario generale di floriculture, 2d ed. (Milan. 1915), vol. 2, p. 1486, *Convolvulus (tamus communis).*

21. Clover: *Funk and Wagnalls,* vol. 1, p. 237; Levi D'Ancona, *The Garden,* pp. 99ff. Plantin: Ripa, *Iconologia,* p. 492; Levi D'Ancona, *The Garden,* p. 308, no. 131, referring to H. Friedman, "The Plant Symbolism of Raphael's Alba Madonna," *Gazette des Beaux-Arts* 36 (1949): 213–20, esp. 218, where it is admitted that no written source has been found for this meaning. The same information is given in *Funk and Wagnalls,* vol. 2, p. 873, citing Grimm's retelling of part of the plantin legend. See also Ferguson, *Signs,* p. 46. Other plants in the painting also have religious connotations: *Convolvulus* is a symbol of perfect and holy love; broom *(Spartium junceum),* behind John's heel, is a symbol of the Incarnation because it is sweet smelling only when touched by the sun (cf. Levi D'Ancona, *The Garden,* pp. 108 and 71). The little palms to the right and left refer to one of the trees of paradise. See above, chap. 2, n. 17.

22. Cf. Panofsky, *Early Netherlandish Painting,* vol. 1, pp. 134ff. See above, chap. 2, n. 23.

23. M. Logan, "Due dipinti inediti di Matteo da Siena," *Rassegna d'arte* 5 (1905): 49–53, was the first to make an attribution, dating the frame to ca. 1465; G. F. Hartlaub, *Matteo da Siena und seine Zeit* (Strasbourg, 1910), pp. 42ff., agreed that it was by Matteo and done ca. 1465, as did M. Salmi, "Postille alla Mostra di Arezzo," *Commentari* 2, nos. 3–4 (1951): 171–72; see also G. H. Edgell, *A History of Sienese Painting* (New York, 1932), p. 228. The current consensus is that the paintings of the frame date ca. 1461–62 (see *Dizionario enciclopedico Bolaffi dei pittori e degli incisori italiani* [Turin, 1975], vol. 7, pp. 286ff., with additional bibliography). This date corresponds roughly to my dating of the *Baptism.* See preface, n. 4. Further, the figures on the right pilaster of the frame, and two predella scenes *(The Baptist Preaching,* and the *Dance of Salome),* have been attributed to Giovanni di Pietra (or the Master of the Ovile *Annunciation),* a collaborator of Matteo's from 1452 to 1461, by E. Fahy, according to a verbal report recorded in *The Cleveland Museum of Art: European Paintings before 1500, Catalogue of Paintings* (Cleveland, 1974), pt. 1, p. 73. It is possible that the lost representation of God the Father looked something like the figure in Matteo's *Assumption of the Virgin* (fig. 53), Church of the Servites, Sansepolcro, that is, floating in stilted frontal foreshortening, with both hands raised in blessing; for a reproduction of the whole painting, see A. Brilli, *Borgo Sansepolcro, La Città di Piero della Francesca* (Sansepolcro, 1972), pl. 37.

24. Salmi, "Postille," (see n. 23 above) proposed that Piero's painting was done in the early 1440s and transformed into a triptych about 1460–70. Davies, *Earlier Italian Schools* 2d ed., pp. 427–28, believes the frame may have existed with another centerpiece which was destroyed

and for which Piero's painting was a replacement. See app. 2 for documentation of the complete altarpiece from 1629 to 1861. Our reconstruction of the lost parts of the frame (fig. 2) was designed by James Brody Neuenschwander and rendered by Johannes G. Albrecht.

25. For a discussion of practices involving separate contracts for the woodwork of altarpieces designed by painters and made by carpenters, see C. Gilbert, "Peintres et menuisiers au début de la Renaissance en Italie," *Revue de l'art* 37 (1977): 9–28. See below, chap. 7, n. 5.

26. The Vanni and Fei altarpieces are reproduced in *La Pinacoteca nazionale di Siena; i dipinti dal XII al XV secolo*, ed. P. Torriti (Genoa, 1977), pp. 188–89, no. 114, fig. 211; p. 179, no. 116, fig. 199. A recent reconstruction of the Masolino/Masaccio painting was made by A. Braham, "The Emperor Sigismund and the Santa Maria Maggiore Altarpiece," *The Burlington Magazine* 122 (1980): 106–22, esp. figs. 16–18, 19–20.

27. See app. 1 for Carter's analysis of the three-part construction and placement of the figure of Christ in the recession.

28. Cf. chap. 2, n. 31. *The Catholic Encyclopaedia* (New York, 1911), vol. 11, pp. 569ff., 748ff.

29. St. Steven (Dec. 26), whose dying prayer caused the conversion of St. Paul; St. Anthony (Jan. 17), beloved by the Camaldolite hermits (see next chapter). Cf. The Common of the Saints, and The Litanies of Holy Saturday. See Voragine, *The Golden Legend*, pp. 54ff., 99ff., Mary Magdalen (July 22), pp. 355ff., St. Catherine (Nov. 25), pp. 708ff.

7

Historical Context

From the time the altarpiece was discovered in the sacristy of the Cathedral of Sansepolcro, its original location has always been designated as the parish church of San Giovanni in the same town. However, this church played no particular part in Sansepolcro's history, and it seems less and less likely to have been a home for the altarpiece as the complicated program of the latter unfolds. Even though their dedications correspond, the sophistication of the one seems out of harmony with the simplicity of the other. San Giovanni in Val d'Afra, the full title of the parish church, is a small, rectangular hall without clerestory, transept, or apse; it was built in the early thirteenth century on the southeast edge of town and named for the stream that runs nearby. Today used as a warehouse, it was deconsecrated in 1807, at which time the altarpiece must have been transported to the cathedral.[1]

At the foot of the side pilasters of the frame are painted escutcheons (fig. 52). The blazon to the left, fleurs-de-lis above small lozenges descending, has been identified as that of the Graziani, a family prominent in Sansepolcro since its founding.[2] On the right, a similar shield is painted with the letters O P A, an abbreviated form of the word *Opera*, the usual term for a religious society or confraternity of good works. These emblems, rather than clarifying the history of the commission as one might expect, create problems of their own. The Graziani family was connected not with the church of San Giovanni Battista but with the church of the Camaldo-

129

lite monastery, called San Giovanni Evangelista, where several of its members officiated as distinguished clerics. Moreover, their period of prominence, even at the wrong church, would seem either too early or too late for Piero's painting.[3]

Archival material dealing with fifteenth-century Sansepolcro is sparse, and thus far a search by several distinguished scholars has yielded nothing concerning our painting.[4] On the other hand, the archive founded after establishment of the bishopric, the Archivio Vescovile, started about 1518, is relatively intact. While postdating the painting by at least half a century, it is in this material that the first historical notices of our painting are to be found.

Periodically, the bishop of an area, with his administrative staff, inspects all the churches in his bailiwick; their mission is to judge if the architecture and its furnishings are suitable for ecclesiastical function. During these visits, known in Italian as *Visite Pastorali*, notes are recorded on each church; every altar is observed and described according to condition; recommendations are made for repair or replacements where necessary. The first recorded *visita* to San Giovanni Battista in Val d'Afra is dated 1583. The notes speak of frescoes covering all the walls and say they are in very bad condition ("scrostati e deturpati per l'antichità"). A wooden Madonna is on one altar, an icon on another, and the high altar is empty.[5] Recommendation is made to procure a beautiful new cross and to whitewash the whole interior.[6] When the church is visited again in 1616, things have improved. Relics, statues, and a new crucifix are described, but there is still no painting on the high altar.[7]

Finally, in 1629, the *Baptism* has arrived. Notes of that year's visit say, "Behind the high altar is an icon painted on wood with images of St. John the Baptist and other saints, with a gilt wood ornament [that is, a frame]."[8] In 1649 it is described again as an "image of St. John baptizing the Lord." Thereafter the altarpiece is mentioned often in this location.

Although once it is referred to as "un quadro all'antica," it is never given an attribution.

In 1787 the triptych is said to be covered with a cloth ("una tenda").[9] By this time, in fact, the church was falling into disuse for demographic reasons. The town had expanded over the years, and the population had shifted to a new neighborhood where it joined the parish of another church, called San Giovanni Battista al Trebbio (the name of another stream). On August 3, 1785, Monsignor Vescovo Roberto Maria Costaguti, on the orders of the grand duke of Tuscany, overlord of the city, decreed that the old church in Val d'Afra should be deconsecrated at the death of the current parish priest. He died in 1807, San Giovanni was thereupon suppressed and an inventory of its goods and furnishings was drawn up. Part of this property was given to the new parish church. The rest was bequeathed to the cathedral. What is significant about these lists is that in them Piero's altarpiece does not appear.[10]

Only one conclusion can be drawn from this omission. Throughout the centuries when the painting was in San Giovanni, it had been on loan, not owned by the church. Since within a few years of the suppression it was seen in the sacristy of the cathedral, the altarpiece must originally have been the property of that church. When San Giovanni stopped functioning, it was returned to its rightful place. This had to have been the case for the Ecclesiastical Chapter of the cathedral to have had the legal authority to sell the *Baptism* to a foreign buyer. The chapter sold the painting in 1859.[11]

If the altarpiece had not been made for the parish church, then for whom indeed was it painted, and for what location? In the records of the Archivio Vescovile, there is a section of documents listing acts of devotion made to the cathedral by parishioners in the form of donations and gifts. Most of the recorded donations, naturally, date from the sixteenth century. However, when the archive was initiated, copies were

made of the records of several major donations that had come
to the monastery in pre-episcopal times. Among these, the
following came to light: on March 10, 1406, a lady called
Diose di Ramoldo di Mazzarini dei Mazzetti gave certain
worked lands, two vineyards, a silver-gilt chalice, and a mis-
sal, for the purpose of founding an altar dedicated to no one
less than St. John the Baptist. This altar, or "cappella" as it
was called, was to be placed on "the first column to the right
entering the Badia, near the holy-water font," (fig. 55).

55. Sansepolcro, Cathedral, in-
terior (after Salmi)

While the location may sound somewhat incongruous to us,
the altar must have been imposing enough, since, according
to the bequest, it was to be used for daily masses for the soul
of Diose and that of her departed husband, to be sung by the

abbot of the monastery himself. The dead husband's name was Giovanni, and hence the choice of titular saint. We know Diose's wishes were carried out and the cappella, as well as a confraternity to tend it, were established.[12] But an altarpiece is not mentioned. Thus there is no hard evidence that later in the century Piero's ensemble was made for this location. Yet there are reasons enough to think this might have been the case.

Toward reconstructing what occurred, I offer the following hypothesis. Diose's donation, sumptuous in 1406 (and therefore memorable), by the 1450s had dwindled; payments for daily masses are very expensive. Moreover, we know from various sources that during the 1430s, the monastery itself had been deeply in debt, so much so that the monks had resorted to usury to try to balance their books. There had also been a long legal battle with the bishop of Città di Castello who wanted the monastery under his jurisdiction; the monks of Sansepolcro preferred to be directly under Rome. Not only was the legal wrangling costly, but the monks had been sentenced to a heavy fine by Pope Nicholas V, which was still pending in 1454.[13] It is therefore doubtless that outside financing would have been very much appreciated.

The wealthy Graziani family, one of whose sons, Simone di Benedetto, entered the monastery in the mid-1450s, could have made a contribution to this end. Their financial responsibility could have included the care and completion of Diose's cappella. It then would have been the Graziani who commissioned Piero and the frame painter to construct an altarpiece where their arms, along with the confraternity's insignia, would have found place on the frame. Such a contribution would have been eminently appropriate. Not only was Simone in the monastery, but several Graziani figured among the priors of the chief lay organization of the town, the Fraternity of San Bartolomeo, which had its headquarters at the Badia. One of these gentlemen was actually named Giovanni: Giovanni di Bartolomeo Graziano, prior of the fraternity in

1461.[14] He may have been the actual donor of the altarpiece. Moreover, there is positive proof of a relationship between Piero della Francesca and the Graziani during the same period. Documents of 1461 and 1462 show Luchino di Leone Graziani to have been the legal representative for Piero's father Benedetto and his brother, Marco, both of whom often acted on Piero's behalf in monetary transactions.[15]

Whatever the circumstances of the commission, by 1524 the altarpiece and the chapel itself had been removed. A notice from that year refers to the place on the column as "una volta fù dedicata à S. Giovanni."[16] The Camaldolite monastery had been disbanded in 1518 and the abbey church reconsecrated as the town's cathedral. Galeotto Graziani, Simone's brother and the last abbot of the monastery, was appointed Sansepolcro's first bishop in 1520; in 1522 Galeotto died of the plague, and he was followed by a Florentine, Leonardo Tornabuoni.[17] With the last officiating member of the family gone, presumably the Graziani withdrew their support of the cappella and it was thereafter dismantled. We may thus understand why Vasari, who probably came to Sansepolcro during the 1540s and who discusses other works in the cathedral in his *Lives of the Painters*, did not mention our painting in his biography of Piero. By the time of his visit, the altarpiece was in storage, where he easily could have missed it.

The last reference to the Cappella di San Giovanni Battista was made in 1583 in the *Visita Pastorale* of the cathedral, where it was noted that a "pro memoria," some sort of plaque, had been transferred from the nave column to the nearby Chapel of SS. Arcano and Egidio.[18] In this connection, it should be recalled that in the same year, 1583, San Giovanni in Val d'Afra was found in need of furnishings. It is possible that the idea of lending Piero's iconographically appropriate and out-of-use altarpiece was conceived as a result of this observation.

Until further documentation comes to light, our association of the painting with the Cappella di San Giovanni Bat-

tista in the Badia of Sansepolcro must remain speculation. But even without documented verification, such an assumption brings increased historical resonance to several aspects of our interpretation. The first is the exegetical interpretation. Writings of the church fathers, in which early in the Middle Ages were formulated the typological associations we have discussed, experienced a direct revival in the fifteenth century. Discovery and collection of manuscripts of Latin fathers and new translations of many Eastern writers played a major role in ecclesiastical humanist activities. One of the great scholars and chief promoters of this neopatristic movement was Ambrogio Traversari, powerful general of the Camaldolite order until his death in 1439. Among Traversari's proudest achievements was the discovery of no less than forty-two homilies by Origen. He also translated and interpreted twenty sermons by Ephraim the Syrian. We know from his own writings that Traversari visited the Badia in Sansepolcro on three different occasions.[19] It is possible that Piero's inclusion of neopatristic themes in his painting reflects Traversarian ideals and thus the Camaldolite setting of his commission. Moreover, if he had needed advice on his complex imagery, he could have received it from Don Simone Graziani, who was educated in the monastery and is described in contemporary documents as having been a distinguished scholar.[20]

Beyond these generalities, it may be possible that the specific image of the Jordan Miracle historically reflects the Camaldolite setting. The clue to this connection is found in the *Divine Comedy* where Dante uses this very figure to describe the concept of a truly great miracle. Arriving in the seventh circle of heaven, Dante meets St. Benedict surrounded by ranks of monastic leaders. Benedict laments the corruption among clerics in modern times, calling it particularly "unnatural" for those dedicated to spiritual good. The most serious among the sins of the monks, he says, and what goes most strongly against the will of God, is the practice of usury. The orders, he continues, were founded in poverty and purity and

now have fallen into this foul wickedness. As black as this situation is, however, he says there is hope for remedy. "The turning back of the Jordan and parting of the Red Sea at the will of God were more startling miracles than divine intervention to cure the present ills would be."[21] Dante puts these remarks in the mouth of the spiritual leader of the Camaldolites, St. Benedict, while seated close by in the ranks is the actual founder of the order, St. Romualdo. Now when we learn that one of Ambrogio Traversari's visits to the monastery in Borgo Sansepolcro was for the purpose of personally eradicating the usury being practiced by the local monks in the 1430s, we may speculate that the image in the painting was meant as a kind of visual verification that the sin had been remedied and that God had returned to more "wonderful miracles."

Yet, even if we are correct, and the altarpiece was commissioned for a Camaldolite setting, we have not explained the choice of the Baptism of Christ as the primary subject of the painting, much less the reference to the full liturgy of the Epiphany season in this context. It is true that the earliest example of the Baptism of Christ used as the center of a large altarpiece before Piero's was at one point in another Camaldolite monastery in the region. This is the triptych by Niccolò di Pietro Gerini (fig. 56), presumably painted in 1387 and after 1413 in the Camaldolite Abbey of San Giovanni Decollato del Sasso, in the hills above Arezzo. Surely known to Piero, this triptych also has full-length figures of St. Peter and St. Paul for its wings.[22] Nevertheless, unless there is some special veneration in the area of southern Tuscany yet to be defined, there is nothing in Camaldolite ritual that singles out Baptism for emphasis; the order uses the standard Roman rite, where, as we have noted, the "object" of the Epiphany celebration is the Adoration of the Magi, and the Baptism is in a secondary position. One point comes to mind in relation to developments in Epiphany liturgy in the fifteenth century: in Italy a new ceremony was introduced, namely, the Blessing

of the Baptismal Waters on the Eve of Epiphany. The ceremony was based on Eastern practice, and reference is made in the reading (but without actual mention) to the Miracle of the Jordan.[23] However, there is no evidence that this practice

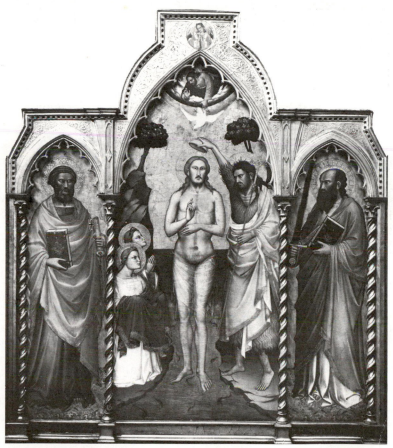

56. Niccolo da Pietro Gerini, *Baptism of Christ*, London, The National Gallery (photo: reproduced by courtesy of the Trustees, The National Gallery, London)

had particular significance in the Camaldolite order or at Sansepolcro any more than elsewhere.

It is only when we question how Piero arrived at the subject of the Baptism of Christ to begin with that his motivation, his object, and his solution become clear and inevitable. From the existence of the painting and its provenance we may take

as given the following points: Piero was commissioned to paint a devotional image for an altar dedicated to John the Baptist in Borgo Sansepolcro. For this assignment he had several choices of subject. He could have painted a large, central image of John the Baptist with narrative scenes of his life in the wings. He could have painted the mysteries of one of St. John's two feast days, the Birth of the Baptist, celebrated on June 24, or the Death of the Baptist, celebrated on August 29.[24] Although historically without precedent, he might have chosen one of a number of other moments in the saint's life (for instance, the Naming of John, or the Dance of Salome). He chose instead the Baptism of Christ. The Baptism is not a feast of John, however, but of Christ. Piero chose, therefore, the one Gospel scene in the life of the Baptist that relates him to the city of Christ's tomb.[25] By isolating the Baptism as the center of a devotional altarpiece in Borgo Sansepolcro, Piero identified his primary subject with the liturgy of January 6. This point is made explicit by allusions to the two other mysteries of that day and to the complex unity within the three-part liturgy. The visual analogue of the liturgical unity is the formal structure of the setting, a view more harmonious than nature because it is organized by principles of linear perspective. And since the locale is the singular valley described by Pliny, we may say that Piero revived the art of ancient landscape painting to portray to the people of Sansepolcro the symbolic meaning of their homeland as the ideal Christian realm.

NOTES

1. Battisti, *Piero*, vol. 2, fig. 64, interior view. Agnoletti, "Le vicende"; Ricci, *Borgo Sansepolcro*, p. 52; G. F. Pichi, *La Vita e le opera di Piero della Francesca* (Sansepolcro, 1892), p. 106; see also Goracci, *Breve istoria*, p. 163.
2. Davies, *Earlier Italian Schools*, p. 427; cf. Ughelli, *Italia sacra*, vol. 3, p. 199, with drawing of the shield. Farulli, *Annali e memorie*, p. 26, discusses the rise of Carlo Graziani, captain of the Perugians; pp.

92ff., List of Priors of the Fraternity of San Bartolomeo, and Goracci, *Breve istoria*, pp. 247ff., List of Ganfalonieri.

3. The first Graziani abbot is named in a diploma of Frederick II, dated 1220 (*Annal. Cam.*, vol. 4, app. 407). A.-M. Graziani, *De scriptis*, p. 79, mentions another, Abbot Giovanni Graziani, appointed in 1348; Simone di Benedetto was appointed abbot in 1480 (see below); his brother Galeotto followed him as abbot in 1509–20, after which he was made bishop; cf. E. Agnoletti, *I vescovi di Sansepolcro* (Sansepolcro, 1972), vol. 1, pp. 17–21. For some unknown reason, A.-M. Graziani, *De scriptis*, says Galeotto officiated at S. Giovanni Battista, not Evangelista; this slip was perpetuated by Ughelli, as Davies points out in *Earlier Italian Schools*, p. 427, n. 7. Cf. G. Cappelletti, *Le Chiese d'Italia* (Venice, 1862), vol. 17, p. 257, who corrects Ughelli.

4. Prebishopric material was surveyed and inventoried by Giustiniano degli Azzi, *Inventario degli archivi di Sansepolcro* (Rocca S. Casciano, 1914). Cf. Battisti, *Piero*, vol. 2, pp. 213ff., who with the aid of E. Settesoldi has provided several new fifteenth-century documents concerning Piero's life.

5. In regard to the empty high altar, I would like to bring to bear an intriguing document published by Milanesi in 1901 and cited by C. Gilbert ("Peintres et menuisiers au début de la Renaissance en Italie," *Revue de l'art* 37 [1977]: 20). The document dated December 21, 1433, pays for the materials and construction of the woodwork of an altar designed by the painter Antonio da Anghiari, afterward to be painted for ". . . altare maius ecclesie Sancti Johannis de Afia de dicto Burgo (Sansepolcro). . . ." Although written as "Afia," doubtless it should read "Afra" and is the church under discussion. G. Milanesi, *Nuovi documenti per la storia dell'arte Toscana dal XII al XV secolo* (Florence, 1901), p. 84, no. 102. The modern collocation of this document is Notarile Anticosimiano S 873; entry under date at the end of the volume. I am very grateful to Professor Julius Kirshner for his generous assistance in finding and checking this document. Obviously, by 1583, this altarpiece had been removed or no longer existed.

6. To be published in full by Agnoletti.

7. To be published in full by Agnoletti.

8. Arch. Vesco. di Sansepolcro, Visitatio Diocesano, 1623–29, fol. 152v, S. Giovanni in Val d'Afra, Altare maius: "Abit iconem depictam in tabula cu[m] Imaginibus sancti Io[annis] Bta et aliorum sanctorum cu[m] ornamento ligneo deaurato" (published by permission of E. Agnoletti).

9. To be published by Agnoletti; see "Le vicende," p. 1.

10. Inventario delle masserizie della chiesa soppressa, 1809; four other paintings are mentioned in the list, showing that it included works of this category; cf. Agnoletti, "Le vicende."

11. This reasoning is again due to Agnoletti, "Le vicende." For the history of the sale, see below, app. 2.

12. Document to be published by Agnoletti. The sixteenth-century copy of the Donation says the information was taken from the "Libro del Confraternità" of St. John the Baptist, which at the time of the donation was yet to be founded. The "cappella" would have been what in English is called a "chantry chapel," an altar donated by individuals for "masses of requiem in perpetuity for the soul of the endower or persons named by him." The practice of having such chapels began in the thirteenth century, by which time most major spaces in the church were occupied; they therefore took an area provided for by screening off the opening between nave pillars or in the aisles of the church; see *The Catholic Encyclopedia* (New York, 1908), vol. 3, pp. 573, 577. The frame of Piero's altarpiece is some four meters in width. It is painted and finished on both lateral ends with floral compositions, *putti* heads, and marbleized surfaces. There is, nevertheless, plenty of room for it on the column, no matter where it was attached: the distance from the facade to the first column is more than nine meters; intercolumniation, more than seven meters; the width of the side aisle is more than nine meters.

13. Muzi, *Memorie ecclesiastiche*, vol. 4, pp. 105ff.

14. See above, nn. 2 and 3. The archive of the Graziani family, which is not open to the public, is housed in Città di Castello, but owned by Contessa Maria Teresa Mels-Colloredo, Florence. Portions of this archive were sold in this century, and are at the Kenneth Spencer Research Library, University of Kansas, Lawrence, Kansas. Most of the material in Kansas dates from the sixteenth century and later.

15. Battisti, *Piero*, vol. 2, pp. 224–25, doc. 66 (17 Dec. 1461), and doc. 68 (26 March 1462). Piero himself was a member of the same fraternity and was elected chief prior in 1480; cf. De Vecchi, *L'Opera completa*, p. 84. Battisti, *Piero*, vol. 1, p. 116, argues for a visual reference to the Graziani in the figures of the three angels, who, as Tolnay claimed, refer to the three graces of antiquity (see above, chap. 2). The graces, Battisti points out, signified "liberality" in the interpretation of Hesiod, which was quoted by Alberti in his *Trattato della Pittura*. Such a reference, Battisti pleads, would be a defense of the Graziani if, by chance, they had been accused of practicing usury. What is more likely, however, is that Piero intended here another pun in the Renaissance manner (see above, chap. 6, n. 16), this time on the similarity of sound between *grazia* (the word for grace in Italian) and the name Graziani. In showing their liberality as patrons, they would be seeking the grace of God, in the usual manner.

16. March 21, 1524, continuation of the document copying the 1406 donation; cf. above, n. 12.

17. *Annal. Cam.*, vol. 8, pp. 3ff.; Ricci, *L'Abbazia*, pp. 43ff.

18. To be published by Agnoletti.

19. Ricci, *L'Abbazia*, p. 21, quotes Traversari's own records of his visits. Cf. G. Voigt, *Die Wiederbelebung des Classischen Alterthums*, 3d ed. (Berlin, 1893); C. L. Stinger, *Humanism and the Church Fathers:*

Ambrogio Traversari (1386–1439) and Christian Antiquity in the Renaissance (Albany, 1977); P. O. Kristeller, "Augustine and the Early Renaissance," *Review of Religion* 8 (1943–44): 393ff. Cf. also Krautheimer and Krautheimer-Hess, *Ghiberti*, pp. 177ff., with references and list of manuscripts discovered by Traversari. See further, R. Sabbadini, *Le scoperte dei codici Latini e Greci ne' secoli XIV e XV*, (Florence, 1905; reprint, 1967). C. Stornajolo, *Codices Urbinates Latini* (Rome, 1902), vol. 1, p. 49, Urb. lat. 481, fifteenth-century, 20 sermons by Ephraim the Syrian translated by Traversari, dedicated by Cosimo de' Medici. Cf. above, chap. 2, n. 4; chap. 3, n. 13; chap. 5, nn. 35, 36; chap. 6, n. 11.

20. Cf. Farulli, *Annali e memorie*, p. 39: "Sixto IV il dì 15 d'Ottobre nel dì di Venerdi [1480] fa Abate dell'insigne Badia di S. Giov: Don Simone di Benedetto Graziani . . . homo insigne nelle lettere, e molto atto a maneggi." It should be kept in mind, notwithstanding the sophistication of the painting's content, that the liturgy expressed was heard annually from at least the eighth century. While the subject matter may be complex, it is thus not recondite. In fact, it is rather surprising that Piero's rendering was, and has remained, unique.

21. E se guardi il principio di ciascuno
 poscia riguardi là dov'è trascorso
 tu vederai del bianco fatto bruno.
 Veramente Iordan volta retrorso
 più fu, e 'l mar fuggir, quando Dio volse,
 mirabile a veder che qui'l soccorso. (*Paradiso*, XXII. 90ff.)

 Cf. *Divine Comedy*, ed. C. S. Singleton (Princeton, 1975), *Paradiso*, part 2, p. 364. Also *Readings on the Paradiso of Dante, Chiefly Based on the Commentary of Benvenuto da Imola*, ed. W. W. Vernon (London, 1900), vol. 2, pp. 173ff. The passage in the *Paradiso* was brought to my attention by Leslie Jones Posner. See above, chap. 2.

22. The predella scenes of the altarpiece (not shown in the photograph) include four scenes of John's life, one being the Decollation. Cf. W. Cohn, "Notizie storiche intorno ad alcune tavole fiorentine del' '300 e '400," *Rivista d'arte* 31 (1956): 66. From documents, the donor is known to have been Don Filippo di Nerone Stoldi, who lived in the Convent of S. Maria degli Angeli, Florence from 1357 to 1409, where in May 1386 his mother founded a chapel dedicated to S. Giovanni Decollato. The first mass was said there Sept. 23, 1387 (hence the date given the picture). Apparently the painting was moved to the monastery with the same dedication after it became Camaldolite in 1413; cf. Davies, *Earlier Italian Schools*, 2d ed., pp. 386ff., no. 579. St. Benedict and St. Romualdo, the two main Camaldolite saints, appear at either end of the predella.

23. Bute and Budge, *The Blessing*; Cabrol, *Dictionnaire d'archéologie*, vol. 2, pp. 2, 708. See above, chap. 3, n. 12.

24. The *Paleotto di S. Giovanni* (detail, fig. 25), depicts St. John enthroned; a fourteenth-century example is Giovanni del Biondo's altarpiece in the Contini-Bonacosi Collection, Florence (cf. M. Meiss, *Painting in Florence and Siena after the Black Death* [Princeton, 1951], fig. 68). Representations of the birth and death miracles were produced by Rogier van der Weyden near the time of Piero's panel, i.e., 1452–55; cf. Panofsky, *Early Netherlandish Painting*, vol. 1, pp. 278ff., vol. 2, pls. 202–06; also Lane, "Rogier's St. John," p. 656.

25. From at least the year 1000, the "notula col sigillo" of Sansepolcro bore a representation of the Resurrection. An inscription in the Oratory of San Rocco (where, incidentally, there is a sixteenth-century replica of the Holy Sepulchre) explains:

> Miraris urbis qui vetusta vividae
> sortita nomen funebre, huius pergama
> si introspicis, figura redivivi Dei
> patet sepulchro fausta dantis omina.

(You, who marvel that the ancient things of this flowering city should have a kind of funereal name, look well at the ancient records. [There you will find] revived the figure of God, who from the tomb gives good fortune.) The motif of Piero's own *Resurrection* fresco, with variations, became the new seal at the end of the fifteenth-century. A. Mariucci, "Lo Stemma della città di Borgo Sansepolcro e la 'Resurrezione' di Piero della Francesca," *L'Alta Valle del Tevere* 1 (1933): 17–20. The reader should keep in mind that the final anagogical interpretation of Baptism is the Resurrection: "By Baptism we not only die to our sins with Christ on the Cross, we also rise to the new life of Grace with Christ risen from the dead" (*The New Marian Missal for Daily Mass*, ed. S. P. Juergens [New York, 1960], p. 381). See above, chap. 6, n. 19.

8

Postscript

By the third quarter of the fifteenth century, the Baptism of Christ frequently appeared as the subject of important altarpieces; that from the shop of Andrea del Verrocchio for the monastery of San Salvi in Florence, on which the young Leonardo da Vinci worked, will spring to mind as perhaps the most famous of many.[1] While it cannot be claimed that all these show the expanded subject matter Piero introduced, there is ample evidence that the meaning of his painting had been well understood.

One of the most striking cases is in the *Baptism of Christ* by Giovanni Bellini (fig. 57), in Santa Corona, Vicenza, 1500–02. In the foreground, a rock-lined patch of pebbled ground appears before the stopped Jordan. Christ stands on dry ground with the water's edge visible behind him. Three venerating angels on the left, and John on the right, are at higher levels on the cliffs, emphasizing the narrow dry space of Christ's descent. The Miracle of the Jordan thus is again represented as a fact of nature, with the same exegetical allusion as in Piero's painting to the Book of Joshua. The stark and somewhat barren setting has been interpreted as a direct reference to the wilderness of the historical Baptism. And in this case the pertinence to the commission is clear. The patron was one Giovanni Battista Graziano Garzadori, who had just returned safely from a trip to the Holy Land.[2]

An even more pointed reference to Piero's painting is found in another subject, the *Annunciation* by Mariotto Al-

bertinelli (fig. 58), painted between 1506 and 1510 for the high altar of the Compagnia di San Zenobi, Florence, today in the Academia.[3] In the left foreground two tall angels shake left hands and one places his hand on the other's breast. When we recall that the moment of the Annunciation is also designated as the Marriage of Christ and the Church[4] and note the airborne angels around God the Father in the upper part of the altarpiece, wearing nuptial wreaths and joyously making music, we are assured that the handfasting angels are, like Piero's, responding empathetically with their own bodies to the Royal Wedding.[5]

Our last example is another *Baptism of Christ* (fig. 59) where reference to the Mystic Marriage at the Jordan is made by attendant figures. Francesco Zaganelli's painting, now in the National Gallery, London, was made for the Church of San Domenico in Faenza; it is signed and dated 1514. Here the composition has a new off-center arrangement. Christ is ankle-deep in the Jordan, which is as still as a mirror.[6] The left bank is populated by female figures, recalling once more Ghiberti's relief (fig. 44). A seated (wingless) angel, holding a lute, wears a costume that leaves the left shoulder bare. Two of the women are adults, the younger one is haloed. A child stands before them, crowned with a wreath of red and white roses like Piero's angel. These figures seem to represent three ages, one of the allegorical interpretations of the Miracle of Cana.[7] The women have also been interpreted as Mary (with the halo) and her mother St. Anne.[8] As witnesses at the Baptism, however, they are surely also the "Daughters of Zion" and allude once again to the wedding taking place at the Jordan.

As we have seen, by 1524, ten years after Zaganelli's work, Piero's altarpiece had been removed from its place of prominence. Following a hundred years of storage, it was installed in a church of little note and its identity lost for two centuries. In the early nineteenth century it reappeared in

57. Giovanni Bellini, *Baptism of Christ*, Vicenza, Santa Corona (photo: Alinari)

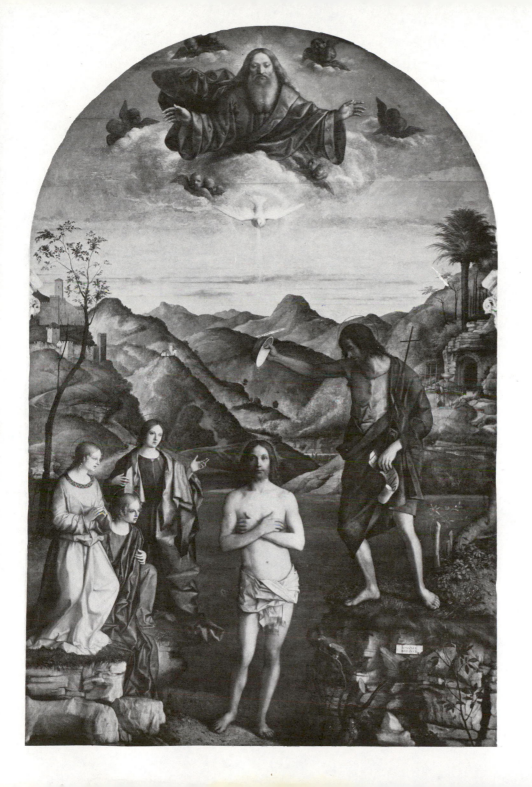

58. Mariotto Albertinelli, *Annunciation*, Florence, Accademia (photo: Alinari)

59. Francesco Zaganelli, *Baptism of Christ*, London, The National Gallery (reproduced by courtesy of the Trustees, The National Gallery, London)

dismembered form, and, though its mysterious power had not faded, the inner coherence of the ensemble was not grasped. The emphasis on the history of style and the focus on formal values that followed public presentation led still further away from the Christian symbolism involved. It has taken another century for us to arrive at a new objectivity and respond directly to Piero's visual signals.

When we do, Piero's pictorial eloquence continues to speak, and we recognize his *Baptism* as conveying a message neoteric in its universality, and universal in its availability to those who follow the language of its visual structure to its logical conclusion.

NOTES

1. Today in the Uffizi, usually dated ca. 1473–78 or a bit later; cf. G. Passavant, *Andrea del Verrocchio als Maler* (Düsseldorf, 1959), pp. 58–87, figs. 37–81; idem, *Verrocchio, Sculpture, Paintings and Drawings*, trans. K. Watson (London, 1969), p. 189, no. 21, pls. 78–82. See also *Baptism of Christ*, by Guidoccio Cozzarelli, in Sinalunga, S. Bernardino, ca. 1486 (see G. Scaglia, "Autour de Francesco di Giorgio Martini, ingénieur et dessinateur," *Revue de l'Art* 48 [1980]: 7–25, fig. 14); *Baptism of Christ* by Lorenzo di Credi, 1490–1500, Fiesole, S. Domenico, Cappella Guadagni, made for the Compania di S. Giovanni Battista detto Lo Scalzo; G. Dalli Regoli, *Lorenzo di Credi* (Pisa, 1966), p. 148, no. 96, figs. 141, 143. *Baptism of Christ*, by Signorelli, Arcevia, S. Medardo, 1508; cf. Davies, *Earlier Italian Schools*, 2d ed., p. 427, n. 9. And also see Signorelli's processional standard, young St. John the Baptist on one side, the Baptism on the other, ca. 1502, Città di Castello, Pinacoteca, reproduced in *Signorelli, Klassiker der Kunst* (Berlin-Leipzig, 1927), p. 185.
2. F. Heinemann, *Giovanni Bellini e i Belliniani* (Venice, 1962), p. 44, no. 147; also G. Robertson, *Giovanni Bellini* (Oxford, 1968), p. 111. That the donor was a member of a Graziani family is suggestive. The direct precedent for Bellini's foreground composition was Cima da Conegliano's *Baptism of Christ*, Venice, S. Giovanni in Bragora, 1492–94, discussed at length by P. Humfrey, "Cima da Conegliano, Sebastiano Mariani, and Alvise Vivarini at the East End of S. Giovanni in Bragora in Venice," *Art Bulletin* 62 (1980): 351–61, esp. 357ff.
3. G. Poggi, "Appunti d'archivio," *Rivista d'arte* 9 (1916): 65; L. Borgo, *The Works of Mariotto Albertinelli*, Ph.D. dissertation, Harvard, 1968, (reproduced by Garland Press, 1976), pp. 101–03, cat. I-20, 318–25.
4. *Reallexikon zur Deutschen Kunstgeschichte* (Stuttgart, 1948), vol. 2, col. 1110, s.v. "Braut-Bräutigam"; *Lexikon der Christlichen Ikonographie* (Freiburg, 1968), vol. 1, pp. 318–24.
5. A late Baroque example of rapturously embracing angels attending the Baptism of Christ may be seen in the painting by Pasquale Rossi (1641–ca. 1725), Rome, S. Maria del Popolo, Baptistry (first chapel on left). Between the figures of Christ and John, two child-angels embrace with their faces brought together and their lips meeting.
6. For the river of Baptism as a mirror, see chap. 6, n. 11.
7. Réau, *Iconographie*, vol. 2, part 2, pp. 362–66.
8. A. Paolucci, "L'ultimo tempo di Francesco Zaganelli," *Paragone* 193 (1966): 59ff.

A Mathematical Interpretation of Piero della Francesca's *Baptism of Christ*

B. A. R. CARTER

The application of geometric configurations to the surfaces of, for example, Greek pots, architectural elevations, or reproductions of paintings, for the purpose of revealing hidden formulae for their design, is a questionable activity. Often there is little evidence for geometric planning within the object itself or, just as frequently, no historical documentation to support the claim that there might be. As a result, geometrical analysis of works of art in general is discredited by most serious art historians.[1] In the case of Piero della Francesca's paintings, on the other hand, it is easy to justify. Piero's talent and productivity in the field of theoretical mathematics are by now common knowledge. The texts of his three important mathematical treatises reveal his deep understanding of Euclidean geometry,[2] and recent studies demonstrate that in some areas his proficiency was equal, if not superior, to that of the greatest mathematicians of his age.[3] What we must bear in mind is that these contemporaries accepted as universally valid the philosophical basis for Euclid's deductive system, namely the Pythagorean-Platonic cosmic order propounded by Plato in his *Timaeus*.[4] They accepted also the symbolic extension of these ideas in the doctrine of cryptic signs. Far from having lost impetus in the emerging rationalism, cabalistic and astrological attitudes inherited from ancient tradition and carried through the Middle Ages can be traced in quattrocento Neoplatonic philosophy, appearing prominently in the writings of Pico della Mirandola,

Marsilio Ficino, and finally Fra Luca Pacioli, Piero's compatriot and mathematical heir.[5] It is probable that Piero shared in these beliefs.

We must note, however, that Piero's own writings are purely technical. Nowhere in his texts does he make reference to any symbolic significance attached to numbers, bodies, or formulae. Yet, as more and more studies show, the surfaces of most of his painted compositions are coordinated by geometrical schemes that closely reflect his geometric theories.[6] It has also been shown in several instances, moreover, that these schemes serve more than structural expediency: through mathematical symbolism, they enhance and deepen the meaning of the visual imagery.[7] I believe Piero used such a schema in his painting of the *Baptism*.[8] This schema provides a structural underpinning for the composition, and, at the same time, it defines the special relationship between the protagonists and reinforces the liturgical significance of the narrative. Because this mathematical symbolism evokes some of the same theological concepts Mrs. Lavin has found to be present in the figural scene, it seemed appropriate to publish my observations as an appendix to her book. My text owes a great deal to her collaboration.

The painted surface of the *Baptism* measures 167 × 116.2 cm without its modern frame.[9] It is composed of two geometric shapes: a rectangle, 112.25 × 116.2 cm, and a semicircle with a diameter of 109.5 cm. The total height (167 cm) is very nearly equal (within .6 cm) to half the width (58.1) added to the diameter of the semicircle. Since Sansepolcro was under Florentine rule when the *Baptism* was painted, I assume the standard measure was the Florentine *braccio* (58.36 cm).[10] The proportion of height to width converts into *braccia* as roughly 3 × 2; the figure of Christ measures 83.7 cm, roughly one and a half braccia, or just about half life-size. These approximations seem simple enough, and eminently appropriate. When we question how

Piero arrived at his precise measurements, however, an un-suspected level of subtlety in the interrelationship begins to emerge. Only one surface measurement truly converts to braccia and that is the panel's width: 116.2 ÷ 58.36 cm = 1.99 braccia, or close enough to be called two braccia.[11] It will be shown that the width of the panel is the given from which the geometric schema was evolved and that Piero thus began his calculations with a rational number in Renaissance terms. Moreover, he seems to have emphasized this dimension at the junction of the rectangle and the semicircle, where "shoulders" of 3.35 cm at each side produce a kind of visual signal, to use Mrs. Lavin's phrase, telling us where to begin our reconstruction.

Two facts are immediately evident: the outstretched wings of the dove align exactly with the top of the rectangle; the figure of Christ coincides with a vertical line bisecting the panel. Using the top side of the rectangle we construct an equilateral triangle, and we find that its apex falls at the point where the central vertical axis passes through the tip of Christ's right foot (fig. 60). We may assume that Piero plotted this inverted triangle, with its trinitarian associations, to symbolize the descent of the Holy Spirit at the moment of Baptism.[12] Its significance here acquires further depth when we locate the center of the triangle and find it to be precisely at the fingertips of Christ's hands in prayer. The relationship between Christ and the dove and their placement on the panel are thus linked by the simple but meaningful construction. This construction, however, does not determine the size of Christ, who could have been shorter or taller and still relate to the triangular shape. Finding the basis for his size becomes important when we realize that his measurement of 83.7 cm exceeds half the panel's vertical dimension by a mere .2 cm. The relationship thus cannot be arbitrary. How then did Piero choose Christ's finite measurement, which determines the scale of all the visual elements, as well as the height

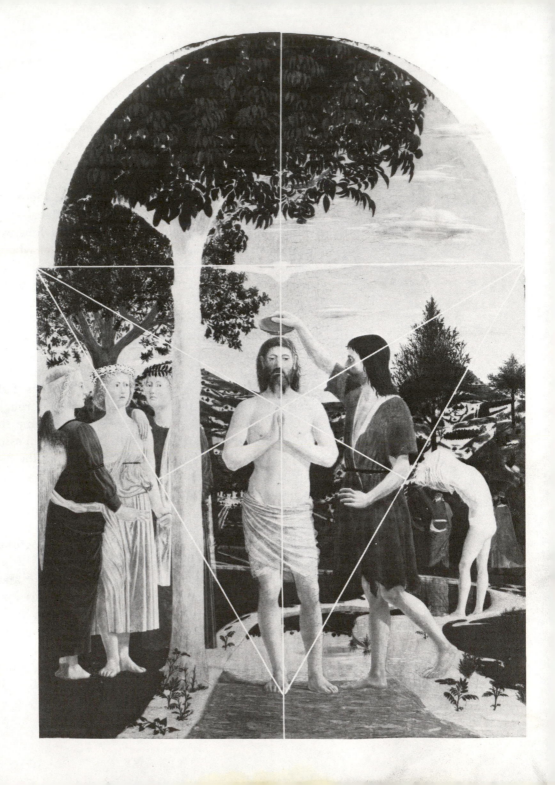

of the panel?[13] The answer is that Piero used a fixed module for the figure, again dependent on the width of the panel, the original given of the schema.

The method for obtaining the module is as follows: having found the center of the equilateral triangle, we are encouraged to encircle it. This done, we are reminded of a proposition of Euclid (prop. 16, bk. 4) which involves constructing a fifteen-sided figure, equilateral and equiangular (fig. 61). The proposition instructs one to inscribe an equilateral pentagon on the triangle and circle.[14] In so doing (fig. 62), Piero achieved another symbolic level: he superimposed on the trinitarian triangle the pentagonal symbol of Christ's five wounds, appropriate to the meaning of Baptism as the beginning of the Passion.[15] Mathematically, the superimposition produces a figure of fifteen sides, each equal to the distance between an angle of the triangle and an angle of the pentagon (indicated by two arrows on the upper left of fig. 62). Measuring one of these sides (i.e., the chord of a segment), we find that it is 27.897 cm in length. We then discover that this number equals precisely one-third of the height of Christ (83.7 cm).[16]

Leon Battista Alberti in his *Della Pittura*, advises painters to construct the human figure by dividing the man into three equal parts.[17] Piero here has followed Alberti's advice. The first unit of 27.9 cm reaches from the top of the head to the midriff. The second ends near the lower edge of the loincloth and line of the river in the middle distance. This latter point, interestingly enough, corresponds roughly to, and perhaps confirms, what Mrs. Lavin finds to be the pseudo–vanishing point of the landscape space.[18]

Thus Piero determined a standard of measure for Christ's body by superimposing the regular pentagon on the equilateral triangle inscribed in a circle centered on Christ's fingertips, and took as a module the dimension of one chord of the circle or one side of the fifteen-sided figure produced by the superimposition.

60. Piero della Francesca, *Baptism of Christ* with geometric overlays by B. A. R. Carter (reproduced by courtesy of the Trustees, The National Gallery, London)

We may now state in mathematical terms how the unit of measure, the width of the panel, and panel's height interrelate. The side of the equilateral triangle (116.2 cm) divided by the square root of three (1.732) is the radius of the circle (67.09 cm), which being multiplied by the sine of 12° × 2 gives the length of the chord that subtends 24° at the center and is the side of the fifteen-sided figure inscribed in the circle: 116.2 ÷ 1.732 = 67.09 × .4158 = 27.896. The latter number is the unit of measure, being one-third the height of Christ and one-sixth the height of the panel to within two-fifths of a centimeter: 27.896 × 3 = 83.688 × 2 = 167.376.

Finally, the fact that the chords subtend 24° at the center of the circle provides the clue to what led Piero to choose this system of measurement. In his commentary to Euclid's *Elements of Geometry*, Sir Thomas Heath tells us it was traditionally held that Euclid included proposition 16 with an eye

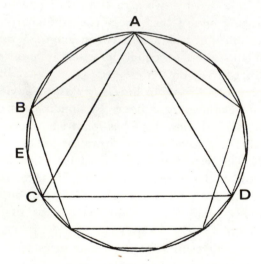

to its use in astronomy. According to most ancient astronomers, 24° was the accepted measurement of the declination of the sun toward the earth. The declination is called the obliquity of the ecliptic. The ecliptic is defined as the line that

61. Illustration for Euclid's Proposition 16, Book 4 (after Heath)

sweeps out a flat surface from the center of the sun to the center of the earth as it moves around the sun (or vice versa according to ancient cosmology). This tilt in relation to the plane of the equator (the plane at right angles to the earth's axis in rotation) gives us the seasons. The belt of the sky extending about 8° on each side of the ecliptic is the region of the sky in which the movements of the sun, moon, and greater planets appear to take place. This belt is of course what we call the zodiac.[19]

Mrs. Lavin has shown that the figural representation of the *Baptism* refers to the liturgy of the Feast of Epiphany, celebrated on the day anciently considered to be the winter solstice and the birthday of the god of the sun. I propose that if Piero wished to reinforce this symbolism and identify Christ as Sol Invictus in mathematical terms, a reference to the angle of the ecliptic would be his logical choice.[20] His appropriation of the Euclidian construction, therefore, determines the scale of the painted space, gives the absolute dimension of Christ's body and, in diagrammatic terms, places Christ at the center of the ecliptic, which is the center of the zodiac. The geometric construction, adding stability to the perspective landscape vista, provides the mathematical way to symbolize Christ as the center of the Universe of Divine Light.

The ecliptic is again the guiding principle, we find, when we ask how Piero decided on the radius of the semicircle crowning the panel (54.75 cm). This time he took the chord of the segment subtending 48° at the center which measures 54.571 cm, as seen in fig. 62, below the segment marked with arrows. The margin of error, .179 cm, is negligible. Stated in mathematical terms the chord measures sine $24° \times 2 \times$ the radius: $.8134 \times 67.09 = 54.571$.[21]

It remains to show that the vertical dimension of the rectangular section of the panel is related to the equilateral triangle and the circle through the same principle. The measure of the side of the pentagon, i.e., chord 72°—which by

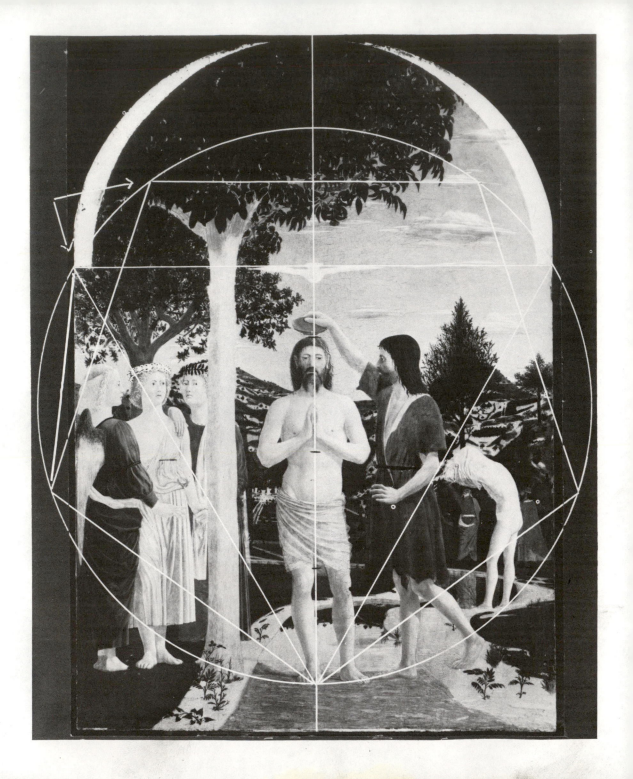

calculation is sine 36° × 2 × the radius: 78.871 cm (1.1756 × 67.09)—is the same as the distance from the center of the circle to the bottom of the painting. This dimension is the same as the radius plus one-tenth of the side of the equilateral triangle (67.09 + 11.62 = 78.71). The .16 cm discrepancy is negligible. Thus Piero integrated his design by the application of all four degrees of chord represented in proposition 16: chord 120° is the basic measurement, the side of the equilateral triangle and the width of the painting; chord 72° is the side of the regular pentagon which completes the vertical dimension of the rectangular section; chord 48° gives the radius of the semicircle; and chord 24° is the module for the figure of Christ and the total height. The cycle of construction is complete and all the main dimensions relate to the starting point, the width of the panel, and the measurement of two braccia.

FURTHER SPECULATION

For one last observation we return to Clark's text, where we note that he saw the tripart horizontal division and the four-part vertical division as forming a central square with the figure of Christ linked to the dove by an implied triangle.[22] In fig. 63 I have made the middle vertical zone into a double square by constructing an inverted semicircle centered on the dove's tail, and by drawing a tangent to the semicircle parallel to the top of the rectangle. The circumference of this semicircle passes through various important elements of the figure composition, e.g., the top of Christ's loincloth, St. John's elbow, and the head of the catechumen. The double square subdivides into four reciprocal double squares, the center two of which combine into a central square. This figure is basically what Clark suggested. Further, the implied triangle with its apex in the dove is an isosceles triangle, with apex angle of 36° and base angles of 72°. In fig. 63 I have developed this

62. Piero della Francesca, *Baptism of Christ* with geometric overlays by B. A. R. Carter (reproduced by courtesy of the Trustees, The National Gallery, London)

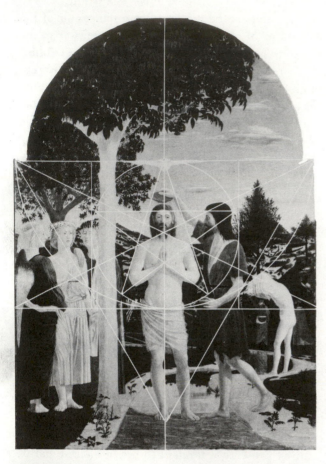

triangle into a regular, or "star," pentagram. We may observe how closely some of the main outlines of the upper part of Christ's figure follow this pattern. This isosceles triangle (whose sides form golden sections with its base) is the elementary triangle of the dodecahedron, the regular body contained by twelve regular pentagons, which Luca Pacioli says "gives formal essence, according to the ancient Plato in his *Timaeus* (chap. 54), to the very Heavens." I assume, once again, that Piero uses it here for its Platonic connotations.[23]

63. Piero della Francesca, *Baptism of Christ* with geometric overlays by B. A. R. Carter (reproduced by courtesy of the Trustees, The National Gallery, London)

NOTES

1. For a discussion of this controversy see R. W. Wittkower, "The Changing Concept of Proportion," *Daedalus*, Special Issue (1960): 199–215.

2. *De prospectiva pingendi* (Italian text) ed. G. Nicco Fasola (Florence, 1942), (Latin text) ed. C. Winterberg (Strassburg, 1899); *Del abaco*, ed. G. Arrighi (Pisa, 1970); "L'opera *Libellus de quinque corporibus regularibus*," G. Mancini, in *Rendiconti dell'Accademia nazionale dei Lincei* (Rome, 1915 [issued in 1916]), ser. 14, pp. 441–580. For the first three hundred years following his death, Piero was remembered as a mathematician rather than as a painter.

3. M. Clagett, *Archimedes in the Middle Ages* (Philadelphia, 1978), vol. 3, pt. 3 (The Medieval Archimedes in the Renaissance 1450–1565), pp. 383ff., esp. 399–400, and 415–16.

4. R. W. Wittkower, "Systems of Proportion," *Architect's Year Book*, 5 (1953): 11: "The philosophical work of the Renaissance was focused on the attempt to reconcile Plato and Christianity. One tried to interpret the great harmony created by God in terms of the Platonic numerical order, and artists were convinced that their work should echo this universal harmony. If it did not, the work was inharmonious and out of tune with universal principles." See also R. Klibansky, *The Continuity of the Platonic Tradition* (London, 1950), pp. 21, 32.

5. Dionysius the Areopagite (fifth century): "These things thou must not disclose to any of the uninitiated, by whom I mean those who . . . fancy that they know by human understanding Him who has made Darkness His secret place" (*Dionysius the Areopagite*, trans. C. E. Rolt [London, 1951], p. 192 ["The Mystical Theology"]). "That Divine and Heavenly things are appropriately revealed, even through dissimilar symbols" (*The Works of Dionysius the Areopagite*, trans. J. Parker [London, 1897], pt. 2, p. 4 ["On the Heavenly Hierarchy"]). Pico della Mirandola (ca. 1486): ". . . to keep hidden from the people the things to be shared by the initiate . . . was not part of human deliberation but of Divine command. . . . The Sphinxes carved on the temples of the Egyptians reminded them that mystic doctrines should be kept inviolable from the common herd by means of knots and riddles" (*The Renaissance Philosophy of Man*, ed. E. Cassirer, P. O. Kristeller et al. [Chicago, 1956], p. 250 ["Oration on the Dignity of Man," trans. E. L. Forbes]). Marsilio Ficino (ca. 1490): "It was the custom of the Ancient Theologians to protect the divine mysteries with mathematical numbers and figures and poetical deceits lest by chance the commonalty should utter them to anyone" (trans. author: Veterum autem Theologorum mos erat divina mysteria cum mathematicis numeris et figuris, tum poeticis figmentis obtegere: ne temere cuilibet communia forent.); (Latin text from Ficino's commentary on and edition of Plotinus, *Opera omnia* [Basel, 1575], p.

1537; quoted by D. P. Walter, "Esoteric Symbolism," *Studies in Honor of James Hutton* [New York, 1975], pp. 218–32). Luca Pacioli (1490s): In chap. 5 of his *De Divina Proportione*, Pacioli defends the suitability of his title because "of the many attributes that we assign to the Divine Proportion [in the nineteenth century renamed the Golden Section] which are similar to the attributes of God himself (convenientie . . . a epso dio spectanti). Firstly, that it is unique and unified; unity being the highest epithet we can attach to God. . . . The second *convenientia* is of the Holy Trinity. That is because there is one and the same substance among three persons . . . so, in the same way there must always be one and the same proportion of this kind between the three terms" (*De Divina Proportione* [Venice, 1509], modern edition, ed. C. Winterberg [Vienna, 1889], pp. 43–44). The third part of this treatise is an Italian version of Piero's tract on the *Five Regular Bodies* without acknowledgment. For analytical discussions of the relationship between Piero's text and Pacioli's, see *Clagett*, ibid., pp. 416ff., and M. D. Davis, *Piero della Francesca's Mathematical Treatises* (Ravenna, 1977), passim, but esp. pp. 107ff. Cf. also G. L. Hersey, *Pythagorean Palaces: Magic and Architecture in the Italian Renaissance* (Ithaca and London, 1976).

6. F. Casalini, "Corrispondenze fra teoria e pratica nell'opera di Piero della Francesca," *L'Arte*, n.s. 1 (1968): 62–95, 108–110, 113–15, 117–19; Battisti, *Piero*, vol. 1, pp. 413, 509; W. Welliver, "The Symbolic Architecture of Domenico Veneziano and Piero della Francesca," *The Art Quarterly* 36 (1973): 1–30; M. Calvesi, "Sistema degli equivalenti ed equivalenze del sistema in Piero della Francesca," *Storia dell'arte* 24/25 (1975): 83–110; C. Verga, "L'architettura nella 'Flagellazione' di Urbino," *Critica d'arte* 41 (1976): (no. 145) 7–19, (no. 147) 31–44, (no. 148–49) 52–59, (no. 150) 25–34.

7. Cf. Lavin, "Piero della Francesca's Fresco;" Wittkower and Carter, "The Perspective of Piero della Francesca's 'Flagellation' "; Lavin, *The Flagellation*; M. Meiss, *La sacra conversazione di Piero della Francesca* (n.d., n.p. [Florence, 1975]), original article published in 1942.

8. Kenneth Clark (*Piero*, p. 13) was the first to observe that "even in the *Baptism*, the least rigidly mathematical of all Piero's paintings, we are at once conscious of a geometric framework; and a few seconds analysis shows us that it is divided into thirds horizontally and into quarters vertically." Clark's passage was the point of departure for the main stream of ideas elaborated here. See below, *Further Speculations*. Cf. also, Hendy, *Piero*, p. 70.

9. Our figures differ slightly from those given in the National Gallery illustrated general catalogue of 1973 where the height is listed as 167.6 cm, probably referring to the dimension of the panel and not to the painted surface; Clark gave 166 x 115 cm, and Hendy gave 167 x 116 cm. I am deeply grateful to Arthur Lucas, chief restorer, retired, and Martin Wyld, chief restorer, National Gallery, London, for their

friendly help in putting photographic records at my disposal and especially for their patient collaboration in checking measurements on the painting in my presence. The edges of the painted surface suffered considerably when the panel was removed from its original frame and placed in a new one. Achieving accurate measurements, therefore, is quite difficult.

10. In the thirteenth century, a delegation was sent from Pisa to Jerusalem to measure Christ's tomb. The measurement of the braccio was determined by dividing this measurement by three. With slight variations, the dimension was soon used throughout Italy. Cf. G. Uzielli, *Misure lineari medioevale e l'effigie di Cristo* (Florence, 1899); idem, "L'Orazione delle misure di Cristo," *Archivio storico italiana* 27 (1901): 333–56; also D. F. Zervas, "The Trattato dell'abbaco and Andrea Pisano's Design for the Florentine Baptistry Door," *Renaissance Quarterly* 28 (1978): 483–503, esp. 491ff.

11. Throughout the analysis, I used modern metric measurements. After it was complete, on the advice of professors George Hersey and Samuel Edgerton, the modern measurements were converted into braccia. Having already found that the width was the given from which the construction of the composition was generated, the conversion showed it to be equivalent to two braccia. Until this moment, no particular reason had been found for the choice of this measurement; in the metric system it seemed a random number. But if Piero started by deciding his panel would be two braccia wide, he took a rational figure as his point of departure. The other basic dimensions in the construction are only vaguely related to braccio lengths: e.g., height of panel, 167 cm : 175 cm, three braccia; height of rectangle, 112.25 cm : 116.7 cm, two braccia; height of semicircle, 54.75 cm : 58.36 cm, one braccio; height of Christ, 83.7 cm : 87.54 cm, one and a half braccia. By contrast, the width of the panel (116.2 : 116.7 cm, two braccia) is almost exact, a fact that can be further related to the rather out-of-the-ordinary physical makeup of the panel: composed of two broad planks, each approximately one braccio in width. See below, app. 2.

12. The equilateral triangle is the elementary triangle of three of the four elements named by Plato: the tetrahedron (fire), the octahedron (water), and the icosahedron (air); throughout the Middle Ages it was held in reverence as one of the holy elements of which God had created the universe. Cf. P. Frankl (and E. Panofsky), "The Secret of the Medieval Masons," *Art Bulletin* 27 (1945): 59.

13. See above, chap. 6, for discussion of the size of Christ on the picture plane.

14. *The Thirteen Books of Euclid's Elements*, trans. and ed. T. L. Heath (Cambridge, 1926), vol. 2, pp. 110–11: "In a given circle to inscribe a fifteen-angled figure which shall be both equilateral and equiangular: let ABCD be the given circle; thus it is required to inscribe in circle ABCD a fifteen-angled figure which shall be both equi-

lateral and equiangular. In the circle ABCD let there be inscribed a side AC of the equilateral triangle inscribed in it, and a side AB of an equilateral pentagon; therefore, of the equal segments of which there are fifteen in the circle ABCD, there will be five in the circumference ABC which is one-third of the circle, and there will be three in the circumference AB which is one-fifth of the circle; therefore in the remainder BC there will be two of the equal segments. Let BC be bisected at E; therefore each of the circumferences BE, EC is a fifteenth of the circle ABCD. If therefore we join BE, EC and fit into the circle ABCD straight lines equal to them and in contiguity, a fifteen-angled figure which is equilateral and equiangular will have been inscribed in it" (with proofs).

15. See above, chap. 6, n. 11. Heath, *Euclid's Elements*, vol. 2, p. 99, tells that the Pythagoreans used the triple interwoven triangle, the pentagram, as a symbol of recognition and that it was called by them *Health*. See V. F. Hopper, *Medieval Number Symbolism* (New York, 1969), pp. 122ff., 135; *Encyclopaedia Britannica*, 14th ed., s.v. "Stigmatization."

16. It appears that Piero used the length of the chord of the fifteen-sided figure for his module rather than the length of the arc. By calculation, using pi $= 3.14$, the length of the arc is 28.0883 cm. This would require the height of Christ to measure 84.265 cm, whereas the length of the chord makes it 83.691 cm, which agrees with the measurement made on the panel.

17. Alberti, '*On Painting*' *and* '*On Sculpture*,' pp. 55, 69. On the fixed module tradition see E. Panofsky, *Meaning in the Visual Arts* (New York, 1955), pp. 62ff.; and Vitruvius, *On Architecture*, Loeb Classical Library (London, 1955), vol. 1, p. 159, and vol. 2, p. 21.

18. See above, chap. 1. One unit or chord of fifteen-sided figure, 27.9 cm : 29.18 cm, half a braccio.

19. *Euclid's Elements*, vol. 2, p. 111. T. Heath, *The Twentieth Century Atlas of Popular Astronomy* (Edinburgh, n.d. [1903]), p. 18, and pls. 1 and 2.

20. The problem of measuring the ecliptic was anything but arcane in Piero's time. Both Alberti and Paolo dal Pozzo Toscanelli were concerned with it and brought to it new realms of precision. In a letter dated February 1464, the great astronomer Regiomontanus (1436–76) praises their work saying while most astronomers claim that the "maximum declination of the sun in our days is 24 degrees and 2 minutes, we, however, my teacher [Peurbach] and I, have ascertained with instruments that it is 23 degrees and 28 minutes almost, and I have often heard Magister Paolo the Florentine and Battista Alberti say, that by diligent observation, they found that it did not exceed 23 degrees and 30 minutes, the figure I have decided to register in our tables"; quoted after J. Gadol, *Leon Battista Alberti* (Chicago, 1973), pp. 195–96; Latin text given by G. Uzielli, *La Vita e i tempi di Paolo dal Pozzo Toscanelli* (Rome, 1894), p. 234. It is further said that

Toscanelli literally built his calculations into the dome and floor of the Cathedral of Florence in 1468, in the form of a solstitial sundial. This arrangement, a hole in the base of the lantern, Toscanelli's *gnomone*, and a bronze plaque on the floor, were restored and graduated by Padre Francesco Ximenez and published by him in *Del Vecchio e nuovo gnomone fiorentino* (Florence, 1757), pl. 8, fig. 24 (our fig. 64). See also the late medieval zodiac mosaic on the floor of the Florentine Baptistry, which was, according to ancient records, part of an early solstitial dial; in the words of Giovanni Villani (*Cronaca*, lib. 1, cap. 60), "fatta per astronomia." For a full account, see Ximenez, *Gnomone*, Introduzione istorica, p. xix, with engraving of the mosaic; and W. R. Lethaby, *Mediaeval Art* (London, 1904), pp. 101–02. The relevance of this dial to its setting in a baptistry is obvious when we recall that, traditionally, the date of Easter, based on astronomical calculations, is announced annually by the bishop on the eve of the Feast of Epiphany.

21. Chord $48° \times 2$ (diameter of the semicircle), plus chord $120° \div 2$ (half the width of the painting) is equal to chord $24° \times 6$ (total height of the painting), or very nearly so. In calculating this "equation," based on unit radius, I found that it yields $2.492972 : 2.494940$. The small difference would not be detectable by direct measurement, and one wonders whether Piero thought it close enough to exemplify a mathematical principle (one might say, a mathematical "miracle"), rather than a happy coincidence.

22. Clark, *Piero*, pp. 13–14.

23. Pacioli, loc. cit (see above, n. 5). For a precedent case of an inverted isosceles triangle imposed on the surface of a perspective space, see P. Sanpaolesi (*Brunelleschi* [Milan, 1962], p. 48 and ill. opp.), who analyzes Masaccio's *Trinity* in S. Maria Novella, Florence. In this case, the triangle is formed by the orthogonals of the barrel vault, which converge to the central vanishing point and are based on the diameter of the semicircular arch. The apex angle is accurately represented by Sanpaolesi, though I find that he places the "horizon" line somewhat higher than the level indicated by the actual point of convergence of the orthogonals. Sanpaolesi does not name the apex angle, but it is again 36°.

Spaccato della Cupola del Duomo di Firenze, e delle due Tribune di S. Antonio e della Croce secondo la direzione del Meridiano.

Fig. XXIV.

Modern History and Physical Condition
of the *Baptism*

The first modern reference to the painting of the *Baptism* was made in 1828 and reads as follows: "Entering, finally into the same [sacristy] of the Cathedral [of Sansepolcro] one finds there a panel with Gothic ornament in the shape of a triptych; and in the center one sees the Baptism of Our Lord colored by Pietro della Francesca, and at the sides, the Holy Apostles Peter and Paul; and on the step below, several stories of St. John the Baptist."[1] Two years later, the altarpiece was put into the context of Piero's oeuvre, in an edition of Vasari's *Life of Piero* which was commissioned by a descendant of Piero's family and annotated by a local historian. Here a fuller description is given. It reads: "In the sacristy of the Cathedral of Sansepolcro, there is a panel which earlier was part of the high altar of the parish church of St. John in this city, suppressed in 1807. This panel is divided into three parts. In the center there is represented St. John the Baptist who baptizes Jesus Christ on the banks of the Jordan under a tree near which are three standing angels. The painting has suffered a great deal from the unskillful way it was cleaned a long time ago. The remainder of the ensemble, which according to various experts in such matters is believed to be by another hand, is painted on a gold ground and rather well preserved. On the right [i.e., Christ's right] one sees St. Peter, on the left, St. Paul; on the sides the little panels [set in] the frame represent St. Arcano and St. Egidio, the founders of Sansepolcro, St. Steven, St. Anthony Abbot, and two female saints [Mary

64. Illustration of the Declination of the Ecliptic in the Cathedral of Florence using Toscanelli's *gnomene*, engraving (after Padre Francesco Ximenez)

Magdalen and Catherine of Alexandria]. Above the painting in three rondels are represented a God-the-Father, and a Virgin receiving the Annunciation from an angel. On the predella are [scenes] of the Birth of St. John the Baptist, St. John preaching in the desert, Jesus Crucified with many figures, St. John reproaching Herod seated on a throne, and Herod at the banquet table with Herodias dancing. These five little scenes are separated by four niches containing the four Doctors of the Church."[2]

During the 1840s and 1850s one of the more elaborate and costly renovations of the Cathedral of Sansepolcro was underway. A new Neobaroque marble high altar had been designed and was partially built. By the mid-1850s funds for the project were exhausted, and the Chapter of the Canons was casting about for a new source of revenue. The panel by Piero, recently brought to public attention but not in liturgical use, came to mind as a salable item. On October 7, 1858, the vicar general, Monsignore Carlo Martelli, acting for the chapter, offered the *Baptism* for sale to the Italian government. Although the idea received eight favorable votes to one negative in the National Assembly, the following spring (April 5, 1859) it was officially announced that such a purchase by the State would be contrary to the laws then in force.

Meanwhile, a proposal to buy the painting had come from a foreign agent. Before it could be considered, proper authorization was necessary, and the local representative of the *Belle Arti*, Conte Carlo della Porta, was called in to give an expertise. Della Porta's statement of April 19, 1859, expressed his opinion in no uncertain terms: "The sale to be made of the Piero della Francesca *Baptism* only, for 2,000 *scudi*, is a really good piece of luck for the Signori. . . . When I examined that painting with my own eyes, it was with pain that I noted not only was it washed out, not to say peeled, but that unfortunately it had been retouched by an inexpert hand. Not so at all the other beautiful panels of the surround, which are intact. As a result, one may say that the Signori are selling

the bone and keeping the meat! . . . For 2,000 scudi they are selling the memory of Piero della Francesca, but not an integral work. Thus I am delighted to add that you should be reassured and not allow this good opportunity to slip through your hands." Commendatore Boncompagni, the commissioner extraordinary of Tuscany, concurred, and permission for the sale was granted. A few days later, on April 22, the contract of sale for 2,000 *scudi fiorentini* (or 14,000 *lire toscani*) was drawn up between Monsignore Martelli and the archpriest Giovanni Battista Rigi, in the name of the chapter, and Giovanni Battista Collacchioni, surrogate for the buyer.[3]

The purchaser of the painting was Matthew Uzielli, a wealthy British merchant and railway director who was also an art collector and member of the Burlington Fine Arts Club in London. His agent had been Sir John Charles Robinson, superintendent of the art collections of the South Kensington Museum, in Italy looking for museum purchases. Robinson recorded the purchase in his own publication of the following year and showed the painting on loan at South Kensington from 1860 to 1861.[4] Uzielli's ownership was brief, and in the sale of his collection held at Christie's in London on April 13, 1861, the *Baptism* went on the block as Lot 184. It was sold for £ 241 10s to Sir Charles Eastlake, first director of the National Gallery, London. Eastlake had mixed feelings about the work, having ruminated over the purchase for six months. In private correspondence from this time, he called it "a most undoubted and characteristic specimen, fortunately almost unrestored, and so it will remain—but the great objection to it is its very ruined state. This weighs with me so much that I am at this moment undecided whether to place it in the National Gallery (where it cannot have a good place) or to take it myself."[5] His decision was made soon enough, however, and the *Baptism*, in a new Renaissance-style rectangular gold frame, was hung on the walls of the National Gallery.

The painting's condition has remained something of an issue. Crowe and Cavalcaselle found that "a serious drawback

to enjoyment of this picture is the abrasion of its colour and its reduction to the condition of a preparation such as we might expect to see in an unfinished work of Correggio."[6] Nearly a hundred years later, Kenneth Clark, at that time the director of the National Gallery, stated flatly that while conceivably the colors had faded slightly, it was "remarkably well preserved."[7] At the same moment, the gallery catalogue provided the first objective account of actual damages.[8]

In 1966, a scientific cleaning of the whole surface was undertaken. While a full account of this campaign has never been published, a condition report in the gallery files yields the following information.[9] The panel, probably made of poplar wood, is constructed in an unusual way: it is composed of two wide vertical planks (58.1 cm each) joined in the center, rather than the more common three or more planks. There is a serious split down the middle of the panel probably resulting from this extraordinary carpentry.[10] The painting was done entirely in egg tempera, and now has a heavy craquelure with patches that have cupped or risen into small, low bubbles. There are, however, no large areas of loss, only minor ones concentrated adjacent to the central crack. Some overcleaning is apparent, especially on the face of the angel to the right, to a lesser extent on the central angel, and on the beard of St. John. The worst damage is the rubbing which occurred over most of the flesh tones. The opacity of the whites has been weakened to the point that too much *verdaccio*, or greenish underpainting, is exposed. This unintentional greenish glow is particularly strong in portions that were meant to be shadowed. The other significant area of physical loss is of applied gold. Besides the rain of gold down the center of the composition, there were golden haloes for each angel; their wings were shot with gold, and the border of Christ's loincloth, embroidered with "kufic" lettering, glistened with golden threads. These areas are now little more than black lines of tooling, with only a few fragments of gold leaf clinging here and there. A certain amount of mental

compensation is thus called for in reconstructing the original effects of luminosity and spiritual evanescence.

The cleaning procedure included removing all the old, yellowed varnish and repainting, especially along the median joint. This area, as well as the flesh tones, Christ's loincloth, and the tree trunk, were lightly retouched with egg tempera underpainting and glazed with MS2B resin medium, asserted to be totally inert and more permanently transparent than natural resin varnish.

With these facts at hand, we may now speak with assurance of the painting's technique and the quality of some of its pictorial effects. There is no question that it was finished; work proceeded from the background forward, the landscape being laid in first and then the figures. As Piero progressed, he adjusted and modified his ideas, making several changes in the scale and position of the figures. See, for example, the feet of the left angel, the arm and drapes of the one whose wing has become quite transparent on the right, and the back of the undressing figure. He used a startling variety in the brushwork; in the background there are slashes and daubs of paint, loosely applied to render terraces of vineyards, olive groves, and patches of sandy earth on distant hills. For the trees and town at the end of the meadow, somewhat more regular strokes of local color are employed, consciously shaping the forms, but still relatively open in application. Single vertical strokes indicate sunlight on the edges of houses and towers. Objects in the meadow and the valley floor itself are laid on with only slightly more disciplined strokes.[11] In the foreground, the brushwork tightens. The forms there are outlined, and within the contours autonomous short and narrow strokes of variegated pigments are placed together with meticulous care to simulate the rounded bodies. Local color comes first, then modeling tones, and finally highlights added on the top. The technique is still more tightened in the heads: hair is rendered stroke by stroke to build the mass, and in the faces no individual stroke is allowed to show. Close foreground de-

tails of plant life and whorls of water are drawn in color with one or two continuous movements of the brush, their larger size indicative of their actual scale. In other words, Piero modulated his brushstrokes to create the illusion of firm reality in the foreground and the effect of blurred vision in the distance, where things are seen through light refracted on vapors that accumulate in the atmosphere. He thus built space and light as well as form of clear, bright color.

NOTES

1. G. Mancini, *Istruzione storico-pittorica . . . di Città di Castello* (1832), vol. 1, p. 340 (reprint of a letter of 1828), vol. 2, pp. 267–68: "Entrando finalmente nella medesima del Duomo una tavola vi si trova con ornamento gotico a guisa di un trittico; e nel mezzo di essa vedesi da Pietro della Francesca colorito il Battesimo di N.S., ed ai lati i Santi Apostoli Pietro e Paolo; e nel sottosposta gradino piú storie di S. Gio. Battista."

2. *Vita di Pietro della Francesca, pittore dal Borgo Sansepolcro, scritta da Giorgio Vasari Aretino* (Florence, 1835), intro. by Magherita Vedova Pichi, notes by F. G. Dragomanni, p. 22, n. 12. As Vasari does not mention the *Baptism* in his life of Piero, it is added in the notes. The original reads: "Nella sagrestia della Cattedrale di S. Sepolcro si conserva la tavola, che prima apparteneva all'altare maggiore della priora di San Giovanni della stessa città, soppressa nel 1807. Questa tavola è divisa in tre parte. Nel mezzo vi è rappresentato San Gio. Battista, che battezza G. C. alle rive del Giordano sotto un albero, attorno al quale sono tre Angeli in piedi; questa pittura ha molto sofferto per l'imperizia di quello che molto tempo fà la ripulì. Il rimanente del quadro (che da varii intendenti è creduto di altra mano) è dipinti in campo d'oro, ed è sufficientemente conservato. Nel quadro a diritta si vede S. Pietro, in quello a sinistra S. Paolo. Dai lati nelle piccole tavole, che formano quasi la cornice dei tre quadri principali sono effigiati S. Arcano e S. Egidio fondatori di S. Sepolcro, S. Stefano, S. Antonino abate e due Sante. Nel'alto del quadro in tre tondi è dipinto un Dio Padre ed una Vergine Annunziata dall'Angelo. Nel gradino poi si vede la Natività di S. Gio. Battista; S. Gio. Battista predicante nel deserto; Gesù Crocifisso con molte figure; S. Gio. Battista che rimprovera Erode seduto in trono; Erode a mensa ed Erodiade che danza. Questi cinque quadretti sono divisi da quattro nicchie con quattro Santi Dottori."

3. The foregoing information depends on Agnoletti, "Le vicende." The

quotation from della Porta's letter of 1859 in the original reads:

> *A vendita che vanno a fare del solo Piero della Francesca, il*
> *battesimo di S. Giovanni, per scudi duemila è una vera fortuna*
> *per loro signori, mentre quando esaminai quel quadro sott'occhi,*
> *con dolore marcai che non solo era slavato, per non dire scortica-*
> *to, ma disgraziatemente da inesperta mano ritocco. Non così è di*
> *tutte le altre belle tavole di contorno che sono intatte, per cui può*
> *dirsi che le signorie loro vendono l'osso e si serbano la polpa! E*
> *con 2.000 scudi vendono la memoria di Piero della Francesca ma*
> *non un'opera di lui intatta.*
>
> > *Tanto mi piace riservatamente aggiungere a di [?] lei tran-*
> > *quillità, e perché non si lascino sfuggire questa buona occasione.*

The contract of sale, surviving in a 1909 copy, is published in Battisti, *Piero*, vol. 2, p. 17. At this time a copy of Piero's panel was executed; it hangs still today in the sacristy of the cathedral.

4. Sir John Charles Robinson, *Catalogue of the Various Works of Art Forming the Collection of Matthew Uzielli* (London, 1860), pp. 266–67, no. 819: "This picture was formerly in the sacristy of the Cathedral of Borgo Sansepolcro from whence it was only removed in the spring of 1859, having been purchased by the author for its present possessor from the Bishop and Chapter, who were desirous of selling it in order to raise funds for the erection of a new high altar." Robinson then goes on to say, "In its original locality it formed the center division of a large altarpiece in three compartments; the original side divisions, however, and predella, had disappeared, and had been replaced by similar portions of another altarpiece by a later and far inferior hand; these latter, therefore, were not removed."

5. A new life of Sir Charles Eastlake has recently been published with documentation from the National Gallery Archive, including this letter: D. Robertson, *Sir Charles Eastlake and the Victorian Art World* (Princeton, 1978), pp. 195, 274, 312. See also Battisti, *Piero*, vol. 2, p. 18, for another contemporary opinion downgrading the painting's condition.

6. Crowe and Cavalcaselle, *History of Painting*, vol. 2, p. 541. These authors go on to pronounce the painting of great value to the English critic in providing a basis for understanding the "Florentine method of oil." In this context, they give what purports to be an analysis of the *Baptism's* surface, even referring to the buildup of transparencies through the use of multiple glazes. The discussion is entirely spurious: the use of oil has been documented in few of Piero's works, and not in the *Baptism*, which is painted entirely in egg tempera; see below, n. 9. Cf. C. Blanc, *Histoire des peintre de toutes les écoles, Ecole ombrienne et romaine* (Paris, 1870), p. 8, who believed the painting was actually unfinished.

7. Clark, *Piero*, p. 204.

8. Davies, *Earlier Italian Schools*, 1st ed., p. 331, no. 665; see also 2d ed., pp. 426ff.

9. The condition report, by John Hargrave, was kindly made available to me by Cecil Gould, keeper of paintings, retired, National Gallery, London. Mr. Gould extended me every courtesy, making my study of the painting and all pertinent records comfortable as well as fruitful. Cf. *The National Gallery, Jan. 1965–Dec. 1966* (London, 1967), p. 65, "Report of the Scientific Department."

10. The two-part vertical construction reflects the geometric organization of the composition; see above, app. 1.

11. Clark, *Piero*, p. 13, declares that the *Baptism* is painted with a looseness and lightness found nowhere else in Piero's work. This assertion is untrue; much of the Arezzo fresco cycle is painted in precisely the same way, with separate colors laid side by side. Clark's opinion, voiced in his 1951 edition, preceded the cleaning of the frescoes, after which this technique became visible.

Bibliography

Agnoletti, E. "Le vicende del 'Battesimo di Cristo' di Piero della Francesca." *La Voce (Settimanale religioso-sociale)*, Oct. 5, 1975, p. 1.

Alberti, Leon Battista. *'On Painting' and 'On Sculpture': The Latin Texts of De Pictura and De Statua*. Edited and translated by C. Grayson. London, 1972.

Annales Camaldulenses ordinis Sancti Benedicti. Edited by J. B. Mittarelli and A. Costadoni. Venice, 1760–.

Battisti, E. *Piero della Francesca*. Milan, 1971.

Baumstark, A. *Comparative Liturgy*. 1st French ed., 1939. Revised by B. Botte, 2d ed., translated by F. L. Cross. London, 1958.

Brilliant, R. *Gesture and Rank in Roman Art*. Memoirs of the Connecticut Academy of Arts and Sciences, no. 14. New Haven, 1963.

Bute, Earl of [John P. C. Stuart], and E. A. W. Budge. *The Blessing of the Waters on the Eve of Epiphany, Translated and Edited from the Greek, Syriac, and Latin*. London, 1901.

Cabrol, F. *Dictionnaire d'archéologie Chrétienne et de liturgie*. Paris, 1910.

Clark, K. *Piero della Francesca*. London, 1951. 2d ed., 1969.

Coleschi, L., and F. Polcri. *La Storia di Sansepolcro dalle origine al 1860*. 2d rev. ed. Sansepolcro, 1966.

Crowe, J. A., and G. B. Cavalcaselle. *History of Painting in Italy*. London, 1864.

Davies, M. *The Earlier Italian Schools*. National Gallery Catalogues. London, 1951, 2d ed., 1961.

Demus, O. *The Mosaics of Norman Sicily*. London, 1949.

De Vecchi, P. *L'Opera completa di Piero della Francesca*. Classici dell'arte, no. 9. Intro. by O. del Buono. Milan, 1967.

Dictionary of the Bible. Edited by J. Hastings et al. Edinburgh, 9th ed., 1928, 11th ed., 1931.

Dionysius of Fourna. *The 'Painter's Manual' of Dionysius of Fourna*. Translated by P. Hetherington. London, 1974.

Eisenhofer, L., and J. Lechner. *The Liturgy of the Roman Rite*. Translated by A. J. and E. F. Peeler. Edited by H.·E. Winstone. 6th German ed., 1953, New York, 1961.

Ephraim Syrus (Ephraim the Syrian). "Hymns for the Feast of Epiphany," in *A Select Library of Nicene and Post-Nicene Fathers of the Christian Church*. Edited by P. Schaff and H. Wace. 2nd ser., vol. 13, part 2. Grand Rapids, 1956.

Evelyn [Franceschi-Marini]. *Piero della Francesca, 'Monarca della Pittura ai suoi dì.'* Città di Castello, 1912.

Farulli, P. *Annali e memorie dell'antica e nobile città di S. Sepolcro, intorno alla sua origine e vita de' Santi Arcadio, ed Egidio Fondatori*. Foligno, 1713.

Ferguson, G. *Signs and Symbols in Christian Art*. New York, 1954.

Funk and Wagnalls Standard Dictionary of Folklore, Mythology, and Legend. New York, 1949.

Galavaris, G. *The Illustrations of the Liturgical Homilies of Gregory Nazianzenus*. Princeton, 1969.

Gilbert, C. *Change in Piero della Francesca*. Locust Valley, N.Y., 1968.

Gnudi, C. *Giotto*. Milan, 1958.

Goracci, A. *Breve istoria dell'origine e fondazione della Città del Borgo di San Sepolcro, 1636*. Edited by F. G. Dragomanni. Collezione di storici e cronisti Italiani, vol. 5, no. 7. Florence, 1847.

Graziani, A.-M. *De scriptis invita Minerva*. Edited by H. Lagomarsini. Florence, 1745.

Hartt, F. *A History of Italian Renaissance Art*. London, 1970.

Hendy, P. *Piero della Francesca and the Early Renaissance*. London, 1968.

Janson, H. W. *The Sculpture of Donatello*. Princeton, 1957.

Jungmann, J. A. *The Early Liturgy: To the Time of Gregory the Great*. Translated by F. A. Brunner. Notre Dame, Ind., 1959.

Kantorowicz, E. "Marriage Belts and Rings at Dumbarton Oaks." *Dumbarton Oaks Papers* 14 (1960): 3–16.

Krautheimer, R., and T. Krautheimer-Hess. *Lorenzo Ghiberti*. Princeton, 1956, 2d ed., 1970.

Kuhn, W. "Die Ikonographie der Hochzeit zu Kana von den Anfängen bis zum XIV. Jahrhundert." Ph.D. dissertation. University of Freiburg, 1965.

Lane, B. "Rogier's Saint John and Miraflores Altarpieces Reconsidered." *Art Bulletin* 60 (1978): 655–72.

Lavin, M. A. *Piero della Francesca: The Flagellation*. London, 1972.

————. "Giovannino Battista, a Study in Renaissance Religious Symbolism." *Art Bulletin* 37 (1955): 85–101; "Giovannino Battista, a Supplement." *Art Bulletin* 43 (1961): 319–25.

————. "Piero della Francesca's Fresco of Sigismondo Pandolfo Malatesta before St. Sigismund." *Art Bulletin* 56 (1974): 345–74; 57 (1975): 307, 607; 59 (1977): 421–22.

————. "Piero della Francesca's 'Montefeltro Altarpiece,' A Pledge of Fidelity." *Art Bulletin* 51 (1969): 367–71.

Levi D'Ancona, M. *The Garden of the Renaissance, Botanical Symbolism in Italian Painting*. Florence, 1977.

Longhi, R. *Piero della Francesca*. Milan, 1927; with additions, 1942 (issued in 1946); with added photographs, notes, and bibliog., Florence, 1963.

Mâle, E. *The Gothic Image: Religious Art in France of the*

Thirteenth Century. 1st French ed., 1902. Translated by D. Nussey. New York, 1958.

Marinesco, C. "Echos Byzantins dans l'oeuvre de Piero della Francesca." *Bulletin de la société nationale des anti-quaires de France* (1958): 192ff.

Meditations on the Life of Christ, An Illustrated Manuscript of the Fourteenth Century. Translated by I. Ragusa. Edited by I. Ragusa and R. Green. Princeton, 1961.

Migne, J.-P. *Patrologiae Cursus Completus. Series Latina* and *Series Greca,* Paris, 1844–1904.

[Muzi, G.] *Memorie ecclesiastiche di Città di Castello.* Vol. 4. Città di Castello, 1843.

Origène, *Homélies sur le Cantique de Cantiques.* Introduced and translated by O. Rousseau. Sources Chrétiènnes, no. 37. Paris, 1953.

Panofsky, E. *Early Netherlandish Painting.* Cambridge, Mass., 1953.

Pogány-Balás, E. "Problems of Mantegna's Destroyed Fresco in Rome, Representing the Baptism of Christ." *Acta Historiae Artium* 18 (1972): 107–24.

Réau, L. *Iconographie de l'art Chrétien.* Paris, 1957.

Ricci, I. *L'Abbazia Camaldolese e la Cathedrale di San Sepolcro.* Sansepolcro, 1942.

———. *Borgo Sansepolcro.* Sansepolcro, 1932.

———. *Storia di (Borgo) Sansepolcro.* Sansepolcro, 1956.

Ripa, C. *Iconologia.* Padua, 1618.

Ristow, G. *Die Taufe Christi.* Recklinghausen, 1965.

Rossi, A. *I Salimbeni.* Milan, 1976.

St. Jerome. *The Homilies of Saint Jerome.* Translated by M. L. Ewald. Vol. 2. Washington, D.C., 1953.

Salmi, M. *Civiltà artistica della Terra Aretina.* Novara, 1971.

Schiller, G. *Iconography of Christian Art.* 1st German ed., 1966; 2d ed., 1969; translated by J. Seligman. Greenwich, Conn., 1971.

Schuster, I. *The Sacramentary (Liber Sacramentorum: Historical and Liturgical Notes on the Roman Missal).* 1st

ed., 1919. Translated by A. Levelis-Marke. London, 1924.

Sterling, W. "The Wedding at Cana in Western Art of the Fourteenth, Fifteenth and Sixteenth Centuries," Ph.D. dissertation, University of Iowa, 1970.

Strzygowski, J. *Ikonographie der Taufe Christi*. Munich, 1885.

Tanner, M. "Concordia in Piero della Francesca's 'Baptism of Christ'." *Art Quarterly* 35 (1972): 1–21.

Testi, L. *Le Baptistère de Parme*. Translated by M. Roques. Florence, 1916.

Tolnay, C. de. "Conceptions religieuses dans la peinture de Piero della Francesca." *Arte antica e moderna* 23 (1963): 205–41.

Ughelli, F. *Italia sacra*. Vol. 3. Venice, 1717–22.

Voragine, J. de. *The Golden Legend*. Translated by G. Ryan and H. Ripperger. New York, 1969.

Vermeule, C. *European Art and the Classical Past*. Cambridge, Mass., 1964.

Weiser, F. X. *Handbook of Christian Feasts and Customs; The Year of the Lord in Liturgy and Folklore*. 1st ed., 1952; New York, 1958.

Wittkower, R., and B. A. R. Carter. "The Perspective of Piero della Francesca's 'Flagellation.'" *Journal of the Warburg and Courtauld Institutes* 16 (1953): 292–302.

Index

Italic numbers refer to illustration numbers

Yale Publications in the History of Art